The Formation of National Collections
of Art and Archaeology

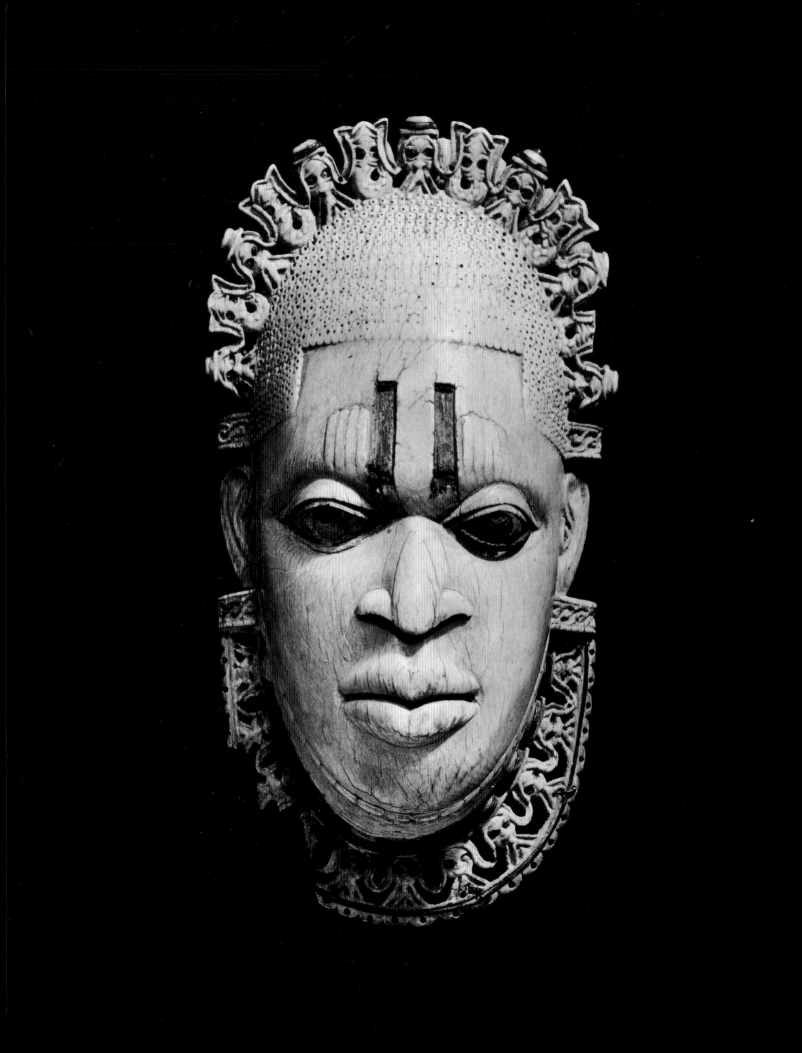

STUDIES IN THE HISTORY OF ART ·47·

Center for Advanced Study in the Visual Arts

Symposium Papers XXVII

The Formation of National Collections of Art and Archaeology

Edited by Gwendolyn Wright

National Gallery of Art, Washington

Distributed by the University Press of New England

Hanover and London

708.009 WRI

This publication was produced by the Editors
Office, National Gallery of Art, Washington
Editor-in-Chief, Frances P. Smyth

The type is Trump Medieval, set by Artech
Graphics II, Inc., Baltimore, Maryland

The text paper is 80 pound LOE Dull

Printed by Schneidereith & Sons,
Baltimore, Maryland

Distributed by the University Press of
New England, 23 South Main Street,
Hanover, New Hampshire 03755

Abstracted and indexed in BHA
(Bibliography of the History of Art)
and Art Index

Proceedings of the symposium "The
Formation of National Collections of Art and
Archaeology," sponsored by the Center for
Advanced Study in the Visual Arts,
24–26 October 1991

ISSN 0091-7338
ISBN 0-89468-202-4

Frontispiece: Queen mother head, Benin
Bini tribe, ivory belt mask, sixteenth century.
Metropolitan Museum of Art, Michael C.
Rockefeller Memorial Collection, Gift of
Nelson A. Rockefeller

Contents

Preface

In October 1991 the Center for Advanced Study in the Visual Arts sponsored a three-day symposium devoted to "The Formation of National Collections of Art and Archaeology." This symposium was held in conjunction with the fiftieth anniversary of the founding of the National Gallery of Art, and was made possible by an anonymous gift.

Fourteen papers were presented at this gathering, which was convened to address a series of issues concerning the relationship between notions of national identity and national collections, as well as the promulgation of cultural identity and national purpose through the establishment of national museums. Participants of this meeting set out to consider: how and why nations established national collections. What ideological, political, social, and cultural purposes were served by these collections both nationally and internationally? How were national museums intended to develop national cultural awareness in a larger public? What were the various concepts that shaped national museums, and who formulated and articulated them? What determines the extent of the holdings of a national collection? How were such issues debated and resolved in political and governmental circles? What relationships were envisaged with other cultural or educational institutions?

These questions were discussed within the context of museums of varied typology that included imperial museums, colonial museums, "indigenous" museums, multiple national museums in the same nation, national museums formed from dynastic or private collections, and national museums formed by appropriated funds. The purpose of this symposium was not to address the chronology of museum collecting or the history of museum buildings, nor the politics and ideology of display and representation, since these subjects have received attention elsewhere. Although the primary focus was on the formation of collections of art and archaeology before the second half of the twentieth century, national museums in newly constituted nations were also considered.

The Center for Advanced Study is grateful to Gwendolyn Wright, who contributed an essay to the volume, prepared the papers for publication, and wrote the introduction. Per Bjurström, Enrico Castelnuovo, Françoise Forster-Hahn, and Werner Oechslin served as moderators of the symposium. Enrico Castelnuovo, Werner Oechslin, and Daniel Sherman presented papers at the symposium but did not prepare them for publication in this volume.

The symposium series within Studies in the History of Art, of which this is the twenty-seventh volume, is designed to document scholarly meetings sponsored under the auspices of the Center for Advanced Study. A summary of published and forthcoming titles may be found at the end of this volume. The Center for Advanced Study

in the Visual Arts was founded in 1979, as part of the National Gallery of Art, to foster study of the history, theory, and criticism of art, architecture, and urbanism through programs of meetings, research, publication, and fellowships.

HENRY A. MILLON
Dean, Center for Advanced Study in the Visual Arts

GWENDOLYN WRIGHT
Columbia University

Introduction

The museum's various and contested roles take on a highly specific focus in this volume.[1] The authors agreed to focus on those museums whose displays of art were meant to represent and celebrate a nation. Through the choice of objects and didactic modes of exhibition, national collections have sought to glorify both real and mythic histories. In addition to historical works produced within the boundaries of the state, such collections included a vast display of other glories—procured by looting, gifts, and acquisitions—all testaments to the nation's military prowess, cultural taste, and financial resources.

Such institutions share certain conventions, even though, conversely, the choice of architecture, site, objects, and their arrangement has also highlighted—or sometimes even invented—distinctive "national characteristics." For example, the building, in most instances, has taken the form of a classical "temple of the arts" (fig. 1) with a long frontal colonnade and a circular, domed central space.[2] Likewise the art within has asserted the country's origins in Graeco-Roman classicism, though sometimes, especially for Western colonial powers, a subtext connected that cultural heritage to the great classical traditions of Asia, Islam, Mesoamerica, and (somewhat later) Africa.

In one sense, therefore, these essays all question the legitimacy of the museum, especially the centralized "national museum," as a pure temple of the arts. The authors raise critical issues about seemingly self-evident matters, yet they are also intrigued by the experiential potency of visual creations in architecture, painting, sculpture, and exhibition design. They recognize the wide range of emotions art can evoke: wonder and delight, knowledge and pride. Thus politics and aesthetic sensibility, rather than being in opposition, can actively reinforce each other's impact.

At the heart of the emotions these collections seek to evoke is national pride. The selection and display of works of art seek to represent such pride, as do the building, even the location, the entry, the plan, the scale, and the style of the architecture. Clearly nationalism is not a fixed and static principle; nor, as we are discovering in the late twentieth century, is it an archaic phenomenon. Rather, as Eric Hobsbawm has so astutely shown, it is a dynamic force, influenced by the changing tides of politics, the invention and revivals of cultural forms, economic conditions at both a macro and micro scale, and the intervention of particular events and actors.[3] The nation must assert an identity, a "public culture," above that of its regions and municipalities, even its aristocratic or royal families and its dominant ethnic or religious groups. Yet these entities certainly do not disappear. For example, as these pages affirm, nationalism is closely linked to the particular cosmopolitan nature of capital cities. In very different ways the cultural

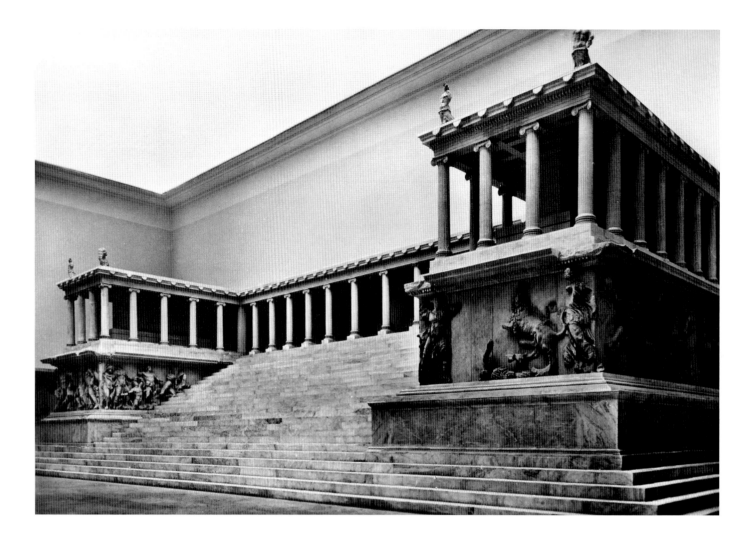

heritage of Paris, Berlin, London, Washington, Stockholm, and Hanoi has each cast its shadow upon the national collection assembled in that city.

Philip Fisher's opening essay, "Local Meanings and Portable Objects: National Collections, Literatures, Music, and Architecture," explores the changes in meaning that occur when any work is transported from its unique initial setting to become part of a private or a museum collection. In each setting we see qualities that elsewhere would be obscured or insignificant. We might be prompted to recognize or ignore an object's ritual significance, the delicacy of its craftsmanship, or its affinity with other objects, according to the context and what else is nearby. The point reaches beyond a simple matter of museums versus original milieus; by extending his reading from that of art objects to other artistic forms such as architecture and music, Fisher

enlarges many of this volume's implicit themes.

The majority of the papers consider the cultural and political goals of specific Western nation-states as they established official national museums. Andrew McClellan initiates the progression with his account of "Nationalism and the Origins of the Museum in France." In 1750 Louis XV's Luxembourg Gallery was the first public art gallery in France and the first museum designed to promote—indeed, to create—the idea of a national artistic tradition, followed by the Louvre in 1791, which opened to the people in the aftermath of the French Revolution.

Per Bjurström's "Interpretations of the Terms *National Collection* and *National Museum* in Scandinavia" situates his topic with reference to such precedents in Paris, Florence, and central Europe. In each case he sees efforts to promote romantic concepts of

1. Pergamon Altar, discovered during an excavation by the amateur archaeologist, Carl Humann, in 1872
Photograph: Kunsthistorisches Institut, Freie Universität Berlin

the nation as an organic whole, united in common values and a shared heritage. Such sentiments were especially strongly felt during times of political instability and foreign incursions.

First Prussia and later Germany took an exceptionally strong interest in the idea of *Kulturpolitik*. Thomas W. Gaehtgens presents the century-long formation of "The Museum Island in Berlin," justifiably honored as one of the most significant collections of art and cultural history in the world (even during its control by East Germany when fewer tourists visited the site). He ties the succession of five museums to the domestic and foreign ambitions of their respective royal patrons, on the one hand, and, on the other, to advances in scientific scholarship and shifts in artistic taste.

Françoise Forster-Hahn complements Gaehtgens' work with a study of a singular institution in two settings: August Stüler's 1848 National Gallery on the Museum Island in the former East Berlin and Mies van der Rohe's new incarnation in West Berlin, built in 1968. In "Shrine of Art or Signature of a New Nation? The National Gallery(ies) in Berlin, 1848–1968" she illuminates the significance of decisions about façade treatments, the placement of portraits, and, more recently, the inclusion of contemporary artwork in the vast open space of a reconstructed railroad station. This tumultuous history of symbolic cultural institutions will certainly continue with Berlin as the new capital of a reunited, though still deeply contentious, Germany.

The case of Britain extends back to the seventeenth century, to the art collections of Charles I. Again, the particularities of that nation's history have had a decisive effect. Charles' execution in 1649 restricted future monarchs to more discreet displays of wealth, while passing both political power and artistic entrepreneurship to the aristocracy. Carol Duncan's "Putting the 'Nation' in London's National Gallery" traces the evolution from Charles I through Parliament's purchase of Lord Angerstein's collection as the nucleus of the British National Gallery, and the ensuing debate about how much public money should be spent on a building.

Sometimes failed efforts prove most interesting to historians. Alan Wallach's "On the Problem of Forming a National Art Collection in the United States: William Wilson Corcoran's Failed National Gallery" explores a seemingly parallel narrative of national politics and social hierarchies. In this instance, however, while Corcoran amassed a collection of artworks that could have formed the basis for a national gallery, the decentralized nature of the United States, at least until the twentieth century, thwarted his ambitions.

My own contribution, "National Culture under Colonial Auspices: The École Française d'Extrême-Orient," asks how these European concepts of artistic classification, narrative subthemes, spatial politics, and cultural hierarchies were incorporated into the global setting of imperialism. The French "national" museums in Indochina asserted distinctive colonial readings of Asian objects and histories; they also tell us much about how Asian art was incorporated into the Western market—including the institutional world of national museums, in France as in southeast Asia.

Further expanding the scope of our inquiry, Annie E. Coombes highlights the issue of the repatriation of art objects removed from their original locales under imperialist or other forcible auspices. "Ethnography, Popular Culture, and Institutional Power: Narratives of Benin Culture in the British Museum, 1897–1992" examines various perspectives on Britain's possession of the famous "Benin Bronzes." Experts and the general public around the world are today engaged in heated debate: do such magisterial works belong to the nations that produced them, especially if they are now independent, or to the Western nations that still claim to represent universal values and more public access to "world masterpieces"?

While most of the papers are concerned with the founding of various national collections from the late eighteenth through the early twentieth century, these issues continue to exercise a potent force in the world today. The concept of national identity has become more contested and textured, seeking to portray a balance between a multitude of ethnic, racial, class, and regional differences and a shared public culture within the same country. Roger Kennedy, former direc-

tor of the National Museum of American History on the Mall in Washington, D.C., makes this point emphatically. "Some Thoughts about National Museums at the End of the Century" reflects on the increasingly complex task of representing a multiplicity of past experiences in a nation highly conscious of its diversity, without abandoning the idea of a common heritage. Kennedy's voice and concerns remind us quite directly of the complex pressures—curatorial and political, individual and collective—that inform the outlook of a museum director.

In the final paper, Donald Preziosi returns to the very nature of art objects removed from their original locales and their modes of organization. "In the Temple of Entelechy: The Museum as Evidentiary Artifact" considers a number of different institutions and their implicit directives about historical progress, uniqueness, and cultural hierarchies— assumptions we have too easily come to take for granted. Indeed, we are reminded, there is no single, unified institutional stance but many actors whose opinions and actions affect such museums: art historians, curators, exhibition designers, museum administrators, patrons, collectors, and various segments of the public.

The national museum as a "spectacle of possession," to appropriate Stephen Greenblatt's words, evokes our wonder in many ways.[4] It is a kaleidoscope, not only of objects but of perceptions. This volume seeks to expand our understanding of museums through an emphasis on complex intentions, diverse aspirations, and specific historical conditions. Patrons and curators appreciated the art they collected; they also sought to create a narrative with a distinctive political resonance. Architects brought their own ideas about beauty, pedagogy, and history as they carried out the commissions. Likewise, visitors have responded in many ways: visual, emotional, cultural, and political.

Our modern world is not so far from those described within these pages. Khaddafi's Libyan Arab Jamahiriya Museum in Tripoli is perhaps the most grandiose recent example of national collections in the countries of the so-called third world.[5] Here, too, the architecture, choice of collections, and modes of display celebrate certain forms and lineages of art in the service of politics. Western museums are making more concerted efforts to enlarge their collections, promote their resources, and reach an expanded public through extravagant exhibits, often reaching beyond the established canon of high art produced in Europe. The ubiquitous use of Acoustiguides seeks to clarify what is being taught.

In all these varied scenarios, the potent forces of nationalism and the experiential joys of art come together. It would be simplistic to suggest that the national collection reduces art to politics. It would be equally naive to bracket out the intricate web of tastes, purposes, settings, and experiences that weaves their fates together.

NOTES

1. In particular see Pierre Bourdieu and Alain Darbel, with Dominique Schnapper, *L'amour de l'art: Les musées d'art européens et leur public* (Paris, 1969); Francis Haskell, *Rediscoveries in Art* (Ithaca, N.Y., 1976); George W. Stocking Jr., ed., *Objects and Others: Essays on Museums and Material Culture* (Madison, Wisc., 1985); Ivan Karp and Steven D. Lavine, eds., *Exhibiting Cultures: The Poetics and Politics of Museum Display* (Washington, 1991); and Douglas Crimp with photographs by Louise Lawler, *On the Museum's Ruins* (Cambridge, Mass., 1994).

2. See Nikolaus Pevsner, *A History of Building Types* (Princeton, 1976); Germain Bazin, *The Museum Age*, trans. Jane van Nuis Cahill (New York, 1967), 141–191; Joseph Rykwert, "The Cult of the Museum," *Cite* 5 (Fall 1988), 16–18; and Carol Duncan and Alan Wallach, "The Universal Survey Museum," *Art History* 3 (December 1980), 448–469.

3. Eric J. Hobsbawm, *Nations and Nationalism since 1780: Programme, Myth, Reality* (Cambridge, 1990).

4. See Stephen Greenblatt, "Resonance and Wonder," in Karp and Lavine 1991, 42–56.

5. Leila Whittemore, "The Libyan Arab Jamahiriya Museum, Tripoli," seminar paper, Columbia University, fall 1993.

PHILIP FISHER
Harvard University

Local Meanings and Portable Objects: National Collections, Literatures, Music, and Architecture

Among all the arts we find the individual work clustered or inserted into collections or larger groupings that amount to unanticipated or undesigned appropriations of the works of art. Individual works of music are grouped into concert programs designed to isolate, contrast, or bring out features not necessarily present or conspicuous if the work were to be heard in isolation. The larger symphonic or chamber repertory makes up a museum structure within which the individual work finds its place. Since the period of romanticism, individual poems or novels find themselves within national literatures organized into a canon of works meant to provide, illustrate, and pass on from generation to generation an account of the Russian, the German, the French, or the British spirit in its evolution over time and in its central spiritual conditions. Museum collections stand for the central instance of this process of arranging and locating the individual object in juxtaposition, in series, and within experiential conditions remote or often scandalously distinct from the earlier first life of the individual work.

In each of the arts the priority of collections, canons, and classical repertories coincides with the strong drive toward explicit, development-oriented histories of the particular art and with the highly selective pressures of political nationalism. Those pressures can be called selective because, for example, poetry written in a national language—where there is a unique national language—will be more explicitly tied to local meanings than works of art produced within materials, styles, and technical procedures that are international. Works that have to be translated even to exist for the experience of those outside the originating culture will inevitably make up a "national collection" in the strongest and most exclusionary meaning of the term. By way of contrast, the life history of portable or reproducible objects and their relation to collections will remain relatively less bound to the matter of national identity and local meaning.

One premise of this essay is that what is now called the "long nineteenth century" (roughly the period from 1789 to 1920) invented a strong and durable set of middle-class institutions within which art, literature, and music might be defined and experienced, but it saddled that institutional world with a weak and troubled set of categories and descriptive formulas for the individual objects that we call works of art. A small number of strong aesthetic terms, such as the concept of a collection, a ruin, or a visual environment, settle down within a weak field of terms for objects—concepts that include design, use, intention, and authenticity—that prevent or deform thought about either the objects, the experience, or the institutions of art. The terms that I refer to control both everyday objects and those objects known as art. They force us to con-

sider objects within a short horizon of time, the lifetime of an object from creation or manufacture through a life of use on to a point of obsolescence, replacement, discard, or, as we say in the case of art, to a point where a vow of preservation takes over that amounts to a guarantee by the culture that it will keep the object or restore the object so as to keep it the same forever.

We owe to this period from 1789 to 1920 the complex debt of a weak vocabulary and a strong structure. The latter would include the art museum, the gallery and collection system organized around the art market with its intellectual appendage of critics and magazines; the symphonic concert hall open to the paying public with its standard orchestra and orchestral repertoire that replaced or complemented private performances; the university study of art and literature, including the creation of national literatures along with their histories and the publication of sets of canonical works such as the Library of America or the French Bibliothèque de la Pléiade. On the side of institutions this amounts to a professionalization and organization of the fields of art, music, and literature.

But on the other side, the side of categories and vocabulary, we find ourselves with the utilitarian distinction between the use of an object and the idea of an alternative, use-free aesthetic contemplation. An interest in use fixed our attention on the purpose of the object, its intended initial use which presumably determined its design. By design we commonly mean both the purpose of the object and the intention of the maker or, as he or she came to be known, the designer, a term that divides the intellectual work of design from the craft work or factory work of making or manufacturing. As an inference from this central question of utility, we find a number of paradoxical or curious situations. Because broken or no longer used objects go on existing, the question can be raised of how their lack of usefulness differs from the purely aesthetic objects that were supposedly never objects of use. How does being seen as a broken pair of scissors differ, for the same physical object, from being seen as a piece of sculpture? Because objects of use function only in a certain environment—a surgeon's scalpel in an operating room, a steam iron in the kitchen of an apartment—the simple act of picturing objects outside their environment seemed to render them aesthetic. Objects from the past, once clearly useful, could seem aesthetic because we no longer use spinning wheels or hay rakes in the present. That is, a wide set of circumstances of once useful, displaced, broken, or obsolete objects seemed to share characteristics with aesthetic objects simply because aesthetic objects had been defined by contrast to working objects, objects of use. It is important to note that all categories of utility assume that we are describing the nature of an object by describing its first lifetime.

These categories fail to account for the long history of objects, their survival in world after world, and often in worlds that did not exist or could not be imagined when they were designed. It is precisely the long history of objects—their refusal to wear out, disappear, be discarded, or serially replaced with updated objects in the same social location—that structures and concerns us when we think of either collections or ruins. In contrast, the aesthetic vocabulary of design, use, and that alternative to use, aesthetic contemplation, with the end point terms of uselessness, discard, obsolescence, and junk is a vocabulary for one lifetime, for the shortsighted history of things.

Object life cannot be defined by use, nor by purpose or first, intended use, nor even by adapted use, transformed use, or even that improvisational use known as bricolage. Nor can it be defined by that nineteenth-century alternative, aesthetic looking. The object or work of art is instead an actor in a social script and, more important, an actor of quite different roles over time in a variety of social scripts. Art objects and objects that become art are unusually labile objects, able to survive resocialization, destruction of context, replacement in unexpected physical or social locations, in the way that certain personalities survive and even thrive under the strain to personality that immigration imposes. Art objects or objects that become art are also objects without generations, that is, without succession over time. Their mystery is tied to the alternative they offer to a biological model or strategy for the occupation of long stretches

of time. The biological model relies on careful duplication so as to replace whatever is wearing out: people, tables, leaves, houses, elephants, cells with a next generation of people, tables, leaves, houses, elephants, and cells which can fit into and occupy the same locations once death or discard finishes off the previous generation. This generational model for objects is a functional one. We replace the old chair with a new one because we still plan to sit down. We hire new firemen when the older generation retires because we still plan to fight fires. New leaves replace those that fell last October because the tree will continue to use the leaves for photosynthesis. This biological, generational model suggests how objects occupy stretches of time longer than one lifetime of use, and it gives us a way of imagining longer spans of time in relation to things.

Art, as I will argue, requires a quite different account, one that fills the same goal but does so by explaining how one and the same object undergoes redesign over time, persists in spite of the narrow horizon of use and uselessness.

Since we often speak of the meaning of works of art, let me use a parallel from language. We ask what does Jackson Pollock's *Autumn Rhythm* mean? What do the scenes on a Greek vase mean? What does Christo's *Running Fence* mean? And we say this just as we might ask: What does the word *hysteria* mean? What does the German word *Heiterkeit* mean? The model, in my opinion, for an art object is not a word like *motel, chariot,* or *hydrogen,* a word that has a meaning that I might or might not know and a meaning that, to be understood, requires knowing a complex social or intellectual world in which many other things exist and are familiar in order to make it possible to say "I understand" when the word *motel* or *hydrogen* is used. Such words are profoundly historical, local, rooted words. The motel cannot exist before long-distance travel by automobile, and it will cease to exist once a certain economy, travel system, and lodging structure become obsolete. Similarly, the word *hydrogen* is a modern word that functions within our theory of the atom and our notion of the periodic table of the chemical elements where hydrogen appears first. The word *hydrogen* implies our contrast between elements, compounds, and mixtures.

The alternative to such rooted words is a word like *grace* that has sufficient inner mobility, energy, and importance to have survived through a theological meaning (the state of grace), which gave way to a primarily aristocratic meaning in European society as in the phrase "your Grace," but then, in our twentieth-century social script, can refer to a dancer whose "grace" we praise. Instead of becoming obsolete, the word undergoes a process of resocialization in which certain aspects of the energy it carried are reformed, others shaved off, and new components are welded on so that the lability of the word tolerates a fundamental relocation within spiritual and mental life over many hundreds of years. At every stage the word is in use. Roman Catholicism, English aristocratic culture in the seventeenth and eighteenth centuries, and the modern aesthetics of the dance are, in this sense, three scripts in which the word *grace* can be, and has been, an actor because of its lability and its power. That there is some continuity of meaning or energy inherent in the word should not lead us to ask what is the core meaning that underlies the uses in different centuries and by entirely different speakers or writers. Nor can we claim that this core of meaning is the authentic or essential residue within these, now superficial, differing "contexts" as we would say. No, the social script has, in my formulation, far more decisive consequences than a context. To use examples from art: a sword swung in battle and a sword in a museum are deployed in two different scripts with different persons present, different rules and roles, and a sum total of quite different presence. Museum and war are complex scripts in which every person, place, and thing has a specified identity and function. A portrait of a family member who is now dead has a valence and structure within the family home that, once sold to a museum as a "Degas" portrait, is entirely and radically defined as the presence or absence, the prominence or recession, of features within the work that only become active or latent in this or that new social script.

This is the model that we need for the work of art, that is, for those objects within

civilization that—we might say—fail to become ruins, because they immigrate into the successor world once their own world of inception weakens or vanishes. The world of a Greek vase is past, as Heidegger put it, but the vase is not. The vase is present, right here in New York in 1993 for us to examine. Often not only a first but also a second and third and fourth world has vanished before we encounter the object in a museum.

In this model, the museum in the period since the creation of public collections, the museum in modern middle-class society, can be seen as a script in which those objects that survived from earlier religious, political, or domestic scripts are now actors. Alongside these immigrants or survivors are the later objects designed from the start to find their place at some later point within collections of this kind. They, too, these modern works of art, are actors within this script of the museum, but for them it is their first world, as the capitalized word *Grace* has its first world in the religious vocabulary of the debate over salvation by God's grace or salvation by human works.

The collection should be thought of as an unanticipated appropriation of the objects that occur within it. If, after a man's death, we find and then publish his diary, we might call this an unanticipated appropriation of what was a private object. So, too, for the religious and familial works of art now found in museums. It did not occur to those who made these things that they would later serve in this social role. An unanticipated appropriation is the alternative to what we might think of as the design or purpose of an object, and to the life history that goes along with design or use, a life history of making, using, discarding, and disappearance once the object no longer serves the purpose for which it was designed. The idea of unanticipated appropriation is equally an alternative to the destruction or neglect of the object, its disappearance or continuation as a mere ruin—that is, an object stabilized at a certain partial stage of destruction. Of course, ruin is also distinct from what we call in the object world "junk."

The collection or museum relation, as we might also call it, has profound consequences for our experience of labile individual works, portable objects open to resocial-ization and resettlement within this or that cluster of what are now taken to be similar things. Easel paintings, the central model for a work of art in the period since the Renaissance in Europe, have been our traditional example of objects made to be portable, and in this term *portable* is included the fact that they are made to be bought and sold, set side by side with a variety of other objects, and are able to survive as experiences under many conditions of architecture and use. By portable objects I mean not only small, freestanding works of art but also literary works, since books can be carried from place to place and, even more important, since the contents of books, or so we believe, can be translated (carried over, the Latin word tells us) from one language and culture to another. Works of music, especially classical music, can be performed in Tokyo, Cincinnati, Leipzig, or Sydney once concert halls, the training of musicians, and a willing audience have been created locally for their production and enjoyment.

The most important meaning of portability in modern culture does not refer to art at all but to experimental results in science. For our civilization, experiments in science can and must be repeatable in any laboratory having the equipment and skills, and this portability of results—that they are not local in time or space, that they are not "irreproducible results," as scientists say—is the essential feature of their being called results at all. They must be portable in space, and portable in time.

The fate of portable objects is to move freely among collections and arrangements, entering experiential conditions never imagined when the objects were created. The aesthetics or intelligibility of such collections makes up one side of my argument, and one should think of a collection as similar to a chemistry textbook or the system of modern medicine, a system of storage and arrangement where results are set together from widely different times and experimental situations, cultures, and purposes, and given a common narrative account. Museums and textbooks are fundamental outcomes of a systematic culture.

The Aesthetics of Nonportable Objects

The other side of my argument is an exploration of the alternative aesthetics and intelligibility of what, for situated or inherently local objects, we could call the *built environment*. What might we mean in aesthetics by a realm of nonportable objects? Ruins might be taken to be the quintessential nonportable aesthetic objects, just as easel paintings are the quintessential portable objects. Ruins are one instance of the category of inherently local objects. So, too, is architecture: massive monuments, bridges spanning gorges in the Alps, the Golden Gate Bridge in San Francisco, skyscrapers, train stations, rows of residential housing in Paris or Berlin or New York, Chartres cathedral, Frank Lloyd Wright's Fallingwater house in western Pennsylvania, but also much poetry that is regarded as untranslatable and music for which no trained musicians, instruments, or suitable buildings or occasions exist in other cultures. All of these in various ways make up inherently local objects, and the list could be extended to famous gardens and sublime natural aesthetic objects such as Niagara Falls or the Rockies.

The quite different narratives of histories of collections and built environments, the radically different conditions of experience in these two cases, will be my theme. A built environment undergoes constant revision, partial destruction, and local replacement. A ruin amounts to a hiatus or gap in the ongoing work of revising, destroying, replacing, and renovating this built environment, work that is the alternative to the preservation of it as is, that is, our temporal relation to portable works of art. Ruins make unique claims within a situation that is otherwise dialogic and mutual, and they function like a scar that interrupts the surface of the skin or a memory that interrupts a chain of thoughts to drag the mind back to some unincorporable fact of the past, a past that has the stubborn actuality of not disappearing. Since collections are also made up of objects of the past that we have not permitted to age or to disappear, collections and ruins are related but distinct terms, related because both are subject to an ethic of preservation, rather than an ethic of ongoing revision like the visual environment of a city or a neighborhood.

Collections and Narrative Histories of Objects

In the last two hundred years we have had collections because we insist on having histories, coherent sequential arguments about the relations among things, their development over time, their occurring as sets of objects with major and minor instances. The folding together of histories and collections is a fundamental fact of our civilization since the eighteenth century. The rise of the history of art with its Hegelian or Whig tradition of self-serving national stories is the companion to the rise of collections.

Whenever an object is loaned from one collection where it has its position and is imbedded in a certain story or path, it is never loaned out so as to be seen alone as a "just this." Of course, it is anchored in a new story, an exhibit whose story is the story of Titian or the story of landscape. It is once again before this and after that, juxtaposed in new ways. It is early or late in the path of the exhibit, it is a minor detail leading up to the major paintings, or it is the climactic work around which others are forced to serve, even though in their own museums they might have been the "star performers," the climax of any visit. The object moves from one history to another, like an actor who plays King Lear tonight, Bottom tomorrow, and a spear carrier on Saturday.

The priority of the narrative, the progressive history over the object is not simply a sign of the power of museum curators to tell their chosen story, using the works as narrative players. It reflects a set of deeper cultural facts.

Works of art in collections are not in a house where they are passed casually, again and again, where they are noticed or overlooked. Nor are they in a civic or religious space where symbolic occasions make them the center of a larger ceremonial experience. Because they are in museums they must be, as we put it, "visited." That they are often visited as a part of tourism, that is, by people who have this and only this chance to see them as one stop on a larger agenda of seeing this and doing that, only exaggerates this fact of a visit. With a traveling exhibit, the work, and its part in the particular narrative in which the exhibit has inserted it, must also be visited because soon it will

"close" and the grouping will be dissolved as of a certain date.

A visit to a museum involves a walk that must begin somewhere, follow a path, and end at an exit. The walk itself, as a daily act, becomes a history made up of first this, next that, and then this and finally that. The work in a museum occurs on a wall next to this or that, or, rather, between this portrait and that tumultuous crowd scene. Juxtaposition commits us to the rhetoric of contrast, before and after, and invites our thinking in both dyadic and progressive terms. This leads to that, this influenced that, this revolted against that. Contrast, progression, sequence are all narrative facts. So is the concept of a room, that fundamental and unnecessary unit of museums. In a room the work must exist as part of a small cluster, some ten works, let us say, that are grasped together, seen in relation, and organized temporarily by the mind as having to do with one another, providing explanations for one another. In the term of Hans Robert Jauss, the works in a room make up the *local horizon* for any individual act of looking or thinking. That we have movements within modern art, or that artists now work in sets or series, seems to me to represent a profound attempt on the part of artists to control in advance the kind of rooms within which the work will be seen by insisting on the artist's right, not that of the gallery director, to make up sets and setting, that is, to chart horizons for the experience of the individual work. The room, with its ten or more diverse works, is of course a miniature version of the museum as a whole, a collection within the collection.

The path, the wall with its juxtapositions, the room with its cluster, are all tiny narratives or histories, built into the architecture and into the experiential unit of the visit. They make the sense they do because the culture at large supplies large-scale histories or narratives about the relation of French art to Italian, or modern American art to Parisian art of the previous century, on which these local incidents of narrative in any one room can draw and depend.

Similarly, in the case of music, a single concert presents us with a small set or cluster of three or four works. Each work is juxtaposed to another. A sequence occurs, first this and then that. The concert pianist can choose to follow Brahms with Webern, even though the essential point of this juxtaposition is hostile to Brahms and would have led to his objections were he alive to hear of it. The concert program inserts the work into a miniature narrative path and into a set of contrasts of works written to be heard alone, but now set next to one another in time along a path reinforcing a particular story. The concert, in this sense, is like a room in a museum, and like the room, its coherence depends on the society of listeners knowing the larger history about classical music, the story of the path from Haydn to Mozart to Beethoven, Schubert, Brahms, Wagner, Mahler, Webern, and Schönberg, along with the part played by Berlioz, Stravinsky, and Schumann.

These highly constructed local episodes—the room, the exhibition, the two-hour concert—are shaped from below, by the necessary phenomenological characteristics of a visit or an event, and from above by the trust the society has in the large, ordered stories that insert, and often overpower, individual works into a series or history, into a narrative that is the verbal partner to the physical collection.

The Museum Script

In his 1923 essay "The Problem of Museums," Paul Valéry wrote of the museum as a "strange organized disorder" which could never have been invented by either a sensuous or a reasonable civilization. He likened the museum to a room where ten orchestras played simultaneously, a room where from all sides the works call out for undivided attention, but where the sense of sight is violated by "that abuse of space known as a collection."[1]

The museum is more than a location. It is a script that makes certain acts possible and others unthinkable. For objects assumed into the museum, those practices efface just what existed as features, despite the fact that these features were the very essence of the object in its earlier life or lives, each life being, in its turn, dependent on the suppression of yet earlier practices. When we think of an object as having a fixed set of traits, we leave out the fact that only within social scripts are those traits, and not others, visi-

ble or even real. It is not only that in a museum we do not notice or even know about the balance of a sword that we see there. Once it is bolted down in a display and not swung in an expert and appropriate way, we cannot say that balance or imbalance is even a fact about it. Without a class of warriors, trained to fight in certain ways, even the permission to lift and swing the sword would tell us nothing. Only one part of what is canceled within the object by the museum is what Malraux insists on as the image or the model. Rather it is the repertoire of practices that brought out certain features and passed over other possible features. Our access assembles and disassembles what the object is, including the question of whether and in what sense it is an art object. Within a museum culture that has looted a past that had earlier been organized as a religious, civic, and familial past, one of the features of objects that came to be suppressed was the image within it, along with those acts, such as memory, instruction, piety, and control, that were elicited by those images.

It is an important civic fact about late nineteenth-century European and American culture that in a period of ever more strident and bombastic nationalism—a period described powerfully by Eric Hobsbawm in his recent small masterpiece *Nations and Nationalism since 1780* as the apogee of aggressive and competitive and ultimately catastrophic nationalism—the civic pride and civic ambition that led to the founding of great museums and orchestras assumed a world perspective on culture: collecting and obtaining Italian and Dutch art, Chinese paintings and objects, French impressionist contemporary works.[2] In their new concert halls the middle class played German music, whether in New York, London, Paris, Leningrad, or Sydney, Australia. They did not demand a celebration of local or national artists and works in these temples of culture. The great curators and collectors in Berlin, Paris, London, and New York were all in pursuit of the same ideal museum: antiquities, Renaissance works, medieval and modern works of a surprising similarity. They did not seek a music or an object world with a uniquely national agenda.

By way of contrast, if we consider the national literatures in the nineteenth century, we can see that they came more and more to stand, as collections, and all canons are collections, as an argument for and a map to a national spirit or perspective. When Europeans looked back to the two civilizations and cultures to which they referred their own experience, Greek and Roman civilization, they saw unique books, Homer's *Iliad* and Virgil's *Aeneid*, that summarized and embodied national spirit and experience, stabilized the language and served as educational encyclopedias of manners and ethical norms while detailing an encompassing myth for the civilization and its purposes. These works were secular scriptures, imagined to play the part that a single religious text might play in a culture, but with the difference that religious works often were transnational in importance, as the Bible or the Koran had been.

Because of the use of literature within education at all levels, literary works inevitably played a more essential part than any other art in serving to inculcate and stabilize social and national constructs and self-images. And because the medium of literature was language, the language of the tribe as Pound called it, it had a unique connection to the boundary that existed between the culture and outsiders, between those who could read or hear the book and those to whom it was gibberish.

These two social facts are primary: first, the relation of literature to primary and secondary education, to social memory, to the deliberate transmission and summary of the culture as it is passed from the old to the young, and to the mythic central stories that summarize the mission of the culture and its core of values; and second, the unique relation of literary works to the national language, that essence, along with a geographical border and a system of laws, for the definition of those inside and those outside a culture. These two features in combination forged a unique and sometimes dangerous connection between literatures and national self-identity in the most strident period of nationalism.

The Europeans and Americans saw not only Homer and Virgil, but singular authors such as Dante, Cervantes, and Shakespeare, as writers who had set the measure for the

vernacular languages as they emerged and defined a reference core for culture and national experience. Melville, writing at the high point of the Young America movement, clearly set out in *Moby Dick* to produce just this kind of central cultural book, as did Whitman in *Leaves of Grass*. Tolstoy in *War and Peace* and Dostoevsky in *The Brothers Karamazov* imagined themselves to be writing the central historical or symbolic episodes for the Russian soul or *Geist*. After Sir Walter Scott's fantastic success in creating the history and sociology for a national identity at the very moment of its distinct political extinction in Scotland, Balzac and Zola in France, Joyce in Ireland, Faulkner, no less than Fennimore Cooper in America, set out to map and to embody in literary texts the memory, the central myths, and the realistic look and feel of everyday life within thriving or—more often—vanishing cultural worlds.

At the same time, from the other direction, educators and literary critics produced literary histories that assembled in America and for Americans the canon of American works, and in Russia and for Russians, the classic Russian works. They built what we call English literature, French literature, German literature, and installed these lists and sequences in primary and secondary schools as the training ground for both language and cultural affiliation with its perspectives and values.

That writers like Goethe stood entirely outside this convergence between education, language, and nationality (understood as group identity), calling as he did for a universal literature, a world of translations and a humanism of the general human spirit, a world literature, only underlines the irony that it would be Goethe himself who would then be deified as the German Dante, Cervantes, or Shakespeare, and his *Faust* converted into the German *Iliad* or *Aeneid*, or *Don Quixote*, that is to say, into the book of the German soul.

As one instance of an aggressive national tradition, we might remember that over the past ten years the National Endowment for the Humanities has funded the Library of America, a solemn and immensely successful collection of our central authors and texts— Emerson and Jack London, Mark Twain and Whitman and Parkman, the *Federalist Papers* and the writings of Jefferson. Our philosophers and historians, our poets and travel writers, our, our, our . . . the repetition of this possessive word points to the strange provincialism of this collection, its nineteenth-century nationalist model, and the growing divergence between such an ideal national canon and the facts of reading, the internationalizations of authors, the alternative world that Goethe called for, a world of translations of Kafka and Kundera, Marquez and Proust, Solzhenitsyn and Kawabata.

To live, as most of us do, in this world of translations, situates us, strangely, in closer rapport with the civic humanism, the encyclopedic visual sense of the late nineteenth-century creators of the major museums than it does to the narrower purposes of the designers of national or subnational "identity literatures" such as American, German, African-American, or New England literature, Southern writers, women writers, Catholic writers—all the many varieties of what I think of as regionalism within modern culture.

Visual Environment

What the museum collection does for and to objects has its equivalents in music and literature. We can easily locate the structural equivalent to the museum or collection in the literary anthology or canon and in music where the repertory of performed works is in effect the museum or collection of works available for our attention and analysis. But for architecture no such collection or anthology relation exists, and the object of our attention and analysis occurs in a strikingly different way, a way that illuminates both architecture's difference and, by contrast, the features of the collection.

Within architecture the context for the experience of the individual work in later times is not a carefully designed set of works, like those that a room in a museum prepares as the horizon for our experience, nor is it the concert program with its small set of contrasted experiences. Instead, the frame for any built object is the environment as it happens to be. One version of the narrative history of architecture is the visual history of the world as it just happens to be, its facticity, but also its interplay between

intention, plan, original purpose, and design, on the one hand, and the action of the accidental, on the other. In the accidental is included not just which buildings did in the end get built, but also their even less predictable history over time, the question of which survived, which were not destroyed by time so as to become sooner or later as invisible as if they had never been built. It includes the external facts of war, fires, earthquakes, economic changes, social shifts toward or away from religion, for example, shoddy or sturdy construction, mistakes made about materials, rigidities of use, later ideas of safety or health, governmental rules or tax structures that might favor replacement, renovation, or preservation at the expense of one another. These make up one dimension of the history of the accidental. Alternatively, this history of the accidental includes which buildings were transformed over time not just as to use, but as actors in a visual environment that, over time, changed around them.

Unbuilt buildings, utopian projects, competition entries that were not selected, and proposals that were never funded are all part of the discourse of architecture, but not part of this visual history of the world as it just happens to be. This planned and accidental world is made up of at least three classes of things: (1) buildings; (2) transformed buildings that have been altered over time, adapted to new uses, partly razed or given additions, gutted and rebuilt within, so that only the shell has continuity of some kind with the former object; and (3) ruins or traces, no longer buildings but still part of the visible world as it just happens to be. These last are in effect reminders, memories of buildings in concrete form.

The history of neglect is just as essential as the histories of preservation or transformation. Neglect is a form of passive vandalism, as is the refusal to update a building once its first purpose is no longer relevant. These are, in the long run, complements to the deliberate destruction described by Anthony Vidler in his essays on the paradoxical relation in the period of the Revolution in late eighteenth-century France between preservation, with its concept of a national patrimony, and the revolutionary violence to the monuments or traces of the past regime

that we would more easily imagine to be the Jacobin relation to the past.[3] Museum and guillotine are, as he argues, machinery of a revolutionary moment.

The Bastille was razed; it was not preserved as a museum, nor was it, after partial destruction, preserved as a ruin. It was made invisible. The new Paris Opera now stands where the prison once stood. This choice between the creation of a museum (as Alcatraz and Auschwitz are today, a ruin, which is also a form of partial museum that includes both the fact and the fact of its destruction, two memories stabilized in the same physical object) or, on the other hand, effacing, as Voltaire wrote: "Écrasez l'infâme!" (Wipe out the infamy)—this is a quintessential modern choice, defining our relation to the past within a museum culture. One clever proposal for the tens of thousands of statues of Lenin recently removed from places of respect throughout eastern Europe is to assemble them all in one lovely wooded park like a nightmare of memory and repetition. The early Christians who came to power in Rome broke the pagan statues, buried them in the ground, or dumped them into the river. They melted them down, pulverized them into rubble. They replaced them with their own symbolic imagery, just as in our day a skyscraper replaces the buildings previously located on the city block that has been cleared—erased—to create its site. The early Christians differed from us in having no category whatsoever for the afterlife of symbolic systems and objects whose worlds were over. The battle in the two decades after 1790 in France between the new idea of *Le patrimoine national*, with its associated idea of preservation, and the Jacobin terror addressed to the slaughter of symbolic objects and buildings (intended to preclude the restoration of royal power as well as its symbols, buildings, and practices) is one of the decisive modern intellectual and political debates that set in place our modern balance between museums, ruins, and the need to make the symbolic past disappear.[4]

This history of the world as it just happens to be divides architecture from all of the other arts. In every art we need not only a history of creation, but also a history of disappearance, of the particular formulas of neglect, later selection, and later disinterest.

The ruin is a stable category within this history of disappearance. Only objects too large to remove, too lacking in value to loot, and not subject to the destructive power of fire are eligible to become, after a certain point, ruins. Every history is a product of remembering, but it is also, equally powerfully, an outcome of the creation of an uncrowded field in which memory is first possible. Every past is made uncrowded by systematic forgetting, overlooking, and the deliberate production of invisibility which is the background to the possibility of remembering. In the other arts most of the products quickly pass into invisibility; they no longer intrude on the present or propose themselves for attention. But in architecture every building, once constructed, continues to be visible, imposing itself as something that has to be, so to speak, built around and taken into consideration by every nearby act of later building, for an indefinite period of time. Its disappearance is at the hands of economic motives, war, or the history of changing social needs, and not a result of architectural aesthetics, except in rare cases. The lack of any internal control over what we have to call historical forgetting, the thinning out of the past, is one of the major conditions, alongside the more or less external conditions that govern what possible buildings actually were built in the first place, comprising a history of the built world as it just happens to be.

War and conquest rain down their destructive effect precisely on the key symbolic architectural structures of the visible public, political, and religious space, making clear just how difficult it is to have, over time, any "collection" of architecture in the way that we have collections of novels, poems, pieces of music, paintings, sculpture, and other small objects. At the same time, this close link between architecture and the damages of war suggests why ruins are essential to architecture but not to the history of drama, painting, or poetry. We have only "fragments" of Sappho's poems, but these are not ruins. The fragments of Heraclitus are not ruins of his philosophical works. But in central Berlin the Gedächtniskirche is clearly a ruin, preserved as bombed so as to permit the experience, in memory or by means of photographs, of the church as it

once was, that is, as it was built and designed, and then as it was "redesigned" by bombing, also on a certain day, month, and year. These two dates of creation—the first by architects and builders, the second by aviators and modern aerial bombardment—are both sites of preservation because Berlin authorities now take care to preserve it just as it was in 1947, the rubble cleared away, the structure stabilized to its current jagged fragment.

The ruin, then, is every bit as deliberate an element of the visual environment as the building, the transformed building, and the set of relations among them as they alter over time. This visual environment—just as it happens to be—is the opposite dynamic system to a collection or canon.

The history of easel painting and all other portable objects is very largely also the history of collecting, of moving paintings from place to place and juxtaposing them to other works in the same room never intended by the painter. Because it is the history of collecting, it is also the history of the buying and selling of works in order to make collections or to move works from one place to another. It is, in that sense, the history of a market alongside a history of the nonmarket activities of theft, looting during wartime, inheritance after death, and vandalism. The buying or selling of works, their theft or their relation to inheritance, their geographical relocations are irrelevant to literature, music, or architecture, but the fundamental fact of the collection as a structure into which the individual painting must enter so as to go on existing makes these into the fundamental elements of a secondary history to which the history of painting is bound.

The imposed order of the collection is also part of the intrinsic importance of a link between the history of paintings and the history of movements within art. Movements we may imagine or speak of in architecture, but the force of the concept is not that six or sixty architects in certain years thought alike, agreed on certain principles, or used materials in similar ways. This would be to see movements as part of the history of production and influence, whereas their real importance lies in the history of collections, display, and consumption within

art. The museum room where ten or more works can be seen together, one after another and in certain groupings as we stand here and there within the room, is what gives reality to the movement as the horizon for the individual work. The room where a small set of works are in relations of nextness, before and after one another in an intelligible cluster, defines the figure-ground relation within which each individual work acquires its experiential intelligibility. It is this room as the smallest unit of a collection that makes movements the most convenient small unit of history.

If a movement of architects produced twenty buildings, one in Baltimore, one in Boston, another in Algiers, and yet another in Portland, a private house in Houston, a museum in Frankfurt, then this would be a less important fact because the buildings cannot be lifted up and put side by side except in the illustrations in art books or in the set of slides of a lecture. Even to consider the movement an important unit of architectural history is to take the ground of reality to be the slide and the book of photographs. It is precisely here that the built and unbuilt, the sketch and the actual building, the model and the original building before it was renovated or altered or destroyed by time, all coexist on a plane of equal reality and unreality that gives no privileged position to what was actually built or to what happens to exist now as a visual experience. The classroom and the architecture book make possible for the first time the point of view of the "collection" in architecture, what in literature is made possible by the anthology. But collections and anthologies are possible states of the poems or the paintings themselves, even inevitable future states of the individual works themselves insofar as they survive. Neither the lecture tray of slides nor the architecture book plays a similar role in relation to the real building, one of the features of which is that it cannot be made part of a "collection" in this sense and therefore is less and less perspicuous when seen as part of a movement, that concept functionally tied to the collection.

Collections or movements are, for portable works of art, what the visual environment is for the work of architecture, the collectivity within which the individual object will come to rest, be seen, and be intelligible. Architectural works have their actual juxtaposition, as Dell Upton has argued, in relation to whatever other buildings are beside them in space in the one location where we can actually be in the presence of the architectural object itself. The actual buildings listed above do not have it as an accident of their nature—to be carefully cropped out in photographs—that they exist in Frankfurt, in a Houston suburb, or in Algiers or Portland. This is one reason why I feel that Dell Upton is right to stress the fundamental choice involved for architectural history in taking as its text the human visual landscape.[5]

This visual landscape is not at all a question of the one building plus its site. Nor, at the other extreme, is it the history of accidents that occurred in the nearby visual space. To return to the history of painting for a moment, we could say that the visual landscape of the actual experience of the work is a premeditated fact for paintings in that it is so conditioned by the one room in a museum where we see the work among ten or so carefully chosen other works. The work is next to one other work to the right and one to the left. It is before and after certain other works, and this is part of the force of our belief in the series within the history of painting. The visual environment of collecting and exhibiting has as its alternative the visual landscape made up of site and nearby buildings in architecture. It is significant that the other buildings within which our experience of a building takes place were, only in part, built before the building itself. Those buildings made up details of the environment as the architect himself saw it in thinking of the building. As time passes the successful building exists as a detail within a more and more unforeseen human landscape, some combination of buildings built before, some after its own creation, some altered, some destroyed or removed.

Two narrative forms for the history of this human visual environment are unique to architecture. The first is the strong form of what Hans-Georg Gadamer in his *Truth and Method* called the narrative of question and answer in the history of the arts. Every later building responds to, in the sense of answering, the buildings that already occupy the human landscape within which the new

building will be inserted. Every new building is not a beginning but a middle. It is an insertion into a design, not a design. As an answer, each new building alters our relation to the already existing buildings which we saw in a different way before it existed. The tallest building suddenly can be dwarfed by a nearby neighbor, an elegant building can make what until then seemed a solid building suddenly seem pompous or operatic, a richly detailed building can make its neighbors seem frugal or lacking in nuance once it sits nearby. The answer always recasts the question. The bright, sharp, glass-and-metal skyscrapers of the twentieth century are answering buildings to the coal-blackened, gloomy, stone, massive but squat buildings of the Victorian city. The business culture updated and contradicted an outdated and, by then, embarrassing image of the factory, commerce, and the business community itself with its twentieth-century headquarters. A nearby answering building alters permanently our ability to see a building in the way that it was first planned. Over time, as these answers are themselves questions that elicit answers or as the very buildings that once made up the site vanish, we can no longer guess just what question this or that building answered, what site it gracefully occupied or insulted or turned its back on.

A second narrative form of the visual environment could be called the alteration of singular, bold, unique visual objects designed, as we say, to "stand out," and the steady work by later buildings designed to weaken that uniqueness. If within a relatively uniform visual landscape of six-story brick buildings, one forty-story glass skyscraper is built, its shock, contrast, and eye-catching singularity are part of its purpose. But immediately other buildings will tame this singularity, reducing it to a short-term episode within the longer history of the building's relation to its environment. Buildings of thirty-four or twenty-six stories will appear. A rival forty-one-story building will appear. In the end, to the uninformed viewer it will not be necessarily clear which came first or second, which was the daring first step, which the much tamer second object, but in any case the singularity will have been eroded over time. All differences are weakened by interposed compromise fig-

ures that bind the two distinct aesthetic facts to which the later building must make, for itself, some relation. In architecture all aesthetic effects undergo dilution in the visual landscape, including the dilution by simple repetition of once rare materials, effects, stylistic gestures. Dilution is one of the key narrative formulas of the visual environment, which is always an environment made up of additions and always open to be added to.

These narratives of answer and overall aesthetic dilution are unique architectural narratives caused by the fact that we can never see one building in isolation in the world. We read one book at a time, see one opera, hear one sonata by Beethoven, look at one still life by Cézanne. The key fact that in the human visual landscape we almost always see only parts of the building that we are trying to look at, and those parts are scrambled with details of nearby buildings in the line of sight and even unanticipated later buildings that the architect could never in his wildest dreams have imagined would be juxtaposed or even superimposed over the building that he designed, makes this a narrative of taming or of violation, of generous friendship, of tribute or of timid self-effacing by later occurrences within the visual field of the only possible actual experience of the building crucial for architectural history. The deference or insults of the nearby make up a significant detail within architectural narrative of the experience of the visual landscape.

When we read one poem the question is what poem we will read next. When we go to a concert the question of what will be played before and what after a certain Mozart piano concerto is decisive. This leads to a special importance of the series as a key element of those histories of poetry, novels, and music. But with architecture the key question is not which building is next to another, but what aspect or visual scrap of a building along with what aspects or scraps of nearby buildings that must be seen for us even to look at the first building, will be seen at the same time. The impurity of the visual experience is eliminated in the slides and photographs in books that try to make architecture into paintinglike objects.

This is one key challenge to architectural

history. How can we define this history of a crowded visual space of experience, one always subject to dominant features never dreamed of by the architect? The effects of neon signs on a street of Victorian stone buildings at night would be one of these purely external effects added long after the buildings themselves were designed, but now fundamental to how we see the stone buildings at all. Of course, the staggering effect of electrification on all buildings built before electric lighting existed could stand in for all such later unanticipated redesigns of the visual effect.

For the architectural landscape the individual work of art is less subject to the laws of autonomy (self-enclosed being, pre-designed harmony of effects, completeness, and the satisfaction of the order of the whole) than any other art, and it is less subject at the same time to an ethos of preservation. We work with literary texts so as to have Emily Dickinson's words as she wrote them. We can restore Monet's color to what we imagine he put down before the darkening of time. But a building, to go on existing and being used, has to minimize the autonomy or the claim of its first state, the state when it was completed by the architect.

This leads to a history that is different from that of painting or literature.

There is inevitably less meaning to the concept of the original or authentic first state of the building. Train stations after the disappearance of widespread train travel cannot be genuinely kept in their "real" condition because one aspect of that condition was to be crowded with the travelers who are now to be found only at the airport. Grand and empty, they have a forlorn and hollow, too silent atmosphere, the opposite of the bustle and noise that the grand structure was meant to counterbalance.

If we regard the architectural environment as a world that is always present, always linked to and adapted to the uses of the present, and as a world subject to revision and to replacement, open to interposition and to the process of comment and critique that nearby later buildings can introject into the line of sight that determines any possible experience of the building or environment itself, then we can see the strongest sense in which the visual environment provides the basis for an alternative aesthetic to the aesthetic of collections which is, of necessity, the aesthetics of portable objects.

NOTES

1. Paul Valéry, "Le problème des musées," in *Oeuvres de Paul Valéry*, 2 vols. (Paris, 1960), 2:1291.

2. Eric J. Hobsbawm, *Nations and Nationalism since 1780: Programme, Myth, Reality* (Cambridge, 1990).

3. Anthony Vidler, "Researching Revolutionary Architecture," *Journal of Architectural Education* 44 (August 1991), 206–210. See also his essay on vandalism: "Grégoire, Lenoir, et les 'monuments parlants,'" in *La Carmongnole des muses: L'homme de lettres et l'artiste dans la révolution*, ed. Jean-Claude Bonnet (Paris, 1988).

4. Vidler 1988.

5. Dell Upton, "Architectural History or Landscape History," *Journal of Architectural Education* 44 (August 1991), 195–200.

ANDREW MCCLELLAN
Tufts University

Nationalism and the Origins of the Museum in France

Ceux qui ont gouverné les peuples dans tous les temps, ont toujours fait usage des peintures et des statues, pour mieux inspirer les sentimens qu'ils vouloient leur donner, soit en religion, soit en politique.

Chevalier de Jaucourt, *Encyclopédie,* on "Painting," 5:1751–1765

Wherever nationalism has arisen, and notwithstanding its different manifestations and patterns of development from one country to the next, it has required as its foundation a conjunction of political and ethnocultural allegiances binding the individual to an enlarged community, usually coextensive with the state. Too large to be perceived or directly experienced, that community, the nation, must first be "imagined," to quote Benedict Anderson, and then assimilated to the point where an individual holds the nation's interests above those of local ties, family, or self.[1]

National consciousness, this identification with the imagined community, is the product of state-sponsored social engineering or education, and it is here that the interests of the state and the function of the museum intersect. If identity presupposes the collecting of objects, as James Clifford and others have remarked, it is no coincidence that the foundation of a national museum has been a high priority of many newly founded nation-states.[2] In Europe the museum age corresponds directly with the emergence of nationalism after 1820. By the end of the nineteenth century, no self-respecting Western nation, with the notable exception of the United States, was complete without its own national museum. One hundred years later the same may be said of the world at large. Typically located in the nexus of government buildings at the heart of the capital, national museums have become necessary ornaments of the modern state.

Public art museums in the West serve the cause of nations in two ways. First, they foster feelings of collective belonging by providing a space dedicated to shared enjoyment of treasures in the public domain and in which equality of access renders citizenship transparent. Second, through their contents and strategies of display, museums identify the nation-states that sponsor them as heirs to Western civilization and adherents of the modern tradition.[3] (In an age of increasing multiculturalism they are beginning to embrace non-Western visual cultures as well.) Frequently the presence of native artists in the collection transforms a passive inheritance of mainstream values into an active participation in and contribution to that civilization. These crucial insights into museum practice are spelled out in the classic essay on the "Universal Survey Museum" by Carol Duncan and Alan Wallach.[4] My aim here is to explore the ways in which the museum movement in early modern France promoted an ideology of nationalism and, in so doing, became a

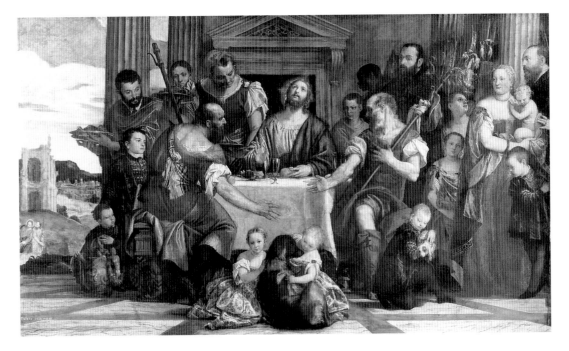

3. Nicolas Guérin,
*Description de l'Académie
royale des arts de peinture
et de sculpture* (Paris, 1715),
plan of the Assembly Room
Author photograph

model for subsequent state museums the world over.

A point of departure in any discussion of French patriotism in the arts must be Charles Perrault's *Parallèle des anciens et des modernes*. First published in 1688, it set the tone for government efforts under Louis XIV and his descendants to put France on the cultural map of Europe and to secure recognition of native achievement among an aristocratic audience. Insofar as painting was concerned, Perrault aspired to supplant an entrenched connoisseurial bias in favor of the Italian Renaissance and baroque masters (who, in the absence of Graeco-Roman painting, had already assumed the canonical status of "ancients") with an objective, historically unprejudiced mode of evaluation that would judge art "for itself," according to a fixed set of precepts. These precepts corresponded to the "parts" of painting as established in contemporary art theory (design, color, expression, and composition) and, judged on these grounds free of prejudice, Perrault argued, modern French painting would be found "more accomplished and

perfect than painting in the age of the old masters."[5]

The drift of his argument would have been familiar to connoisseurs, for in essence Perrault was merely doing for French art what a number of Italian and Netherlandish artists and writers had already done, writing their own national "schools" into art history in the wake of Vasari's Tuscan-biased *Lives of the Artists* (1550). One crucial innovation, however, was Perrault's reliance on publicly displayed paintings to clinch his point. In Perrault's text, constructed as a conversation among elite art lovers, an abbé guides two friends to Versailles to view Charles Lebrun's *Tent of Darius* (fig. 1) and Paolo Veronese's *Pilgrims of Emmaus* (fig. 2), hung in the antechamber of the Grand Appartement of the King, "where it seems they were placed opposite each other precisely in order that one might compare them." Comparative exegesis based on the parts of painting decided in favor of the Frenchman, and the abbé concluded that, because art progresses by virtue of selective imitation of past examples, modern (French) artists must necessarily improve over their predecessors. In this royal palace, itself a statement of French artistic and technological might, the pairing of the Lebrun and the Veronese proclaimed the historical arrival of French painting.

If comparison proved one effective means of affirming French artistic identity, a second was critical mass, the concentrated display of French art across time and type (genre). In Paris, by the turn of the century, the Royal Academy had mounted such an exhibition in its chambers at the Louvre (fig. 3). A suite of six rooms was decorated, one might say saturated, with French paintings and sculpture encompassing the artistic production of the past hundred years. Portraits of royalty and patrons mingled with those of artists and their works. According to Nicolas Guérin, the purpose of the display was to demonstrate "to all of Europe" the progress made by the arts in France under the aegis of the Academy.[6]

These two display strategies were appropriated and combined by the organizers of the first art museum in France, the Luxembourg Gallery, which opened in 1750. The Luxembourg was not only the first public

MIGNARD Virgin & Child 56		LEBRUN Christ Raised on the Cross 52		VOUET Victory Holding the Infant Louis XIII 51
SANTERRE Magdalen 55	Window	LEBRUN Christ Bearing the Cross 53	Window	LA FOSSE Mary Before Jesus Christ 50
54 MIGNARD Faith				

4. Reconstruction of the Throne Room (west wall), 1750, Luxembourg Gallery, Paris
Author photograph

gallery in France, it was also the first museum designed to promote indigenous artistic achievement and to represent (indeed to invent) a national artistic tradition. The first two rooms presented an eclectic selection of Italian, Northern (Dutch and Flemish), and French pictures, all drawn from the royal collection, arranged in such a way as to force the beholder to compare and contrast different subjects and styles. According to mainstream art theory of the late seventeenth and early eighteenth centuries, it was only through comparison that one learned to judge quality in art, the goal of connoisseurship.[7] The Luxembourg's mixed-school display constituted a training ground for aspiring connoisseurs; but equally important, the juxtaposition of the three schools provoked competition as well as comparison, and some visitors felt the gallery would improve the critical fortunes of the French school. In the words of one proud connoisseur: "[at the Luxembourg], the masters of the different schools compete for superiority, and the French, too often seen as inferior to their rivals, have performed honorably, and perhaps may even claim victory."[8]

The third room, the so-called *Salle du Trône*, was devoted exclusively to French artists of the seventeenth and eighteenth centuries (fig. 4). A strong tradition of history painting was particularly in evidence, demonstrating sustained mastery of the most exalted of genres. The Luxembourg argued better than could any text for the strengths, depth, and tradition of the French school.

Almost certainly the patriotic character of the collection was in response to La Font de Saint-Yenne's influential *Réflexions sur quelques causes de l'état présent de la peinture en France*, published in 1747, which exhorted the artist to paint for posterity and the government to spur emulation by creating a public museum in which the aspiring artist could envisage his works hanging one day among those of the great masters of other nations.[9] Perhaps with La Font's text in mind, another visitor remarked that the Luxembourg was sure to inspire the young: "Our modern painters will be encouraged by the strong showing of the French school among works by the greatest of masters. Vouet, Poussin, Le Sueur, Lebrun, Antoine Coypel, Noel Coypel, La Fosse, Mignard, Le Moyne are every bit the match for those athletes."[10]

When the Luxembourg closed in 1779, plans were already afoot to build a more magnificent museum in the Grand Gallery of the Louvre. Up to that point, there had been significant overlap in the patriotic purpose of the exhibitions mounted at Versailles, the Royal Academy, and the Luxembourg Gallery, but henceforth primary responsibility for defining the French artistic tradition shifted to the Louvre. Where Perrault used words to argue for the triumph of the (French) moderns over the ancients, this set of overlapping spaces culminating in the Grand Gallery sought to demonstrate that triumph visually.

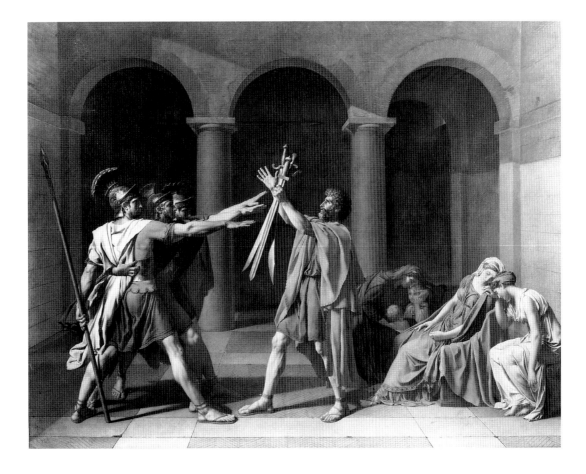

Louis XVI's director general of buildings (in effect, minister for art), Comte d'Angiviller, conceived the museum as an institution that would reflect glory on France and the king. More than once he described the museum as a "truly national" project, and in that spirit he spent the first years of his administration building up the Louvre holdings in French art.[11] In addition to buying celebrated recent works at auction, including Vien's *Sleeping Hermit* (Salon 1753) and Greuze's *The Village Betrothal* (1761), he pursued decorative works attached to the walls of Paris *hôtels* and had them transformed into gallery pictures, and, to crown his campaign of new acquisitions, he persuaded the Carthusians of Paris to part with their celebrated Saint Bruno cycle by Le Sueur.[12] Most important, every two years beginning in 1777, he commissioned a set of history paintings and "Great Men" statues from living artists, works also destined for the Grand Gallery. The purpose of the series, in his own words, was to inspire in the pub-

lic "sentiments of virtue and patriotism." Though these paintings and statues are usually referred to as prime examples of the Enlightenment's influence on art, we should attend equally to their political purpose, and in particular to the vision of *patrie* invoked.

D'Angiviller's paintings fell into two categories: those dealing with ancient history, like Jacques-Louis David's *Oath of the Horatii* (Salon 1785; fig. 5), and those narrating modern French history, such as François-André Vincent's 1779 canvas showing President Molé standing firm against antiroyalist insurgents during the Fronde. The latter, together with the *Grands Hommes* sculptures, had obvious patriotic intent. They presented exemplary acts of heroism and virtue by French men (no women were included) to rival the exploits of the ancients and stir pride in the viewer. But we should ask: what events were chosen? Whose history is in evidence? Whose heroes?

Ideologically this group of paintings and statues worked to represent France as a uni-

fied kingdom, whose vitality and history issued from the succession of royal dynasties. Together with other state apparatus—official historiography and incipient national educational programs, like the one put forward by d'Angiviller's friend and ministerial colleague, Turgot—these images composed what might be called an absolutist iconography of nationhood; they defined in royal terms the ideal French subject and determined what would be remembered as the nation's past.[13] At a time when many, if not most, French subjects identified primarily with their *pays natal* and spoke regional dialects that were mutually incomprehensible, these historical works bodied forth a conception of a collective community centered on the throne. Linking protagonists from different backgrounds and professions was steadfast loyalty to the king. In this royal space—the Louvre was of course still a royal palace—even men who on occasion had spoken against absolutism (such as the "Great Men" Montesquieu, d'Aguesseau, and Fénelon) were by their presence in the Grand Gallery embraced, forgiven, and silenced by the monarchy.[14]

The government's desire to affirm the unity of monarchy and nation in a permanent public spectacle represented a reaction to a long-running and bitterly divisive campaign on the part of the twelve regional Parlements to separate the traditional identification of king and country and to suggest that they, the Parlements, constituted necessary intermediary bodies representing the interests of the sovereign to his subjects, and vice versa. The suggestion of separate interests, indeed the very idea of something called a nation with a will of its own and not identical with the king, threatened the mystical, historical essence of the absolutist state, as Louis XV made clear in a stern rebuttal to Parlementary claims in 1766:

It is only in my person that the sovereign authority resides. . . . The whole public order derives from me. . . . My people exist only in their union with me; the rights and interests of the nation which one dares to separate from the monarch are necessarily united with mine and rest only in my hands.[15]

In short, the purpose of the French history paintings and sculptures was political,

and their audience primarily domestic. Few outside of France knew of or had reason to care about President Molé and Chancellor d'Aguesseau. The French subjects commissioned by the crown under Louis XVI contributed in highly significant ways to contemporary political discourse, and signal an increased politicization of art and public space in the buildup to the Revolution. But, important as they were, within d'Angiviller's larger museological scheme they took second place to the ancient history pictures.

Of the eight paintings commissioned every two years, only two depicted French history. Because the appropriate canvas size was smaller, French commissions paid less than the major classical subjects, and they tended to be given to lesser or younger artists. When given the choice, artists invariably chose to paint ancient history.[16] Though French subjects remained popular with the Parisian Salon-going public, artists and administrators understood that French claims to superiority in the fine arts needed to be ratified by an international audience and thus required a universal mode of address. D'Angiviller himself insisted in 1776 that "in order to maintain the grand manner in art," preference should be given "to subjects of ancient history over those of modern history."[17] Whereas the French history paintings relied on local settings and reliable portraits in order to communicate successfully, the ancient history picture eschewed the particular and aimed for the ideal and universal; it aspired to be legible throughout educated Europe.[18] The universal style in late eighteenth-century Europe was what we now refer to as neoclassicism, epitomized by David's *Oath of the Horatii*. The international stage for the demonstration of French mastery of that style was to be the Louvre museum. The display of national identity and cultural achievement at the Louvre rested not on demonstrable *difference* and the celebration of the local (as it was later to do in many nineteenth-century museums), but rather on superior command of a transcendent, universally valid language of painting. To paint in what was recognizably a French manner was a failing, the result of parochial training, as the *Journal de Paris* remarked in its review of recent works at the Salon of 1783:

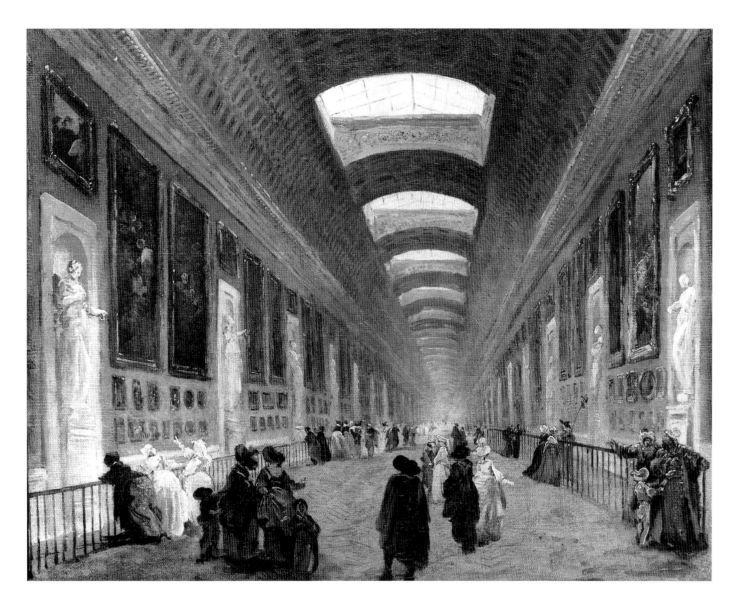

6. Hubert Robert, *Project for the Arrangement of the Grand Gallery of the Louvre*, 1780s, oil on canvas
Musée du Louvre; photograph: Réunion des musées nationaux

What strikes one on the first sight of this year's Salon is the style of the history paintings; they announce a School which, so to speak, is rejuvenated, and which begins to disencumber itself of the routine and the prejudices which for a long time have served as nourishment to pupils in their earliest education.[19]

In addition to displaying recent French efforts in painting, the museum was intended to play a part in producing that art, for, in accordance with contemporary art theory, a universal style in painting must be grounded in a knowledge and assimilation of the best art of the past.[20] In theory the museum would sustain the grand manner by presenting regional artistic traditions, including the French, and making them accessible to aspiring young artists for the purposes of study and copying. In an important sense the museum shaped the future even as it represented the past.

The relationship between d'Angiviller's Louvre and the regular exhibition of contemporary art at the Salon was both spatial and temporal. Modern French paintings making their debut at the Salon would, if deemed worthy, pass next door to the adjoining walls of the Grand Gallery where they would become the latest installment in an unfolding triumphant narrative of French painting. In step with museological developments elsewhere in Europe, d'Angiviller intended the Louvre to conform to the new

7. Nineteenth-Century
Gallery, Musée du Louvre,
1991
Author photograph

taxonomy of school and chronology. There
is no reason to think the arrangement of pic-
tures at Louis XVI's museum would have
differed in kind from that realized at the
Revolutionary Louvre in the late 1790s, with
the French school displayed at the Salon end
of the Grand Gallery followed by separate
sections devoted to the Northern schools
and the Italians, in that order. Within each
school an attempt would have been made to
hang works by the same artist together and
in chronological order.

The comparative hanging system of the
Luxembourg was replaced by diachronic in-
struction in the history of art, yet here too
was a political statement. No modern Italian
or Northern pictures were bought for the
Louvre, implying that those traditions were
now moribund; in contrast, the Salon would
provide a continuous and potentially endless
supply of contemporary French painting.
Displayed chronologically by school, the
Louvre collection would represent a thriving
native tradition superseding the spent artis-
tic traditions of France's once dominant ar-
tistic rivals. In Hubert Robert's imaginary
views of the Grand Gallery (fig. 6), through

which the beholder or visitor progresses to-
ward an indefinite horizon, implying an in-
finity of time as well as space, one can imag-
ine static foreign schools increasingly
encapsulated in a receding past, numerically
overwhelmed by French painting marching
into a "limitless future."[21] In the Louvre
museum the future of European art belonged
to France.

Such dreams of hegemonic glory were
shelved, at least temporarily, during the first
years of the French Revolution. When the
Louvre opened on 10 August 1793, the pic-
tures were hung in an eclectic fashion recall-
ing the Luxembourg, and the historical works
commissioned by d'Angiviller were nowhere
to be seen. Coinciding with the first anni-
versary of the founding of the Republic, the
museum's eventual opening contributed to
the celebration of Revolutionary triumph
over despotism. Erstwhile property of the
crown, émigrés, and the church, collectively
designated *biens nationaux*, was assembled
in a former royal palace turned palace of the
people. According to the priest turned revo-
lutionary, the abbé Grégoire, those treasures
"which were previously visible to only a

privileged few . . . will henceforth give pleasure to all: statues, paintings, and books are charged with the sweat of the people: the property of the people will be returned to them."[22] The monarchical past was subjugated to a bright Republican future and the promise of a new dawn in time.

To be sure, it was vitally important that the Republic foster an image of itself as the natural and legitimate heir to Enlightenment civilization, especially after the bloodletting of the previous year (the September Massacres and so on), but for a brief moment at the height of the Revolution, what mattered most at the Louvre, as in Paris generally, was bodying forth the principles of popular sovereignty and liberty, equality, and fraternity. Offering equal access to "liberated" treasures in a space that had been appropriated guaranteed what Lynn Hunt has termed "transparency" among individuals and between citizens and the state.[23]

It was fitting that the museum opened on the occasion of the Festival of National Unity, a day-long celebration orchestrated by David in order to bring together, in his own words, provincial politicians and black Africans, butchers and stonemasons—everyone, in other words, yearning to pledge allegiance to the new republic.[24] In a space such as the Louvre, free circulation and joint ownership of nationalized art would forge communal bonds of belonging and loyalty to the state sufficient to dissolve preexisting differences of origin, class, race, and language. Recognition of mutual ties to others who were different in those respects made it possible to imagine the nation.[25] The then minister of the interior, Dominique Garat, was particularly keen that the Louvre welcome the provincial representatives assembling in Paris for the 10 August festival, in order to show them that recent "political turmoil has in no way diminished the cult of the arts among us."[26] As a national institution, the Louvre could represent and convey the state of the nation.

The desire to assert French supremacy in the arts, dormant in 1793, was reawakened by the movement to export revolution abroad following the Terror.[27] In return for "liberation" through imposed republicanism, France's neighbors would yield their greatest cultural treasures to Paris. Republicans justified their policy of confiscation with heady rhetoric describing France as the "land of liberty" and thus the only true home of genius and artistic expression. Witness the speech by Luc Barbier to the National Convention following the arrival of the first convoy from Belgium in 1794:

The fruits of genius are the patrimony of liberty. . . . For too long these masterpieces have been tarnished by the gaze of servitude: it is in the bosom of a free people that the legacy of great men must come to rest. . . . The immortal works of Rubens, Van Dyck, and the other founders of the Flemish school are no longer on alien soil . . . they are today safe in the home of the arts and genius, in the land of liberty and righteous equality, in the French republic.[28]

Beneath the rhetoric, however, lay an older ambition to make Paris the cultural capital of Europe and the Louvre the envy of the world.

Following the example of d'Angiviller's museum, the Louvre under the Directory and Empire, replete with conquered booty, was organized chronologically by school, with French pictures displayed at the Salon end of the gallery. Limitations of space restricted the latter to a selection of acknowledged masterworks. Further French art, including paintings by living artists, went on display at the newly created Musée Spécial de l'École Française at Versailles (a short-lived forerunner of the Musée Luxembourg which opened in 1818).[29] Yet in the Grand Gallery the implicit passage from Salon to museum still held; spatial contiguity between the two pointed to the vital current that linked past and present and held out the promise that eventually, as the new became the old, those pictures which stood the test of time would earn a place in the Louvre. In 1810 the early masterpiece of David's protégé Jean-Germain Drouais (1763–1788), *Christ and the Canaanite Woman*, painted in 1782, entered the museum, setting a precedent that must have encouraged Drouais' surviving colleagues and their pupils.

Meanwhile the loosely chronological display of Italian and Northern pictures illustrated schools whose vitality had waned. According to art theory and historiography of the late eighteenth and early nineteenth

centuries, all schools of painting, like empires, rise and fall; each progresses from rude beginnings to a "time of efflorescence, of its perfect development," as Hegel put it, before suffering inevitable decline.[30] Art history, then as now, concerns itself mainly with those perceived periods of excellence and their leading lights. As Linda Nochlin has remarked, "art historians are, for the most part, reluctant to proceed in anything but the celebratory mode."[31] And museums, for the most part, dedicate themselves to the celebration of outstanding movements and key works. The Revolutionary generation in France believed that the creative forces that fueled the Italian Renaissance had long since dissipated and the once robust traditions of the Low Countries were in decline; mean-while the French school, empowered by the enlightened support of a politically and culturally superior nation, had entered its "time of efflorescence," and the Louvre, as an institution and instrument of the state, was called upon to represent history accordingly. The Grand Gallery became a space in which the triumph of the French "moderns" could be celebrated by the nation and witnessed by foreigners.

To judge by the Louvre that Napoleon built, only French painting had a future. And of course this is still the way the future looks as one passes through the climactic nineteenth-century galleries in the Louvre's grand circuit (fig. 7) and moves on to the Musée d'Orsay.

NOTES

1. Benedict Anderson, *Imagined Communities*, 2d ed. (London, 1991). My understanding of nationalism has also been shaped by the following texts: Eric J. Hobsbawm, *Nations and Nationalism since 1780: Programme, Myth, Reality* (Cambridge, 1990); Ernest Gellner, *Nations and Nationalism* (Oxford, 1983); Hans Kohn, *The Idea of Nationalism* (New York, 1944); Orest Ranum, ed., *National Consciousness, History, and Political Culture in Early Modern Europe* (Baltimore, 1975); Otto Dann and John Dinwiddy, eds., *Nationalism in the Age of the French Revolution* (London, 1988).

2. See James Clifford, *The Predicament of Culture: Twentieth-Century Ethnography, Literature, and Art* (Cambridge, Mass., 1988), 217; and Richard Handler, "On Having a Culture: Nationalism and the Preservation of Quebec's Patrimoine," in *Objects and Others: Essays on Museums and Material Culture*, ed. George W. Stocking Jr. (Madison, Wisc., 1985), 192–217. For some fascinating non-Western, postcolonial examples, see Anderson 1991, 178–185; and Dawson Munjeri, "Refocusing or Reorientation? The Exhibit or the Populace: Zimbabwe on the Threshold," in *Exhibiting Cultures: The Poetics and Politics of Museum Display*, ed. Ivan Karp and Steven D. Lavine (Washington, 1991), especially 444–456. Barbara Kirshenblatt-Gimblett has remarked: "One of the very first things that one can observe in new states is the imperative to create museums of ethnography and national heritage and to form national folkloric ensembles. . . . The strategy becomes even more powerful when all of this is called 'art,' because the term confers upon the material the highest accolade. Rhetorically speaking, a nation without art is not a nation." *Art in America* (September 1991), 81.

3. On museums and the construction of a modernist tradition, see Donald Preziosi, "Modernity Again: The Museum as Trompe L'Oeil," in *Deconstruction and the Visual Arts*, ed. Peter Brunette and David Wells (New York, 1994), 141–150.

4. Carol Duncan and Alan Wallach, "The Universal Survey Museum," *Art History* 3 (December 1980), 448–469. Also see Carol Duncan, *Civilizing Rituals: Inside Public Art Museums* (London, 1995).

5. Charles Perrault, *Parallèle des anciens et des modernes en ce qui regarde les arts et les sciences* (Paris, 1688), 1:220. All translations are mine unless otherwise stated.

6. Nicolas Guérin, *Description de l'Académie royale des arts de peinture et de sculpture* (Paris, 1715), 6.

7. Roger de Piles, the leading critic and theorist of the day, insisted: "It is only through comparison that things may be determined good or bad." Quoted by B. Teysèddre, *Roger de Piles et les débats sur le coloris au siècle de Louis XIV* (Paris, 1957), 251. For a full account of the Luxembourg, see Andrew McClellan, *Inventing the Louvre: Art, Politics, and the Origins of the Modern Museum in Eighteenth-Century Paris* (New York, 1994).

8. [Anon.], *Lettre sur les tableaux tirés du cabinet du Roy, et exposés au Luxembourg depuis le 14 Octobre 1750* (Paris, 1751), 2.

9. [Étienne La Font de Saint-Yenne], *Réflexions sur*

quelques causes de l'état présent de la peinture en France (The Hague, 1747), 44.

10. *Collection Deloynes*, Bibliothèque Nationale, Paris, vol. 52, pièce 1429.

11. Archives Nationales, Paris, 01 1670, folios 219, 246. Cited by James Leith, "Nationalism and the Fine Arts in France 1750–1789," *Studies on Voltaire and the Eighteenth Century* 89 (1972), 921. Also see McClellan 1994, chapter 2.

12. See Jules-Joseph Guiffrey, "Lettres et documents sur l'acquisition des tableaux d'Eustache Le Sueur," *Nouvelles archives de l'art français* (1877), 274–360.

13. See Ranum 1975, especially chapter 2; on Turgot's ideas on national education, which aimed to spread uniform patriotic ideas through the realm under Louis XVI, see Kohn 1944, 220.

14. See Andrew McClellan, "D'Angiviller's 'Great Men' of France and the Politics of the Parlements," *Art History* 13 (1990), 175–192.

15. Quoted by Kohn 1944, 199. On the Parlementary crisis and the issue of political representation in pre-Revolutionary France, see Keith Michael Baker, *Inventing the French Revolution* (Cambridge, 1990), 31–106, 224–257; and William Doyle, "The Parlements," in *The French Revolution and the Creation of Modern Culture*, ed. Keith Michael Baker (Oxford, 1987), 1:157–167.

16. On the commissions, see Barthelémy Jobert, "The *Travaux d'encouragement*: An Aspect of Official Arts Policy in France under Louis XVI," *Oxford Art Journal* 10 (1987), 3–14; also Thomas E. Crow, *Painters and Public Life in Eighteenth-Century Paris* (New Haven, Conn., 1985), and Marc Sandoz, "La peinture d'histoire comme trait marquant du siècle des lumières finissant," *Studies on Voltaire and the Eighteenth Century* 199 (1981), 263–285.

17. Archives Nationales, Paris, 01 1925 B1; dated 20 March 1776.

18. For a discussion of the universal in eighteenth-century history painting, see John Barrell, "Sir Joshua Reynolds and the Englishness of English Art," in *Nation and Narration*, ed. Homi K. Bhabha (London and New York, 1990), 154–176. Whereas in England, the universal was conceived in terms of a discourse of "civic humanism," in absolutist France, as Barrell has pointed out elsewhere (*Oxford Art Journal* 9 [1986], 67–70), there was no space or public for such a discourse, leaving the state and its institutions as the beneficiaries as well as the producers of high culture. On the question of "style" in d'Angiviller's paintings and sculptures, see Norman Bryson, *Word and Image* (Cambridge, 1981), chapter 8.

19. Quoted by Jobert 1987, 13, note 43.

20. See Rudolf Wittkower, "Imitation, Eclecticism, and Genius," in *Aspects of the Eighteenth Century*, ed. Earl Wasserman (Baltimore, 1965), 143–161; also Jeffrey M. Muller, "Rubens' Theory and Practice of the Imitation of Art," *Art Bulletin* 64 (1982),

229–247.

21. Benedict Anderson (1991, 11–12) observes that nations "loom out of an immemorial past, and, still more important, glide into a limitless future." On Robert's views of the Louvre, see Marie-Catherine Sahut, *Le Louvre d'Hubert Robert* (Paris, 1979).

22. Abbé Henri Grégoire, *Rapport sur les destructions opérées par le vandalisme* (Paris, an II [1794]), 21.

23. Lynn Hunt, *Politics, Culture, and Class in the French Revolution* (Berkeley-London, 1984). See also Duncan 1995; and McClellan 1994, chapter 3.

24. For an account of the festival, see *Procès-verbal des monuments, de la marche, et des discours de la fête consacrée à l'inauguration de la Constitution de la République Française, le 10 août 1793* (Paris, 1793); also Mona Ozouf, *La fête révolutionnaire, 1789–1799* (Paris, 1976).

25. For clarification of this point I refer the reader to Benedict Anderson's discussion of the way that colonial education affirmed the extent and reality of the nation-state by bringing together in the capital far-flung and often ethnically diverse provincials; see Anderson 1991, 126–127.

26. Alexandre Tuetey and Jean Guiffrey, eds., *La Commission du Muséum et la création du Musée du Louvre (1792–1793)* (Paris, 1910), 213.

27. See Florence Gauthier, "Universal Rights and National Interest in the French Revolution," in Dann and Dinwiddy 1988, 27–38.

28. *Moniteur Universelle*, 3 vendémiaire an III (24 September 1794), reprint, vol. 22 (1847), 26–27. See also McClellan 1994, chapter 3.

29. On the holdings of the Musée Spécial de l'École Française, see *Notice des tableaux, statues . . . composant le Musée spécial de l'école française* (Versailles, an X [1801]).

30. Quoted by Hans Belting, *The End of the History of Art?*, trans. Christopher S. Wood (Chicago, 1987), 71.

31. Linda Nochlin, *The Politics of Vision* (New York, 1989), 56.

PER BJURSTRÖM
Nationalmuseum, Stockholm (emeritus)

Interpretations of the Terms National Collection and National Museum in Scandinavia

During the nineteenth century, national museums were founded in Denmark, Norway, and Sweden. This was part of a movement stemming from the late eighteenth century that saw the birth of several national museums elsewhere in Europe. The earliest manifestation of this was in Italy.

The Uffizi Gallery in Florence opened to the public and hired its first director in 1769. It was a program expressive of the ambitions of the new grand duke, Pietro Leopoldo, who hoped to reform education by making the museum a public facility that was part of the educational system. In 1773 the dynamic Raimondo Cocchi was appointed as the new director. He presented what became an epoch-making program for the collection, bringing together relevant material from every available source to create a collection that covered the history of Tuscan art.[1]

The Uffizi could be considered the first gallery that was a "national" gallery with respect to the two principal meanings of the term. First, it belonged to the state. This, of course, was not the state of Italy (which was not a united nation-state until the nineteenth century), but the state of Tuscany, today regarded as a province. Second, it was a comprehensive collection representing the artistic gamut of one polity, the geographical region of Tuscany. The primacy of Tuscan art was maintained and its history traced back to the ancient Etruscans. It was not only a

question of *amore di patria*, for there were also parallels with reform movements initiated by Pietro Leopoldo around 1782. All paintings from other geographical regions were shown in two rooms under the strongly misleading label *Stanze di Quadri Fiamminghi*. Raimondo Cocchi also saw that *Niobe, Venus Anadyomene,* and *Apollo di Villa Medici* were brought from the Villa Medici in Rome to stand in places of honor in the Uffizi Gallery. This strengthened the dialogue between antique sculpture and "modern" painting already characteristic of the Uffizi and other eighteenth-century art galleries.

In France the situation was more complicated. The Musée du Louvre, or Museum Central des Arts, as it was originally called, opened in 1793 as an international art museum. It had, however, a weak representation of French art. The Revolution had placed religious and royal art in precarious positions. They were at great risk of being destroyed as symbols of authority. In response to this, the Musée des Monuments Français was founded to protect medieval and Renaissance art taken from churches. This also explains why art objects from these periods were gathered in 1790 and placed in the safety of the Monastère des Petits-Augustins in Paris. The painter Alexandre Lenoir, the prime mover of this initiative, was in charge of the collections. Because of Lenoir's influence, the clerics of the convent

41

made the collections into a museum on 18 October 1792. Less than a year later, 10 August 1793, the museum opened to the public. Lenoir was appointed director in 1794.

At the Musée des Monuments Français, seven rooms devoted to the exhibition of art were accessible from the garden which they surrounded. The first room was the Salle d'Introduction where choice objects were organized chronologically to provide an overview. The other rooms were each dedicated to the art of one century from the thirteenth through the seventeenth. Together, they revealed the historical evolution and progress of the arts in France. The architectural framework of each room was in keeping with the character of the art on exhibition. South of the Salle d'Introduction was a chapellike room featuring the tomb of François I from Saint Denis. This complex of galleries and chapel was of great historic significance, for it offered the public its first overview of the development of French art from the Middle Ages and the Renaissance through the baroque. Its focus was not narrow, for it included the exhibition of tombs, altarpieces, reliefs, stained glass windows, and even floors. A major change, of course, was that the objects were now removed from their religious context. Instead of being presented to the public within their original ecclesiastical settings as objects to facilitate prayer and worship, they were given a new aesthetic function.

The most attractive part of the museum was the garden. It was designed as an English park, peopled with monuments, both empty cenotaphs and real tombs in memory of great Frenchmen, and a *Campo santo romantique* where visitors were supposed to rest in gentle melancholy.

Lenoir, however, met strong resistance from Quatremère de Quincy, the revolutionary who as a Parisian representative to the *Conseil des cinq cents* rose to become one of the most powerful art administrators in France. Quatremère's orientation toward classical art explains his admiration for ancient and Italian Renaissance art. He disapproved of Lenoir's museum, arguing that the artworks should be returned to their original settings. In spite of Lenoir's resistance, the museum was dissolved after the fall of Napoleon in 1816. Many monuments were

returned to the churches and monasteries from which they had been taken. Others were transferred to the Louvre. Thus failed the first attempt to create in France a museum devoted to French art.[2]

The idea of a "national" museum along the lines of the museum of Pietro Leopoldo in Florence and that of Alexandre Lenoir in Paris was to develop in the German-speaking world as a means of making the arts the cultural expression of the people. The first museum of this kind was the National Museum in Budapest, founded in 1802 with the explicit purpose of arousing nationalism among the Hungarians. This was followed by the establishment of similar museums: the Bruckenthalsche Nationalmuseum für Siebenbürgen in 1803, the Joanneum in Graz in 1811, the Landesmuseum für Böhmen und Mähren in Brünn in 1817, and the Vaterländisches Museum in Prague in 1818.[3] In many cases, the museums were founded to protect medieval art, formerly the property of churches and monasteries, now in private hands. Goethe played a decisive role in a movement to make collections of medieval art public property.

These institutions, although originally planned as art museums, became museums with a strong cultural-historical character. An excellent example of this are the developments in Bavaria. In 1833 Freiherr von und zu Aufsess initiated the Germanisches Nationalmuseum, founded in 1852 and 1853.[4] The purpose of this museum was fourfold: to provide a general repertory of source material concerning German history, literature, and art from its beginnings to around 1650; to create a public museum containing art and antiquities from the same period; to keep the collections open to the public; and to disseminate knowledge: "to spread the knowledge of the national prehistory by publishing the foremost source-treasures and educating handbooks."[5] The program of the Germanisches Nationalmuseum set the precedent for museums of cultural history, particularly in northern Europe.

The art museums were created in a period in which classical ideals dominated and in which an interest in Renaissance and ancient classical art was fashionable. In effect, a set of values, cultural and aesthetic, dating

from the late eighteenth and early nineteenth centuries had a decisive and long-lasting impact on the museum world. This helped to create a system of evaluation in which some art objects were judged on an aesthetic level for complying with classical principles, while others were valued primarily for their historical significance. One result of this was that historical periods were differentiated according to which type of art object they produced. Another early consequence was the exclusion of medieval art. Early museums, with the exception of Florence, often left out the art of the Middle Ages. Lenoir failed in his early efforts to complete the program at the Louvre with the inclusion of French medieval and Renaissance art. These objects were considered simply as interesting historical artifacts in their original setting. This approach and the judgments it suggested have, by and large, remained intact to the present.

Museums of cultural history were products of the romantic movement. Their purpose was to uncover the roots of the people in their material culture. In turn, a people's knowledge of its own heritage, as experienced through these objects, was to promote national pride. Aesthetic merit was secondary simply because medieval and northern Renaissance art, which had relevance in revealing the historical beginnings of the society, did not comply with the preconceived notions of classical beauty. In Scandinavia these factors combined with conditions and circumstances that were uniquely Scandinavian to strongly influence the development of national museums.

Although there were strong cultural and ethnic identities in Scandinavia for centuries, only two nation-states in the modern sense of that term existed before the twentieth century: Denmark and Sweden. At the beginning of the nineteenth century, Denmark was a much larger country than it is today. During the ensuing century, it would lose Norway and part of what is now regarded as northern Germany. Here too the creation of a national museum was closely related to a desire to discover, understand, and promote cultural identity as an expression of national pride. This need was strongly felt in a period of national catastrophes. Denmark's failure to stay neutral during the Napoleonic Wars ended with the British bombardment of Copenhagen, the complete destruction of the Danish navy in 1807, and the loss of Norway to Sweden in 1814.

In 1807 a "Commission for the Preservation of National Antiquities" was created in an effort to emphasize Danish identity. The initiative was primarily due to the efforts of the librarian Rasmus Nyerup who was strongly influenced by Alexandre Lenoir's Musée des Monuments Français. Nyerup had dealt with the problem for the first time in a thesis of 1803 and a paper published in 1806 entitled "A survey of the ancient monuments of the country as they may be arranged in a future National Museum."[6] He tried to inspire collectors to leave their collections to a future museum with an article published in the newspaper *Dagen* on 17 March 1807:

All that has thus been left by Patriots is a mite on the altar of the Country. Once when a National Museum, worthy of the Nation and the Government, has been erected, this collection will, together with all the objects already present in the Royal "Kunstkammer" and other public collections, form a foundation for future expansion.[7]

The museum was housed in the loft of the Trinitatis church from 1807 to 1832. Its official name became the Royal Museum of National Antiquities; the designation "national museum" then only existed in Nyerup's writings.[8] In 1816 Nyerup was succeeded as head of the museum by Christian Jürgensen Thomsen, a wealthy businessman with a liberal middle-class background. Thomsen served as director for fifty years.

Other political events now came into play. In 1848 the southern, mainly German-speaking, provinces of Holstein and Slesvig revolted against Danish rule with the support of Germany. The inability of King Frederick VII (1848–1863) to handle the situation culminated in a new democratic constitution. Despite this dramatic change, Denmark eventually lost the two provinces to Prussia and Austria in 1864. The size of Denmark was reduced by thirty percent and its population by forty percent.

By now old hostilities between Sweden and Denmark were virtually forgotten. The Scandinavian countries stressed their shared cultural roots dating back to prehistoric

times, as well as their respective "national" origins. Thus the "national" character of cultural artifacts and art was emphasized, resulting in the nationalization of the Danish royal collections in 1849. Although expansion took place with the creation of new departments and the founding of the ethnological collection in 1845 and classical antiquities in 1853, the museum remained a vehicle to express Danish patriotism, largely directed against its southern neighbor. It did not, however, receive its present name until 1892.

Norway had been a Danish vassal state since the Middle Ages. When Denmark lost Norway to Sweden at the end of the Napoleonic era, a powerful "nationalist" movement began to take shape. A Norwegian constitution was ratified on 17 May 1814, and the need for distinctively Norwegian institutions arose. Its first university was founded in 1811 and its first theater in 1827, both in Oslo.

The establishment of an art museum also figured prominently in the founding of Norwegian institutions. In 1836 the Norwegian parliament allocated funds to the art school for the acquisition of older artworks to be used as the core of a collection and as models from which young students could learn. Edvard Munch, the grandfather of the painter, was appointed chairman of a proposed art museum. The beginnings of an art collection took shape when twenty-eight paintings by old masters were acquired in 1837 at auction in Copenhagen. During the following years additional works were purchased. Among them were paintings by two important contemporary Norwegian painters, Johan Christian Dahl and Thomas Fearnley. These purchases foreshadowed the direction the new museum would soon take.

Finally, in 1841 the museum was allotted three rooms in the newly erected royal palace in Oslo.[9] The Nationalmuseum opened to the public on 3 January 1842, with visiting hours on Mondays and Thursdays from 11:00 A.M. to 3:00 P.M. Three years later, in 1845, the museum was moved to a small house in the city.

By the end of the 1840s, the growing reputation of a considerable number of Norwegian artists was a crucial factor in redirecting the collecting activity of the museum. From this point onward, the Nationalmuseum would emphasize the collection of works by Norwegian artists. Thus the museum was given a truly nationalist character. In 1850 its name was changed to the Nasjonalgalleriet. The museum became one of the most important institutions that promoted the national identity of modern Norway.

Born in a romantic era, Norwegian institutions were not dependent on the classical traditions of the eighteenth century that had influenced the formation of art collections and museums on the continent and in Sweden. Nor was there a tradition of royal collections since Norway had belonged to Denmark until the early nineteenth century. Furthermore, the Norwegian national art museum was created in a period when the Norwegian artists educated in Düsseldorf (where a narrative attitude was developed) presented an image of Norway as a country of independent peasants, deep fjords, and dramatic mountains. The reputation of Edvard Munch, the painter, some decades later strengthened the role of the Nasjonalgalleriet. Its only competitor as a symbol of national identity, the Viking Ship Museum, was founded much later to house the famous Oseberg ship, discovered in 1904. As the Nationalmuseum in Denmark helped in strengthening national identity at a time when Denmark felt threatened by Germany, the national museum in Norway played a crucial role in defining Norway as a rural culture distinct from Denmark and Sweden and their royal and aristocratic backgrounds. Norway gained complete independence from Sweden in 1905, its national institutions already in place.

Sweden was early to establish a publicly owned collection of art, but it was the last of the Scandinavian countries to use the term *national museum* to describe its art collections. There are many reasons for this. Although Sweden lost Finland to Russia in 1809, Swedish independence and sovereignty were never threatened. This made the need for a nationalist movement less imperative. Moreover, Swedish cultural life had been closely bound to the continent, primarily to France, during the eighteenth century. The creation of its first museum, a museum of art founded by King Gustavus III, closely resembles the process in Vienna and Paris.

Unlike other European kings, however, Gustavus III did not inherit an art gallery. Works of art were dispersed in royal castles and palaces throughout the country, but not brought together as an artistic ensemble. There were no rooms or galleries intended for the display of art in the magnificent baroque royal palace designed by Nicodemus Tessin the Younger and erected during the first decades of the eighteenth century. King Gustavus III did, however, inherit an interest in and collections of art from his parents.

His mother, Louise Ulrike, sister of Frederick the Great of Prussia, assembled an important collection of artworks. This was greatly augmented by the generous gift of a collection of paintings, mainly French, from her father-in-law, King Frederick I. In 1749 Frederick I had bought the collection of Carl Gustaf Tessin, a well-known collector and son of the famous architect, who was by then financially ruined. After the death of her consort, Adolph Frederick, in 1771, Louise Ulrike acquired from his estate a number of important works of art, primarily Netherlandish.

The transactions within the royal family might seem confusing. Gustavus III acquired works from his father's collection and purchased his mother's collection in 1777 when she was insolvent. Perhaps embarrassed by the circumstances that contributed to the division of the family inheritance, Gustavus III decided that all the works of art, including those of his parents, should be acquired by public means. He wrote that they should be "owned by the state for eternity, not being able either to be relinquished nor dispersed, neither by will or by inheritance within the royal family."[10] Thus it can be said that the year 1777 gave birth to the publicly owned Swedish art collection. In 1780 Gustavus initiated the first display of selected paintings from the collections in two adjacent rooms of the palace.

The king's attitudes toward art can be partially explained by his own political circumstances. In 1772 Gustavus III had staged a bloodless revolution, which signaled the end of the so-called "time of freedom and the power of nobility." To achieve this political goal, he had sought and attained the support of the lower estates—the burghers and the peasants—whom he was prone to idealize.

In particular, Gustavus III was inclined toward ennobling the peasants of Dalecarlia, who once had brought his namesake, Gustavus I Vasa, to the throne. He used arguments based on physiocratic reasoning to justify these romantic notions. Victor de Riqueti de Mirabeau, for example, proclaimed the importance of the peasantry, the moral value of their simplicity, and the virtue of their lives in his *L'ami des hommes* (1756–1758). The rise of agriculture, according to Mirabeau, encouraged the improvement of both economic conditions and moral character.[11] Mirabeau launched an attack on and offered an alternative to mercantilism which, he believed, offered blind faith in money-based economies and promoted avarice, acquisitiveness, and other morally questionable qualities. Mirabeau proposed that citizens should not compete with each other and ask for remuneration for services, but serve society with their loyalty and ambition, as had the ancient Romans of the Republic who considered laurels, monuments, and triumphs the prizes of virtue. Gustavus III tried to follow in this tradition when he established the Order of the Vasa and medals of the Patriotic Society as contemporary equivalents of ancient honors.

The art collections in the royal palace were in an embryonic state when Gustavus III left for Italy in 1783. Although the official rationale of this trip was to tend to his health at a spa in Pisa, an underlying purpose was to study the artistic milieu of the country. He soon proceeded to Florence, where he stayed for a month visiting the Uffizi Gallery no less than fifteen times. He had an opportunity to meet and speak with Grand Duke Pietro Leopoldo and Emperor Joseph II. Princely meetings, which may have involved little more than a polite exchange of greetings, probably influenced Gustavus III less than his visits to the Uffizi where he would have seen how works of art were displayed. La Tribuna, which was at its center, contained the collection's most precious paintings and important antique sculptures, situated in the middle of the room. Here he found a model compatible with his own preferences, which he made clear in a speech honoring the founding of the Swedish Academy on 5 April 1786:

You may remember, dear sirs, the memory of those times in old Rome, when one could see the foremost citizens combine the care of literary arts with the noblest tasks of the country, and with the same voice that they participated in the deliberations, with the same hand that they signed the resolutions, they enlightened the citizens with their scriptures and adorned the language with their belles-lettres.[12]

Although Gustavus III spoke primarily of "the care of literary arts," we know that his interests and passions covered the whole artistic field: literature, theater, and pictorial art.

Gustavus III went from Florence to Rome. There he became a frequent visitor to the Museo Pio Clementino, which he visited at least five times.[13] The high point of his stay in Rome in 1784 was a New Year's day visit to the Museo under the personal guidance of the pope. If the idea had not occurred to him before, it may have been this visit that inspired Gustavus III to create an art collection in Stockholm modeled after that of the Vatican.

The king was in a position to acquire *Endymion*, the marble statue said to have been discovered in the ruins of Hadrian's Villa. The sculpture was intended to be, and indeed became, the *pièce de résistance* of the collection of antique sculpture. At the same time, the king bought from Giovanni Volpato the complete set of Apollo and the Nine Muses, which had been produced from antique fragments and modern additions. Gustavus III thus returned to Sweden with a greater understanding of antiquities, enthusiasm for classical ideals, and fresh arguments in favor of creating a public art collection in Stockholm.

Gustavus III soon contacted the artist Louis Masreliez about plans for galleries in the royal palace. The king had great confidence in Masreliez, whose interior decoration for a couple of rooms in the royal palace he deemed a success. In addition, Masreliez was well versed in the arts of France where he had studied for some years before returning to Sweden in 1782. A plan was implemented to complement two existing galleries of paintings with the so-called "lower gallery," located in the middle of the north wing of the palace and decorated with green fabric on its walls.

Using the estate inventory of Gustavus

III, Carl Nordenfalk has managed to reconstruct the display of paintings in the lower gallery.[14] Nordenfalk based his conclusions about the appearance of the installations on a series of articles, *Om målningar* (On paintings), published between 1791 and 1792 in the Stockholm newspaper, *Stockholmsposten*. The articles were written by Lucas von Breda Jr., himself an energetic collector of art. Nordenfalk also included a description published by two French emigrants, Chevalier Louis de Boisgelin de Kerdu and Comte Alphonse de Fortia de Piles, who had been visiting Stockholm for five months in 1791. Nordenfalk's reconstruction reveals that Masreliez followed the same principles of exhibition that were then current in Germany and France. Instead of crowding many paintings together, each wall was arranged symmetrically, usually with a large work in the center flanked by smaller ones.

Masreliez's selective process stressed quality. Twenty years later, he described the approach in a memorandum, explaining how he brought together paintings that had previously been dispersed in different rooms of the palace. The exhibition of "thirteen antique marble statues" remained an important consideration. Of this, Masreliez wrote:

The most valuable of them all is Endymion, *which is displayed in the center of the gallery. It is a piece of great beauty and dignity, and it is compared to the finest works of antiquity. He is reclining; one arm and one leg are restored, which could have been better done. The king bought this marvelous piece in Rome in 1784, and it did not cost him more than 2,000 ducats. The pope would have found it difficult to accept that Endymion had been sold from Rome, had it not been for the king. The* Nine Muses *was likewise acquired in Rome for 3,000 ducats, as well as three other statues.*[15]

Masreliez's arrangement remained unchanged until the death of Gustavus III.

We do not know how accessible the collection was to the general public. Articles on the gallery by Lucas von Breda in *Stockholmsposten* were didactic in nature and served to guide the educated public. There is every reason to suppose that the collections were available to artists, a qualified local elite interested in art, and visiting foreigners.

In his efforts to promote the education of

the public, Gustavus III was not solely dependent upon Mirabeau. He was familiar with the writings of Dubos and Diderot as well. This was undoubtedly one factor that influenced his founding a Swedish Academy centered around literature, scholarship, and taste. Literature and scholarship did not raise any problems, but taste—or *goût*—who possessed that? According to Henrik Schück, Gustavus III believed that taste was bred and manners acquired through the upper echelons of society. The king, identifying which categories should be represented in the academy, once wrote:

Those who are in the highest positions of the country, or who have been in the environment since childhood, have acquired their taste through the scrupulousness demanded by high-ranking offices or through the ever-changing group of people they meet on their mission, which demands a careful language and an accurate choice of language that concurs with the particular feeling, and which gives each word its intended meaning while prescribing the borders that may not be surpassed.[16]

It was important to Gustavus III to care properly for and develop the collections under his personal guidance.

As we evaluate the proposals for instituting a royal museum which were presented three months after the king's death on 28 June 1792 by Gustavus' brother and the regency, we realize that the idea of a national gallery did not rise from nothing. We must take into consideration that the king was about to erect a large museum palace at Haga, whose foundation stone was laid on 19 August 1786, the anniversary of the revolution of 1772. This design was based upon drawings by Olof Tempelman and Louis Jean Desprez.

The murder of Gustavus III abruptly brought to a halt the momentum for creating a public art museum in Sweden. Construction of the magnificent museum palace at Haga stopped. Today the enormous foundation of the museum remains as a picturesque ruin. As he formulated an inventory of the king's estate, Count Erik Ruuth, former minister of finance, found that Gustavus III's art collections could not be bequeathed to his heirs because they were deemed to belong to the state.

The responsibility for establishing a royal museum was left in the hands of Carl Fredrik Fredenheim, probably the only person in Sweden able to meet such a challenge. Fredenheim considered his primary task to create a worthy setting for antique sculptures. He achieved this end when he obtained use of the ground floor of the northeast wing of the royal palace (Stone Museum) and confirmed that the galleries already reserved for paintings would be part of the museum. A small staircase joined the rooms. The museum opened to the public in 1794 with the name Royal Museum. Although the collections were national property, any name using the word *national* instead of *royal* would have been impossible in the kingdom of Sweden at this time. Such use of the word would have had revolutionary implications. To some extent the words *royal* and *national* were interchangeable in Sweden in the same way that *national* and *imperial* were in France. The Louvre was renamed following changes in the political structure of the country.

The museum seems to have been fairly well visited during its first decade. General interest in the museum faltered, however, after the death of Fredenheim in 1803. In 1830 the responsibility for the museum passed to Lars Jacob von Röök, who was one of its most successful and colorful leaders. He revitalized a museum that was in bad shape and made it popular with the public with special events such as nightly candlelit receptions. Although he made the museum into an open and unconventional cultural center, he stressed its royal associations, being that it was still located in the royal palace, and in a compatible fashion emphasized his own role as that of courtier.

During the mid-century period, the character of the museum was dramatically transformed by its director, Mikael Gustaf Anckarsvärd (1844–1858). This was part of the redirection of Swedish culture away from international classicism toward romantic nationalism. At this time, special provisions were made for the collection of national, meaning Swedish, art. As early as the 1810s a group of three giant statues of the Norse gods Odin, Thor, and Freya (later substituted with Baldur) by Fogelberg had been commissioned by Sweden's French-born king, Charles XIV John (Jean-Baptiste Berna-

2. Carl Larsson, *Ehrenstrahl Painting King Charles XI*, 1895, fresco
Photograph: Statens Konstmuseer, Sweden

dotte). A major shift took place in the 1850s when emphasis was given to the collection of pictures of Swedish landscapes and subjects from Swedish mythology and history.

In 1847 funds were granted by parliament for a separate building for the museum. When the collections were placed in their new building in 1866, the museum was renamed Nationalmuseum, a designation that emphasizes both its public ownership and its collections of Swedish art.[17] The building housed the Royal Armory until 1885 and the collections of National Antiquities until 1939. The museum in its original form thus provided the public with a complete survey of Swedish history and culture in accordance with the ambitions of the four estates of the parliament and with respect to the ideals of the increasingly powerful bourgeoisie.

The architect of this classical edifice (fig. 1) was the German August Stüler, famous for his Neues Museum in Berlin (1843–1845). He was also the original architect of the Nationalgalerie in Berlin, which was subsequently completed by Heinrich Streich in 1876. There is a striking difference between the Nationalmuseum in Stockholm and its counterpart in Berlin. The front of the Nationalmuseum was decorated with statues and portrait likenesses of Swedish artists, authors, and scholars. The façade of the museum in Berlin was dominated by an equestrian statue of the emperor, and inside were large battle paintings glorifying the Franco-Prussian War. The first appearance of a king in the embellishment of the Swedish Nationalmuseum dates from 1895 and is a fresco by Carl Larsson depicting King Charles XI in a rather disrespectful manner being painted by the artist David Klöcker Ehrenstrahl (fig. 2).

The national museums in Scandinavia thus emerged as the result of political conflict with specific antagonists in mind: Denmark felt threatened by Germany; and Norway was in search of its own identity after five hundred years of Danish rule and at a time when it sought complete autonomy from Sweden. In Sweden, the powerful bourgeoisie asserted its rights and responsibility over that of the monarchy for the national cultural heritage. These circumstances helped define the character of the three collections of art and gave distinct meaning to the usage of the word *national* as part of the names of each museum. As a result the term *national museum* had three completely different meanings in Denmark, Norway, and Sweden.

NOTES

1. L. Pellegrini Boni, "Struttura e regolamenti della Galleria nel periodo di Pietro Leopoldo," in *Gli Uffizi: Quattro secoli di una Galleria. Fonti e documenti* (Florence, 1982), 274–275, 291.

2. René Schneider, "Un ennemi du Musée des monuments français," *Gazette des beaux-arts* 4:51 (1909), 356.

3. Ludwig Grote, *Museum und Geschichte: Altonaer Museum in Hamburg* (Hamburg, 1964), 19–20.

4. *Das Germanische Nationalmuseum und seine Sammlungen* (Nuremberg, 1861), 1.

5. Nuremberg 1861, 58.

6. "Oversyn over Faedernelandets Mindesmaerker fra Oldtiden, saledes som samme kan taenkes opstillede i et tilkommende National-Museum. Et forsög," Johannes Bröndsted, "Introduction," in *Danmarks Nationalmuseum*, ed. Aage Roussell (Copenhagen, 1957), 25.

7. *Alt, hvad som saaledes af Patrioter her bliver deponeret, er en Skjaerv paa Faedrelandets Alter. I sin Tid, naar et, Nationen og Regjeringen vaerdigt, Nationalmuseum vorder oprejjst, bliver naervaerende Samling, tilligemed hvad der allerede haves paa Konstkammeret og andre offentlige Steder, at ansee som en Grundvold, hvorpaa fremdeles kan bygges viddere.*

Bröndsted 1957, 25.

8. The royal collections of art were never incorporated with the National Museum but arranged separately in a couple of rooms in the royal Christiansborg palace, where they were made available to the general public in 1827 and remained until the palace caught fire in 1884.

9. Sigurd Willoch, *Nasjonalgalleriet gjennem hundre år* (Oslo, 1937), 17–42.

10. "The Minutes of the Council, 1777," cited in Per Bjurström, *Nationalmuseum 1792–1991* (Stockholm, 1992), 56.

11. Sven Delblane, *Ära och minne: Studier kring ett motivkomplex i 1700 talets litteratur* (Stockholm, 1965), 114–116, and quoted there, Victor de Riqueti de Mirabeau, *L'ami des hommes, ou traité de la population*, vol. 1 (Avignon, 1760), chapters 4–7.

12. [King Gustavus III] *Konung Gustaf III:s skrifter* (Stockholm, 1906), 21–22.

13. Carlo Pietrangeli, *I Musei Vaticani: Cinque secoli di storia* (Rome, 1985), 74.

14. Carl Nordenfalk, "Tavelgalleriet på stockholms slott," in *Svenska kungaslott i skisser och ritningar*, ed. Gunnar Jungmarker and Per Bjurström (Stockholm, 1952), 119–142.

15. Fredrik Sander, *Nationalmuseum: Bidrag till taflegalleriets historia* (Stockholm, 1876), 77–79.

16. Henrik Schück, *Svenska akademiens historia*, vol. 1 (Stockholm, 1936), 93–94.

17. It is worth mentioning that just about the time Anckarswärd began his planning of the new museum, the monopoly of the Royal Theater came to an end by the first independent theater, the New Theater, in 1842 being granted permission to perform. The strong royal and official attachment of the Royal Theater is emphasized by the fact that the theater was the center of the first primitive Swedish secret service. Georg Nordensvan, *Svensk teater*, vol. 2 (Stockholm, 1918), 2–4.

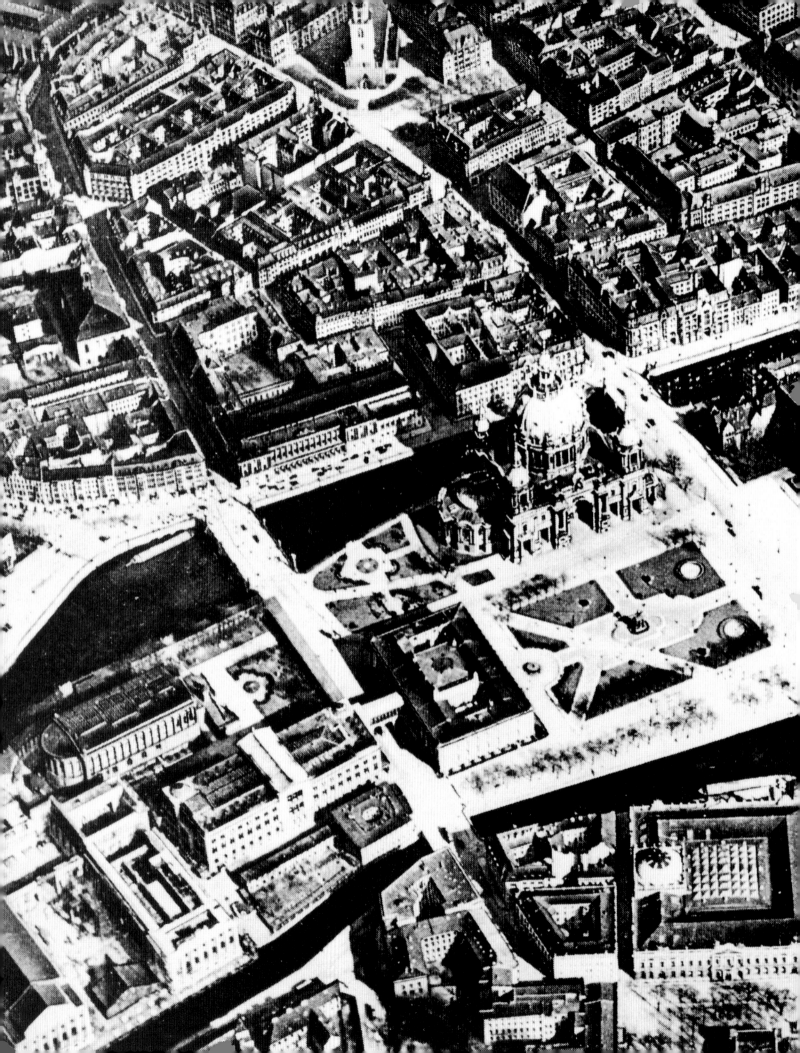

THOMAS W. GAEHTGENS
Kunsthistorisches Institut der Freien Universität Berlin

The Museum Island in Berlin

The Museum Island in Berlin is rightfully considered among the most important complexes housing collections of art and cultural history. Five buildings, parts of which are of exceptional architectural and historical significance, are situated on a peninsula in the heart of the city, surrounded by the rivers Spree and Kupfergraben. Works of art from diverse cultures, European and non-European, ancient and modern, are preserved and displayed here.

Completed over the course of approximately one century, the Museum Island represents the architectural, museological, and political ideas of several generations, which contributed to this unique urban, cultural-historical *Gesamtkunstwerk*. The museum complex did not develop along a straight course. Each expansion and each new collection reflects the efforts of many years, often decades. The history of the Museum Island thus represents a vital chapter in the cultural and intellectual history of Prussia and Germany.

The evolution of these museums most often has been presented in the context of the history of collecting and the history of the sciences. The expansion of the collections and their conservation were closely tied to developments in the disciplines of art history, archaeology, Egyptology, and the cultural history of the Near and Far East. Dynamic advances in scientific scholarship during the nineteenth century were a princi-pal factor in the increasing cultural importance of museums. These developments influenced the acquisition and study of objects, their conservation and cataloguing, as well as their display, and stimulated intellectual discourse about them.

The collecting and conserving of works of art, however, required sponsorship. In Prussia and Germany, the monarch and the state were the patrons who assumed responsibility for the expansion of the collections and museum buildings. The Museum Island therefore is not only testimony to intellectual and scientific developments, but is also the particular result of Prussian and German *Kunst-* and *Kulturpolitik*.[1]

The Museum Island has not yet been sufficiently appreciated from this perspective, but before discussing this in detail, I would like to question the prevailing opinion about the museum complex, and to emphasize historical interpretations of this structure that so far have been largely neglected. Central to my examination are two juxtaposed theses. One, often mentioned during the recent heated debate about the reconstruction of the Museum Island, is that the combination of the museums, devoted to a multiplicity of cultures, is due to a *concetto*. It is the product of a vision—a vision of great diversity based on the same foundation. The culturally and artistically diverse objects, gathered in one location, document the wealth of human expression and creativity formed by

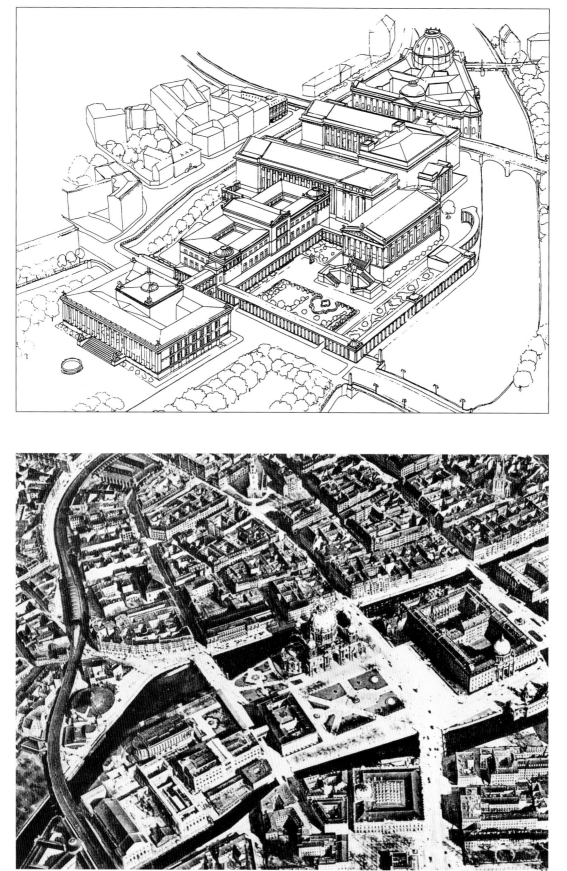

1. Museum Island,
perspective drawing
Photograph: Kunsthistorisches
Institut, Freie Universität Berlin

2. Museum Island, aerial
photograph, c. 1930
Photograph: Kunsthistorisches
Institut, Freie Universität Berlin

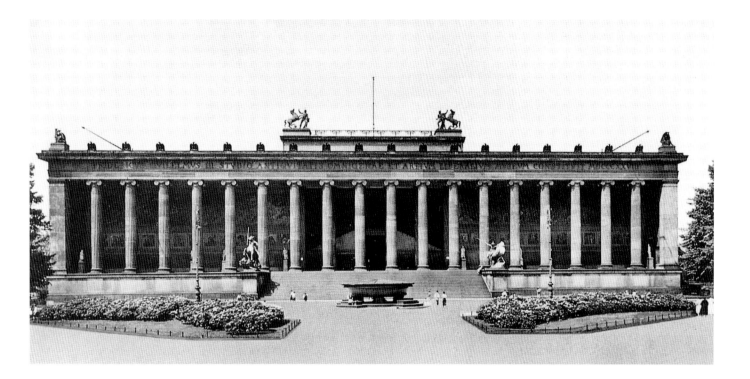

certain historic periods and physical environments. By moving from one culture to another on the Museum Island, visitors have the opportunity to establish this link for themselves.

Not wanting to deny that a visitor to the Museum Island might have such an experience, I would like to argue, however, on a different level. I propose that the idea of combining cultural artifacts had already been addressed in a certain sense in the early nineteenth century, and that this romantic notion changed fundamentally over the course of the remainder of the century. The expansion of existing collections and the acquisition of new ones were not merely intended to illustrate the range of human artistic activity. It seems that the collections grew at a much faster pace once the *Kunst-* and *Kulturpolitik* of the Prussian king was adopted by the German emperor. After Bismarck's departure in 1890 under William II, worldwide ambitions came to determine the foreign policy of the German Reich, and the collections benefited from increased royal patronage, which in turn was intended to further imperial political goals. The Museum Island, as I would like to show, was first a product of Prussian and later decidedly imperial politics.

The Altes Museum (Old Museum)

There are essentially five museums on the Museum Island, each with several curatorial departments (figs. 1, 2). It is impossible to describe an ideal fixed state of the collections; they changed constantly over the course of many years. This attests to the vitality of the institution: a museum is not and cannot be a static formation.

The oldest museum, and probably the most important from the viewpoint of architectural history, is the Altes Museum, built by Karl Friedrich Schinkel and opened to the public in 1830 (fig. 3).[2] It originally housed sculpture from antiquity, some plaster casts, and on the upper level select paintings of all schools.[3] Schinkel's Altes Museum was the result of a wish list, to which the king had responded after lengthy deliberations. Museums had been built in other European capitals long before the Prussian monarch decided to make the funds available for this building. The Musée Napoléon in Paris was the culmination of a long period of museum planning and the result of Napoleon's expansionist politics. Napoleon made Paris the cultural center of his empire by robbing other countries of their art. His museum held masterworks collected as war booty with

the claim that the countries of their origin were past their prime, but that he had created a golden age in France. The Musée Napoléon was an art-political institution by origin as well as in its mission, which was defined by the emperor.[4]

Napoleon's museum became such an attraction for all of Europe—not least because of its great public success of 1815—that the states of the alliance demanded the return of their stolen treasures to exhibit in their own public museums. Prussia, however, had no such institution. Attempts over the years to convert the academy into a museum had not succeeded. When Frederick William III finally agreed to Schinkel's plans in 1823, it was for political reasons. It was no coincidence that Klenze's Alte Pinakothek was built in Munich at the same time and also opened in 1830.[5]

The Altes Museum was built opposite the monarch's residence. This positioning stated clearly that the reigning monarch had donated the building, with the intent that "the foremost and highest goal of a museum should be the awakening and education of a sense for art."[6] "The façade invites all the population," says a nineteenth-century description; Schinkel's columned foyer was interpreted as an invitation by the donor for all to enter.[7] According to a statement by the commission for museum facilities, under the leadership of Wilhelm von Humboldt, the museum should "first delight, then instruct."[8] For this the monarch transferred 348 paintings from his palaces to the museum.[9]

The Altes Museum housed and displayed antiquities on the lower level and modern paintings on the upper level. The so-called Antiquarium and the Kupferstichkabinett were below ground. Under Frederick William III, assisted by Wilhelm von Humboldt, the first museum institute was established, with an independent administration headed by experts. The idea that the museum should be administered as an independent academic institution had already gained ground, though in the next generation the state took charge of the museum.

The Neues Museum (New Museum)

Frederick William IV, the romantic who next ascended the Prussian throne, made the royal museum part of his personal administration. On the one hand, this decision reflected his own artistic interests, but on the other it attested to the fact that the state did not want to relinquish control over the arts (fig. 4).

Frederick William IV not only planned and built the Neues Museum and began installation of the works of art, but also deserves the credit for the Museum Island. On 8 March 1841 he decreed that "the entire Spree island behind the museum be made a sanctuary for art and science."[10] Designs for the king's architectural projects were conceptualized in detail by Friedrich August Stüler. These plans, however, were not executed (fig. 5). Instead, the Neues Museum was built, between 1834 and 1855, by Stüler; conceived as an extension of the Altes Museum, to which it was connected by a bridge, it was to house not only additional antiquities and plaster casts, but the prehistoric and especially the Egyptian collections, which by now had grown considerably.[11]

In the Neues Museum, exquisitely furbished galleries were devoted to the culture of ancient Egypt (fig. 6). The royal museums now attracted international attention. The museum thus joined an international academic effort, which London, Paris, and Turin had already spearheaded with their holdings. The most prominent German Egyptologist, Richard Lepsius, who himself had overseen the installation of Egyptian antiquities since 1855, substantially promoted Egyptology as an academic discipline; and Berlin also became a center of the highest rank for collections and research.[12]

The second museum on the island, the Neues Museum, offered more exhibition space and a brand-new ideological concept. Schinkel had already made room for contemporary art in the Altes Museum with his paintings of mythological scenes, which surrounded the grand staircase and gave the building a pictorial program (fig. 7). On a much larger scale, Wilhelm von Kaulbach, with the help of many assistants, created huge historical paintings for the Neues Museum, depicting a summary of the history of mankind. His lively, multifigured compositions, most of which unfortunately were destroyed in World War II, spanned the time from the Tower of Babel to the

4. Friedrich August Stüler, Neues Museum, 1841–1855, seen from the Kupfergraben
Photograph: Kunsthistorisches Institut, Freie Universität Berlin

5. Plan for the project by Friedrich August Stüler
Photograph: Kunsthistorisches Institut, Freie Universität Berlin

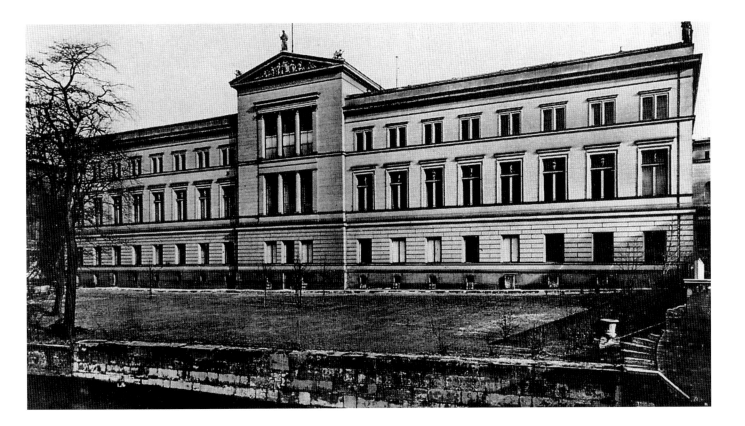

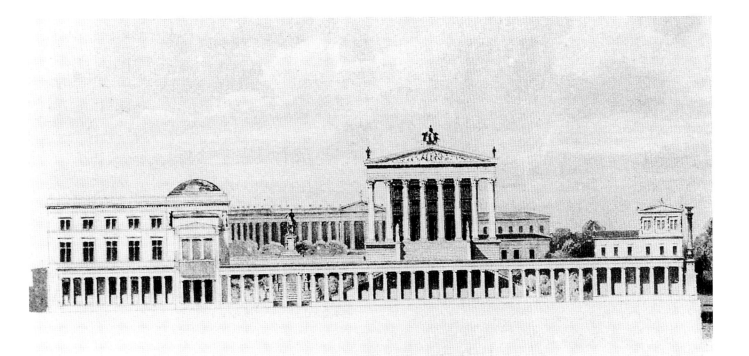

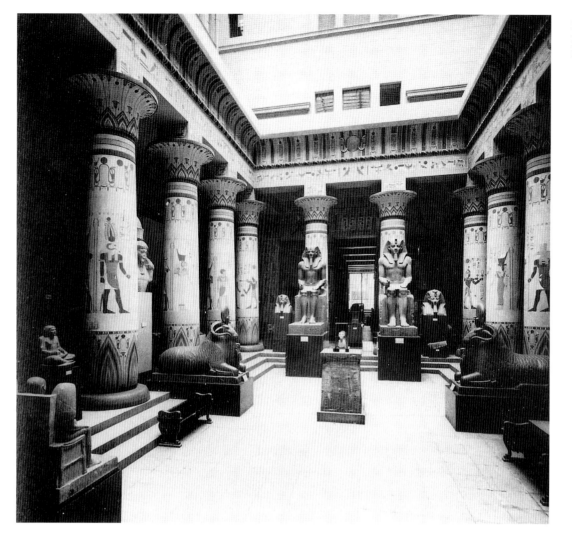

6. Neues Museum,
Egyptian court
Photograph: Kunsthistorisches
Institut, Freie Universität Berlin

Reformation. While Schinkel had created a philosophical interpretation of the divine world and the fate of mankind with his difficult allegorical and mythological depictions, the pictorial program for the Neues Museum emphasized history. One might say that the historical-philosophical approach was replaced by a historical-didactic one.[13]

The collections reflect this cultural large-screen production only to a very limited extent. Yet it is symptomatic of the time that the presentation of the collections and the decor of the interior were given a didactic format. The Neues Museum was meant to be an educational institution, to elucidate historical contexts for the visitor. The objects on display could be viewed individually but were also part of a comprehensive educational program. The "enjoyment of art," which had guided the previous generation,

was replaced by a new emphasis on education by historic example.

The Nationalgalerie

The next building, the Nationalgalerie, was also based on the ideas of King Frederick William IV himself and after plans by Stüler.[14] The architect was Johann Heinrich Strack, who saw the building through from its inception in 1866 to completion in 1876. This pseudoperipteral edifice arose from the desire to present German art in worthy surroundings. Like the Walhalla near Regensburg, a symbol of newly awakened patriotism after the Napoleonic Wars, the Nationalgalerie was built in classicist style. Strack relied on Greek models from antiquity (fig. 8).

Neither the Altes nor the Neues Museum

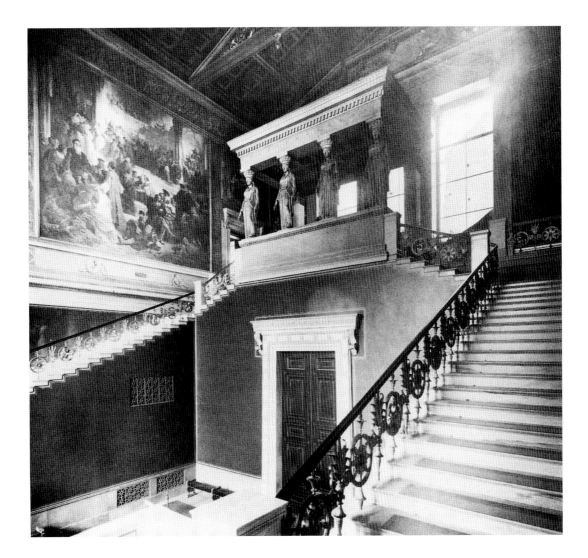

was suitable for contemporary art by concept or design. Baron Karl Friedrich von Rumohr had once suggested that "a department of the royal gallery be devoted to the most outstanding living artists."[15] His concern was now repeated more and more frequently, especially after 1848, when it became relevant on the national level. The issue was not only to dedicate a museum to contemporary art, but also to create "a self-portrait of the nation through the medium of art."[16]

The Prussian cultural ministry debated a proposal made by Düsseldorf artists at the parliament in Frankfurt: to create a German national gallery. The Prussian state, however, did not see fit to make the necessary funds available, despite the art academy's recommendation.[17] Evidently the time was not yet right for Prussia to make the nation's

concerns its own. Since the Prussian king, Frederick William IV, had declined to become president of the Frankfurt National Assembly, the Prussian state was unwilling as well to assume cultural tasks on behalf of the federation.

The establishment of the Nationalgalerie progressed considerably when in 1859 Consul Joachim Heinrich Wegener left his extensive collection of German paintings to Crown Prince William.[18] But construction of the building still did not begin for a few years and only neared completion in 1876.

It should be mentioned that at the time the Nationalgalerie was built, Berlin was not considered a principal center for the arts in Germany. Far more noteworthy collections of contemporary painting were amassed in Düsseldorf, Karlsruhe, and Munich. Compared to these cities, Berlin was provincial.

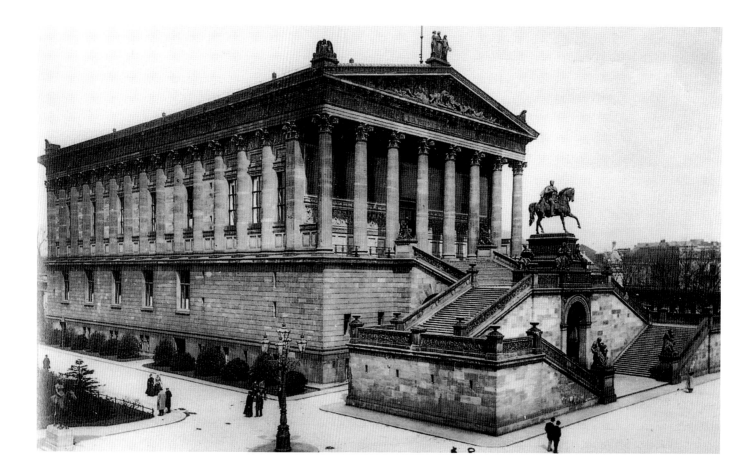

With its growing political role, however, a leading position in the arts was pursued as well. The ruling family sought visibility through its collections.

Visible from afar, an inscription on the Nationalgalerie, "To German Art MDCCCLXXI," alluded to the national role that Prussia, aided by Bismarck, felt called upon to fulfill. The figure of Germania as patroness of the visual arts occupies the center of the sculptural frieze on the pediment, a clear indication that Prussia intended this temple of art for the entire nation.

An equestrian monument, completed by Calandrelli in 1886, was placed in front of the museum for the Prussian king, Frederick William IV. Thus the donation by the monarch was publicly acknowledged and the statement made that the museum was an initiative on behalf of the nation by a Prussian king. By placing a monument before the museum, monarch and state confirmed their claim to the leadership of this public institution. The same claim was re-

peated a few decades later with the monument for Emperor Frederick III in front of the Kaiser Friedrich Museum.

The interior of the museum, whose original design was lost in later reconstructions, pointed out to the visitor repeatedly as well that the gallery was intended as a national institution. The political character of the institution was obvious not only in Geyer's frieze in the staircase, which depicted German cultural achievements ranging from the Germanic tribes to William II, but also through sculpture and paintings. The Nationalgalerie ostensibly collected and exhibited German, particularly contemporary, art. The integration of battle scenes and depictions of notable events in Prussian history proves, however, that the framework for the art was political propaganda.

Karl Scheffler said it best when he wrote in 1921:

The Nationalgalerie served dynastic interests quite intentionally—on occasion it has been

8. Johann Heinrich Strack, Nationalgalerie, 1866–1876
Photograph: Kunsthistorisches Institut, Freie Universität Berlin

confused with a temple of fame. Battle scenes of German victories, paintings and sculpture of sovereigns, statesmen, and generals were displayed there, with a distinct preference for works of art that seemed suited to support the existing social conditions. The gallery served to steer the "education" of the wider population in a certain direction: to keep it pious and politically reliable.[19]

It is of interest in this context that the director of the Nationalgalerie, Max Jordan, did not answer to the general director of the royal Prussian museums. Jordan was a civil servant of the Reichsgovernment and an ex officio member of the state art commission. Because of persistent conflicts with members of the commission over acquisitions, as well as the artistic views of William II, Jordan resigned his position in 1895.[20] Not only he, but all leading museum directors of the empire profited from the government's use of the museums for political purposes, but they also suffered from its regimentation. The firing of Hugo von Tschudi in 1909 remained a well-publicized exception.[21] "In this time of imperial self-glorification," as Scheffler said, most museum staff had to go along with political currents as well as fend them off. The museums benefited from the political focus, literally owed it their success, but they also tried to escape the stranglehold of having to represent the state and the political aims of the government.

Not only were works of art collected and displayed on the Museum Island in Berlin, but the museums were also an effective vehicle for the promotion of Prussian cultural politics. The changes that occurred between the time of the Neues Museum and the Nationalgalerie, from the museums' original mission to the imposed selection of the works of art on display later on, made it very clear that the direction of Prussian art politics had changed in accordance with the general political situation. The historical mission for the good of humanity gave way to the demand for national leadership in Germany. The politics of art now served the politics of the day. Prussia aimed to become a leader of the arts and the museums in all of Germany. Prussian museum politics needed to reach beyond Prussian borders to become representative of imperial Germany.

Museums outside the Spree Island: The Völkerkundemuseum (Museum for Ethnology) and the Kunstgewerbemuseum (Museum for Applied Arts)

After the Prussian king was proclaimed German emperor in 1871, the royal collections were systematically yet further expanded. The patronage of Crown Prince Frederick was of greatest importance: to prevent him from further involvement in political activities, he had been given the stewardship over the museums.[22]

In the first two decades of his patronage, two noted museums were built, albeit not on the Museum Island. One was the Kunstgewerbemuseum, today named after its architect, Martin Gropius, and situated on the future Prinz Albrecht Strasse in 1877–1881 (fig. 9). Exactly opposite, in the Königgrätzer Strasse (later Stresemann Strasse), was the Völkerkundemuseum, built in 1880–1886 by Herrmann Ende (fig. 10) and torn down after the war to make room for the extension of the city's freeways.

The decision to break ground for a new building for the prehistoric and ethnological collections had already been made in 1873.[23] Lack of space was a paramount consideration here as well. The collections in the Neues Museum had grown exceptionally quickly under the directorship of Baron Leopold von Ledebur. Not only had Alexander von Humboldt expanded them in his time, but the department had made major purchases such as parts of the collections of Cook and Prince Maximilian von Wied, and had received sizable donations.

Essential for the establishment of their own building was also the fact that the perception of the collections had changed during the nineteenth century. They had once been viewed as curiosities, but were now considered scientifically informative cultural relics. Awareness grew that the cultures of Africa, the Americas, and the Far East were being altered or destroyed by their contact with Western civilization; the holdings now became the subject of scientific research.[24]

It had, however, also become apparent that the issues raised in the preparation and display of the objects removed them further from the other departments of the royal museums. It was evident to Schöne that the eth-

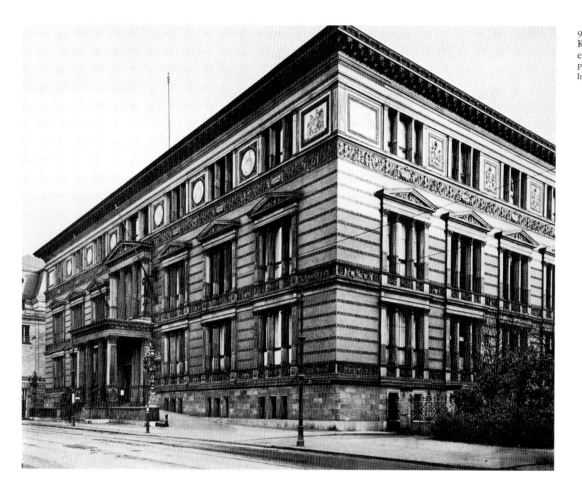

9. Königliches
Kunstgewerbemuseum,
exterior view, c. 1900
Photograph: Kunsthistorisches
Institut, Freie Universität Berlin

10. Völkerkundemuseum in
the Königgrätzer Strasse
120, 1926
Photograph: Kunsthistorisches
Institut, Freie Universität Berlin

nological collection "moved further and further away from the viewpoint once so strongly espoused by Wilhelm von Humboldt," that it was not possible to derive artistic enjoyment from these objects. It also seemed no longer possible to assemble a united committee for new acquisitions, to do justice to both works of art and ethnological pieces.[25]

The successor of Ledebur, Adolf Bastian, did not oppose this development. As the first director of the Museum für Völkerkunde, he was instrumental in making the museum an institution of world renown by supporting expeditions. During times when "many ancient cultures became extinguished by a heavy hand," he felt it was the responsibility of mankind to document and pass on its earliest history. Any objects that embodied those cultures, even seemingly insignificant ones, should be considered collectible. Only when "artistic products of a culture entered the realm of the historical" did they belong to art history and the domain of the art museums.[26]

With Bastian's tireless efforts, the collections grew in great bursts.[27] It is important to understand that the support Bastian received was granted only because of the ambitions of the government regarding its foreign policies. Academic interests and the desire to increase the collections would hardly have sufficed as reasons to award the funds for buildings and expeditions. Bastian was able to expand the ethnological museum because the ambitions of imperial politics were geared to satisfying the demands of the national liberals, and other sectors of the general public, to acquire colonial property. Colonial acquisitions and scientific expeditions went hand in hand.[28]

The occupation of Southwest Africa, New Guinea, and the Bismarck Archipelago was of utmost consequence for the ethnological collections. Aside from supporting ethnology as a science, the government's support of the museum in the Königgrätzer Strasse also helped popularize the colonial aims of the empire.[29]

The physical separation of the Museum für Völkerkunde came about not only because of space problems; it also helped in clarifying the methodology and content of collecting. Ethnologists and art historians recognized the differences in their interests. Those who wanted to preserve the Museum Island as a refuge for high art prevailed. The arguments surrounding this issue are by no means a minor chapter in the history of museums in the last century. The debate was continuous. Karl Scheffler resumed it in 1921 in a polemic with the poignant title "War of the Berlin Museums." In the spirit of Bode, he called the ethnological collections, which seemed to be growing out of bounds, the result of imperial colonial politics and megalomania.[30]

The fight never ceased. In one camp were the art historians, defending the art museum as exclusively intended for works of high artistic quality. The other consisted of ethnologists and cultural historians, who wanted to place exceptional works of art in the context of a comprehensive presentation of culture that included nonartistic objects as well.

When Wilhelm von Bode succeeded with the foundation of an East Asian collection, he faced considerable resistance from his colleagues at the ethnological museum, who were not willing to part with outstanding works of art or agree at all to such an institution.[31] Prehistorians and ethnologists defended their cause again in the 1920s, using the same reasoning as a report by the commission in 1893. The argument against Scheffler was: "It is obviously nonsense to assume that art exists in a void, without any link to culture in general."[32] The debate resumed again when the display of the collections on the Museum Island was under discussion. While the conservators of the Near Eastern, the Egyptian, and the antiquities departments tended to favor a more cultural-historical presentation of the holdings, the art historians were neither willing to mix categories, as Bode had already done, nor to integrate fine art into the cultural achievements of an era.[33]

The Kunstgewerbemuseum (Museum for Applied Arts) was built outside the Museum Island for other, not entirely unrelated reasons. First established by a private society in 1867, it came under the protection of the state only in 1885. The society's goal was a didactic collection that could serve as a learning tool for teaching the crafts. The

South Kensington Museum in London had been expanded by one department in 1852 for this reason. Gottfried Semper's writings in Germany had also made a major contribution to the promotion of schooling in crafts-oriented professions.

The goal of the museum was to improve the quality of contemporary crafts.[34] The school for crafts, which adjoined the exhibition galleries, was the true heart of the institution. The central mission of the institution, called the German Trade Museum from 1868 on, was education, aided by visual examples from the collections.[35]

The building in the Prinz Albrecht Strasse, constructed by Gropius and Schmieden from 1877 to 1881, finally made it possible to house the collections in appropriate surroundings. They had grown by extensive donations, in part from the royal Kunstkammer. At the groundbreaking for the building, the institution, called the Kunstgewerbemuseum since 1879, was not yet under the general management of the royal museums, even though it had long been supported by the state, which had financed the building. The funding for museum and school came from the ministry for trade, crafts, and public works, not the ministry of culture.[36] It was taken over by the state and included in the royal collections only in 1885. The didactic character of the collections and the school remained intact.

The joining of museum and school, as well as the fact that the crafts were considered part of the so-called useful or applied arts, meant that the museum did not enjoy the same prestige as the art collections on the Museum Island. Incorporation of this collection with the other museums on the Island was therefore never considered.

The Kaiser Friedrich Museum and the Pergamon Museum

With the completion of the Nationalgalerie, the Museum Island could have been completed as well. A complex had been built that could house art and cultural monuments from Egyptian times to the present. But the most dynamic phase of the Berlin museums only began with the proclamation of the German empire. I would like to mention a few reasons for that here only as an aside—they are not important to my examination, although of crucial significance for the development of the collections themselves.

The economic upswing of the Gründerzeit encouraged private collections of very high quality, critically supported by Wilhelm Bode. One factor was the war reparations imposed on France. They contributed to economic crises there, making it possible for German and American collectors to acquire important works of art on the art market. Also, aristocratic families in Italy and England who had incurred debt, in particular because of the import of inexpensive American wheat, tried to recover economically by selling works of art. German museum professionals profited as well, especially Wilhelm Bode, who was instrumental in acquiring sculpture and painting for the Prussian museums from 1872 on. Additional factors were new structures in the art market, the administration of museums, and the sciences.

This remarkable expansion of the art holdings in Prussia would not have been possible, though, without the intrinsic willingness of emperor and government to increase the Prussian collections so that they could compete with other European capitals in quantity and quality. The works of art on the Museum Island after the proclamation of the empire in 1871 were certainly not on a par with holdings in Munich, Vienna, Paris, or London. Within just over forty years, however, from 1871 to World War I, the Berlin museums, in a burst of activity, compiled a treasury of works of art equal to that of the other European metropolises.

Once the national leadership of Germany was held by Prussia, the museum politics of the German empire dictated two approaches to achieving the goal of joining the ranks of the cultural capitals. First, the quality of the collections had to be improved as well as their display. Second, the collections were to reflect the status of the empire, to testify to the empire's global, imperial claims. On both levels, the government supported efforts at home and abroad in many ways.

For the Museum Island itself these political aims meant further expansion. With the completion of the Kaiser Friedrich Museum and the Pergamon Museum at the beginning of the twentieth century, two buildings now

stood in which the museum politics of the empire would achieve its cultural zenith. The first building had holdings in Western art, assembled with scholarly expertise; the other the enlarged collections of Greek and Roman culture and the recently added cultures of the Near and Far East.

In 1882 the decision was made to combine all the great art collections on the Museum Island. Two years later, in 1884, a competition prompted a fierce debate.[37] Some separately submitted projects were evaluated, but it remained unresolved whether a new building for the collection of antiquities was desirable or if modern sculpture and paintings should be given a new home, as they were now housed in the Altes Museum in much too crowded surroundings and not exhibited thematically.

The competition brought on heated disagreements between the department heads and the general director of the museums, Schöne. The tip of the island was going to be the location for a new building for sculpture and painting from the beginning of Christianity. Bode and his colleagues, however, suggested a building site outside the Spree island. They preferred a location opposite the Gropius building. Bode supported his argument by saying that contemporary art should be housed near the crafts of the same period.[38]

After Bode's presentation, Schöne prevailed over his colleagues. His opinion was that the high cultures should remain together on the Museum Island. The museum pragmatists and the directors anticipated further growth of the collections and searched for realistic solutions with an eye toward the future. Schöne, however, clung to the thinking of the previous era: to realize a coexistence of high cultures on the Museum Island.[39]

As usual the plans for the new buildings, aside from debates about their design, were accompanied by objections and by setbacks due to lack of funding. The ministry of finance was not at all helpful with support for the suggested projects, which at first concentrated on the construction of a new building for a museum of antiquities, necessitated in part by the Pergamon Altar. Schöne was able to strengthen his position by threatening to resign and then retracting

his request, but only in the 1890s could the plans be realized which Fritz Wolff had drafted for the Pergamon Museum.

Various conflicts of interest and intrigues led to a temporary stalling of the plan for a new building for the Pergamon Altar, in favor of the so-called Renaissance museum. Bode evidently had great influence over the course of events through Frederick's empress.[40]

When Frederick III died in 1888, the museums lost their most avid supporter. William II nonetheless quickly became a direct participant in the further development of the Museum Island. It was his decision that immediately prompted two new buildings, both begun in the 1890s. From 1897 to 1899 Fritz Wolff completed the Pergamon Museum, the so-called interim building (fig. 11).[41] Concurrently, in 1897, Ernst Eberhard von Ihne began the most ambitious building yet, the Kaiser Friedrich Museum, which is today the Bode Museum (figs. 12, 13).

This celebrated structure of the German imperial era occupied the upper northern tip of the Museum Island between Spree and Kupfergraben. It was opened to the public with lavish ceremonies in 1904. The building, as I have discussed elsewhere, differs from the earlier classicist structures. It is unique in reiterating Prussian architectural forms of the seventeenth and eighteenth centuries. Its exterior resembles a city palace and demonstrates the largesse of the reigning Prussian monarch. The interior also reflects the royal donation with Bode's conception of a mixture of sculpture and paintings, displayed in huge banquet halls. With the Kaiser Friedrich Museum, the Prussian king and German emperor had commissioned a museum that rivaled the Kunsthistorisches Museum in Vienna, completed in 1892, or the older collections in Munich, Paris, Saint Petersburg, and London.

The Kaiser Friedrich Museum did not bring building activities to conclusion. During construction it became apparent that certain newly established departments, such as that for Islamic art, could not be accommodated for lack of space. The interim building was not large enough for the Pergamon Altar. The renewal and expansion of the Pergamon Museum were therefore energetically pur-

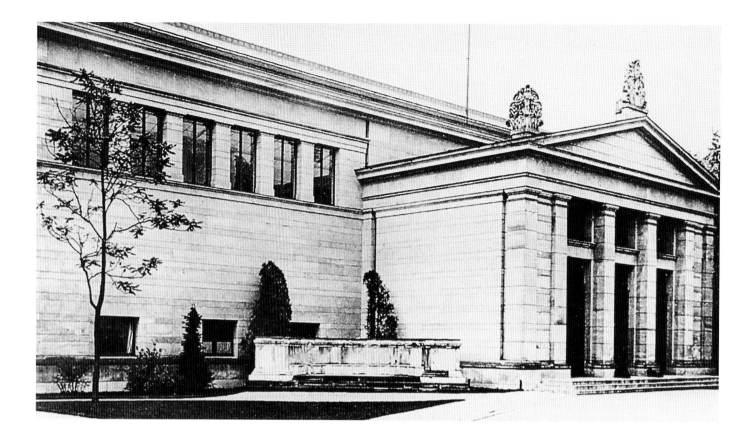

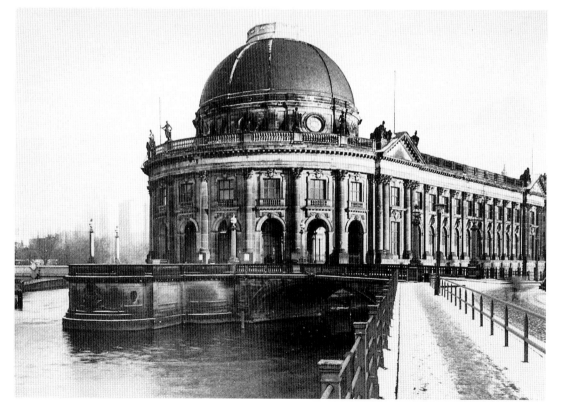

11. Fritz Wolff, Interim Building (first Pergamon Museum), between 1899 and 1908, on the Museum Island
Photograph: Kunsthistorisches Institut, Freie Universität Berlin

12. Ernst Eberhard von Ihne, Kaiser Friedrich Museum (today Bode Museum)
Photograph: Kunsthistorisches Institut, Freie Universität Berlin

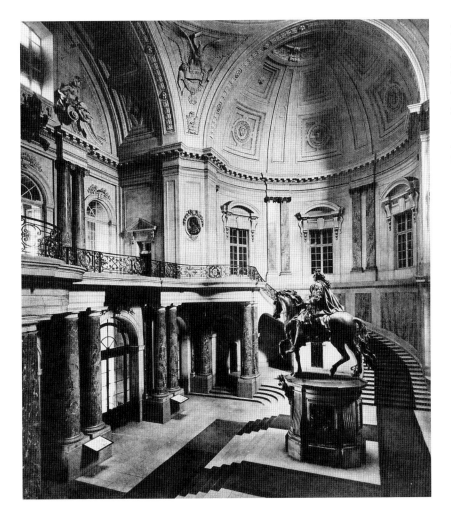

13. Kaiser Friedrich Museum, large staircase with the cast of the equestrian statue by Andreas Schlüter
Photograph: Kunsthistorisches Institut, Freie Universität Berlin

Museum Island that had evolved over a span of one hundred years. The Altes Museum, Neues Museum, Nationalgalerie, Kaiser Friedrich Museum, and Pergamon Museum were each built at different times, with differing artistic views. The museums were supported by monarchs who pursued divergent goals, and not governed by the pragmatic concern to award the growing collections a suitable, appropriate exhibition space. The question arises: what political and intellectual concerns caused first the Prussian, then the imperial political bodies to undertake the enormous expansion of the holdings?

The Role of Archaeology

The Museum Island in Berlin and two other museums located further out, the Kunstgewerbemuseum and the Völkerkundemuseum, were a result of German imperialism. Over several centuries, England and France, Holland and Italy had acquired foreign colonies, but the unification of the German states into the German Reich came too late to pursue such goals extensively. German Southwest Africa and a few other enclaves were the only colonies of an empire that had established a naval fleet too late to be able to participate fully in the exploitation of natural resources across the seas. Some efforts were made, however, which in turn benefited the ethnological collections.

In addition to these activities, it was the foreign policy of the German Reich to nurture diplomatic relations with the Near East, in order to increase its own industrial output and its exports and in competition with England and France. German engineers built roads and railroads in the Near East. Here, too, the growth in economic and technological exports affected the cultural realm, especially archaeology.

Enthusiasm for archaeological digs, privately undertaken by an engineer for road construction, resulted in the acquisition of the Pergamon Altar for the Museum Island. Carl Humann happened on the Pergamon sculptures while working on a project as an engineer; he began to excavate systematically in 1878 and transported his finds to Berlin in agreement with the Turkish government.

The Pergamon Altar was an academic

sued by Wilhelm Bode from 1905 on, when he became general director.[42]

The current Pergamon Museum, begun in 1912 by Alfred Messel, was only completed decades later, in 1930 (figs. 14–16). Its construction had been interrupted by World War I and then continued by Ludwig Hoffmann after Messel's death. The monumental building, also in the classical style, housed the Pergamon Altar and the Deutsches Museum in its north wing, and in the south wing the immeasurably rich contents of the Near Asian Museum. The Ishtar Gate and the processional road set a counterpoint to the altar from Pergamon (fig. 17). With the Pergamon Museum, construction finally ended on the Museum Island. Additional museum buildings were moved to other parts of the city, to Tiergarten and Dahlem.

In essence five museums, each featuring different fields of collecting, comprise the cultural-historically unique complex on the

sensation. Berlin was able to boast that it had won this masterpiece of the antique, equal only to the Parthenon frieze in London. Jacob Burckhardt claimed that "Berlin had become one of the foremost art pilgrimages of the world."[43] It has often been pointed out that the discovery of the Pergamon Altar caused a reevaluation of hellenism. For contemporary sculptors of the German empire, the altar was a definite source of inspiration and object of study. The neobaroque pathos of Reinhold Begas' works found an equivalent in the dramatically animated figures of the late antique.[44]

The enthusiasm for the Pergamon Altar even elicited comparison between a certain period in late antiquity and the German empire: just as the Attalides of Pergamon had overcome the demise of minor states, so the German empire had achieved the unification of Germany through Prussia.[45] Although this interpretation may be far-fetched, there cannot be any doubt that the acquisition of valuable cultural goods occurred for the glory of the Reich's capital.

It is of interest in this context how the Pergamon reliefs came to the Berlin museums. After Carl Humann had sent two relief sculptures to Berlin in 1872, accompanied by the request for permission for an archaeological dig, the two pieces initially remained at the depot, completely ignored.[46] Only the newly appointed director of the antiquities collection, Alexander Conze, recognized the quality of the fragments and supported further excavations. Negotiations were conducted with utmost discretion; the importance of the digs was minimized so the Turkish government would grant permission. The crown prince as protector of the museums helped plan the project, for which 50,000 Marks from the emperor's funds and 50,000 Marks of museum funds were made available. To ensure secrecy, the general administration of the museums was not informed.[47] The affair was conducted like a clandestine government mission. Within about one year, the reliefs had been transported to Berlin.[48] The extraordinarily successful excavation was celebrated as a triumph for German archaeology, and the Berlin museums now matched the most outstanding collections of antiquities, equal to London and Paris.

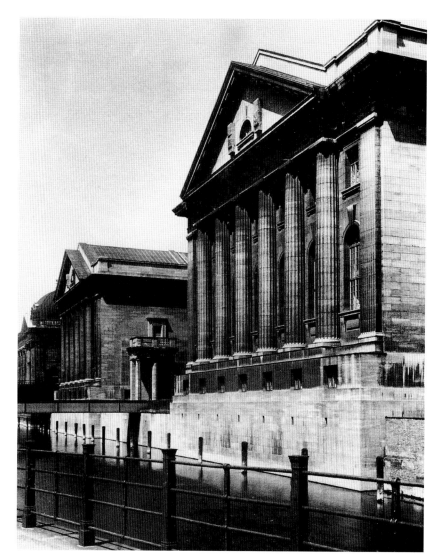

From today's viewpoint, of course, the dig was only a limited scholarly success. The road construction engineer Carl Humann must be considered an amateur archaeologist, despite his passion and even though he was acting with the best intentions and to his best knowledge. He was above all a treasure hunter, gaining professional experience only gradually as he excavated. The crown prince and the ministry of culture acted on instructions by the museum administration, on the recommendation of Alexander Conze, who deserves the credit for the first discoveries in Pergamon, and general director Richard Schöne. The museums were assured political backing for obtaining one of the most important cultural artifacts—spectacular finds of works of art helped the representational,

14. View of the Pergamon Museum with a temporary building for the entrance portico at the Deutsches Museum in the northern wing
Photograph: Kunsthistorisches Institut, Freie Universität Berlin

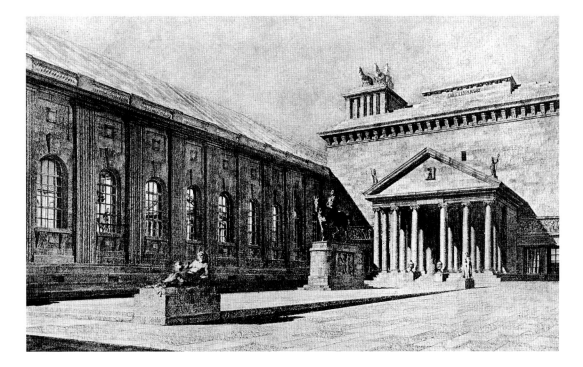

15. Alfred Messel, plan for the Pergamon Museum, 1907
Photograph: Kunsthistorisches Institut, Freie Universität Berlin

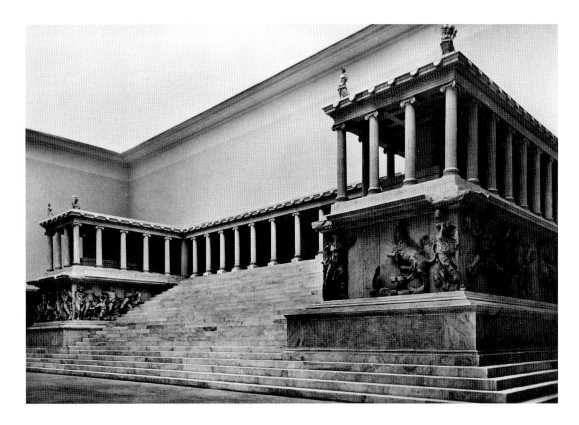

16. Pergamon Altar
Photograph: Kunsthistorisches Institut, Freie Universität Berlin

cultural-political goals of the empire. The imperial political forces were not afraid to leave a friendly government in the dark about their true intentions. On 5 January 1880, Emperor William I and Empress Augusta viewed the reliefs, which were layed out on the floor of the Altes Museum after their arrival in Berlin, as though they were trophies of a victorious military campaign.[49]

The excavation of the Pergamon reliefs was an inestimable boon to scholars. Their acquisition for the Berlin museums was praised, after successful completion of the mission, as a masterful political move for the glory of the empire. At the highest political level, in parliament, representative Heinrich von Sybel stated: "Gentlemen, the three-dimensional component of our collections, namely sculpture, has so far been of secondary importance. . . . By incorporating the Pergamon creations, our museum has instantly moved to the forefront of European collections."[50] Bismarck personally participated in negotiations with the Turkish government for permission to export the reliefs.

The Pergamon Altar was installed in a building constructed for that purpose, the so-called interim building. Raised by Fritz Wolff in 1879–1901, it was not large enough for the altar itself and the accompanying finds.[51] Also, the reliefs were installed in reverse order, just as the Parthenon frieze in London, for display indoors, contrary to the original installation. Nevertheless, the Pergamon Museum helped the Museum Island considerably in achieving national and international recognition.

The Pergamon Altar was the most magnificent find, but definitely not the only one and not even the one to captivate the public as much as Schliemann's excavations of Troy had and Ernst Curtius' since 1875 at Olympia. Supporting the excavations became a focus of imperial museum politics.

After his excavations in Troy in the early 1870s and the spectacular transport of the so-called treasure of Priam to Berlin, Heinrich Schliemann made his sensational discoveries of the Mycenaean culture in 1876. Although he did not find the funerary sites of Agamemnon and Clytemnestra, but instead, as we know today, far older graves, his contemporaries were enthusiastic about

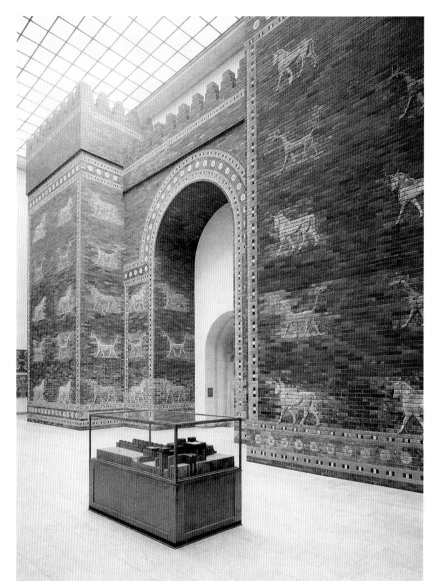

the results of his investigations. Schliemann had at first turned most of his finds over to the Greek government. While he had excavated on his own, at his own expense, the ministry of culture did supply funding for academically respectable, scholarly archaeologists. Foremost among them was Ernst Curtius. His excavations at Olympia were one of the most prestigious efforts of the German empire. Curtius had excellent rapport with Crown Prince Frederick and had been an instructor of his son, the future Emperor William II. The expensive venture enjoyed continual support not in small measure because of these superior connections.

The excavations at Olympia can be called

17. Ishtar Gate from Babylon
Pergamon Museum, Berlin; photograph: Kunsthistorisches Institut, Freie Universität Berlin

the academically most highly accomplished in the entire history of archaeology; they established new standards for the discipline. This achievement was possible only on the basis of state support, which was looked upon with pride as a cultural-historical pioneering effort of the German empire. One could read about "the systematic discovery of Olympia by the German empire" in detailed accounts about the results of the excavations.[52] The archaeological examinations were viewed almost as a national effort: "The excavations at Olympia, the first major peace effort of the newly established German empire and an enterprise to which every German citizen made a contribution, enjoyed the enthusiastic participation of the widest strata of the population from the beginning."[53]

The exploration of antique sites, their excavation and scholarly preparation, were therefore a "peace effort," contributing to the glory of the empire just as the military did, but on an intellectual and cultural level. Supported by widespread enthusiasm, Curtius founded the German Archaeological Institute in Athens, followed by comparable institutions in Rome, Cairo, Damascus, and Baghdad. They are subsidized to this day by the German foreign ministry, in continuation of the foreign policy of the German empire.

The collections of objects from ancient cultures had achieved international acclaim and become increasingly of interest to the general population. One vital factor in the exceptional growth of the holdings were highly qualified scholars such as Conze and Curtius, who were hired by Schöne. But the initiative did not always come from the museums. Like Humann, who had accidentally encountered his finds while pursuing work as a road construction engineer, and Schliemann, who became a treasure hunter from personal enthusiasm, other independent scholars requested funding from the state for their excavations. The experts did not always condone their proceedings. But even against the advice of the museum administration and the German Archaeological Institute, support was granted by the emperor. A typical example of subsidies given by Emperor William II personally was the allocation of funds to the independent scholar Ohnefalsch-Richter, who excavated on Cyprus in the

1880s without the approval of the experts. The official interest in the growth of the museums sometimes outweighed scholarly prudence.[54]

In the Near East a virtual fight ensued for the prestigious permission to excavate in certain prime areas. The archaeologists were able to ask diplomatic representatives for help with their negotiations, since the governments of the European superpowers considered scholarly exploration and the glory of winning the monuments for their own collections a political power ploy. German archaeologists, for example, tried in vain to continue the excavations in Didyma, which had been abandoned by the French. An objection by the French ambassador to Turkish officials prevented this pursuit by Germany. Even though the excavations were on hold, the French were not willing to give up any archaeological soil they had "conquered."[55]

Theodor Wiegand continued the work of Conze and Curtius in the next generation. After Humann's death, he successfully directed the excavations at Priene before beginning major work in Milet, which continued over many years. Wiegand had excellent connections to the emperor, and, as son-in-law of Georg von Siemens, also had access to influential German business circles, whose chief representatives supported the archaeological efforts wholeheartedly.[56] Von Siemens, as director of the German Bank, played a substantial role in building and operating the Anatolian railroad. He traveled through Turkey in 1898, accompanied by the emperor, to attend the inaugural ceremonies for the Konya line. On this occasion, von Siemens visited the excavations in Priene and met Wiegand there. Wiegand was a key figure in keeping close ties between economic and political interests to assure the support of scholarly investigations and excavations in the Near East. Because of his diplomatic abilities he succeeded in establishing good rapport with Turkish officials. He was able to transport a large part of the excavated monuments to Berlin, thereby greatly contributing to the expansion of the Berlin museums.

It was Wiegand's decision to accept not only sculpture and selected pieces of ornamental jewelry, but also architectural fragments for the collections. His idea to expand

the Pergamon Museum into a museum for architecture was finalized in 1906 with the permission to transport and install the Market Gate of Milet. Importing such monumental architecture, which seems preposterous to us today, naturally necessitated further spatial expansion. Messel responded with his design for the new Pergamon Museum in 1909, which was, however, completed only after many years of debate with Ludwig Hoffmann.

The vast dimensions that the collections had taken on did not go uncriticized. Scheffler, in his polemic of 1921, stated that the museums were wrong to collect for historical cohesion and not according to strict guidelines for artistic quality: "Our time demands large representative museums, and the museum leadership in Berlin has responded with truly passionate speed, always spurred by the emperor's lust for glamor."[57] Scheffler directed this criticism not only to the collections of antiquities, but especially the Oriental collections, which had grown since the turn of the century by extremely valuable additions from Didyma and Baalbek.

The Near Eastern Collections

German interests were not limited to Greek cultural sites; archaeologists forged ahead to Mesopotamia, the Land of the Two Rivers, the cradle of humanity. The founding of the German Orient Society in 1898 encouraged expeditions to areas in the Near East that had previously remained largely unexplored.[58] During William II's trip to Palestine, which was planned with great pomp, the emperor made an excursion beyond Beirut to visit the ruins in Baghdad and Baalbek, indicating that the government and the emperor himself were interested in the exploration of these early high cultures.[59]

The excavations by the German empire from the 1880s to World War I had probed further into the Near East, so that additional new buildings on the Museum Island became inevitable. Bode had already utilized a large part of the available space in the Kaiser Friedrich Museum for the Oriental collections: the donation of the Mshatta façade and the new Islamic department. With the excavations in Mesopotamia, the discovery of Nineveh and Babylon by German archae-ologists, and the export of massive architectonic fragments to Berlin, another addition to the museum became necessary after 1900.

After Bode became general director in 1905 and completed the project closest to his heart, the Kaiser Friedrich Museum, he fought for years for the realization of the last huge building complex, the new Pergamon Museum, begun by Alfred Messel in 1912 and completed by Ludwig Hoffmann only in 1930. He substantiated the necessity for further expansion in a memorandum as follows: "Completely new, formerly unanticipated areas of collecting have become accessible: with the extraordinary success of the excavations in Mesopotamia the extensive field of Near Asian art; with the immense finds in Baalbek, Milet, Didyon, and so forth the expansion of the antiquities collections in architecture and the decorative arts; and with the donation of the Mshatta façade the wide-ranging art of Islam." Finally, he attempted to reinstall German sculpture of the Middle Ages and to create a German museum in the new building. "In addition to the necessity of procuring space for all these needs, I also feel obligated to ask for a new museum for older German art—not least for nationalistic reasons."[60]

According to chronology, the Near Asian department of the Berlin museums was installed before the Islamic, which was founded by Bode only in 1904. The German Orient Society supported excavations and scholarly evaluation of the finds in the Near East with the help of governmental and also substantial private funds. The highlight of the finds in Mesopotamia was the excavation of Babylon by Robert Koldewey. The processional road, the Ishtar Gate, and the front of Nebuchadnezzar's throne room reached Berlin because of Koldewey's efforts before the outbreak of World War I and became the foundation for the world fame of the Near Eastern collections.[61]

Conclusion

With the opening of the Pergamon Museum in 1930, the Museum Island was completed. The unique complex had been built within one hundred years. The historically evolved *Gesamtkunstwerk* owes its distinction architecturally and in terms of its collections

to the greatest breadth of aims. While the Altes and the Neues Museum had inaugurated the museums' educational and didactic mission, the Nationalgalerie was also a symbol for the national leadership Prussia wanted to assume in politics and the arts. The arts received support, but in turn had to represent the state, a duality that remained characteristic for the empire.

From the inception of the German empire, the museums had grown parallel to the rank that Prussia, with Berlin as its capital, wanted to demonstrate to the Reich and the world. Its military strength, proven by the military campaign against France, was to be equaled by its economic strength and cultural achievements in order to make the empire a European superpower. The Kaiser Friedrich Museum and the Pergamon Museum were entities visible to the world at large, confirming that Prussia and the German empire were emerging nationally and internationally as cultural centers of world class.

The Museum Island received its most significant support during the German empire. Without the expansion of the collections from that time period and the establishment of the two monumental buildings, the museums would have remained at the level of provincial capitals such as Kassel, Karlsruhe, Frankfurt, or Stuttgart until 1870. The empire, however, wanted world fame, wanted to be competitive with Paris and London.

This goal could only be attained because several factors coincided. The ambition of the rulers—Frederick III and William II personally participated in the expansion of the Museum Island, often enough against considerable resistance from their ministers—and the economic prosperity of the Gründerzeit worked to their advantage. The nation participated by staffing the museums with qualified civil servants and by providing considerable acquisition budgets, but world class status was possible only through sponsorship from private industry. The German Orient Society or the Kaiser Friedrich Museum Society helped the government with excavations and acquisitions for the expansion of the museums. These societies, over which the emperor himself presided, counted among their members the most distinguished entrepreneurs of the empire.

A separate investigation of the close relationship between government, economy, and academia would be worthwhile. It is certain that this connection and partnership proved most profitable for all involved. Good diplomatic relations with Turkey and the Arab sheikdoms were politically important to counterbalance English, French, and Russian influence. They were of the highest importance economically, by allowing the German Reich a leading and profitable role in the construction of roads and rail lines from Turkey to Persia. It should be mentioned again that Carl Humann arrived at Pergamon as a road construction engineer and that the Mshatta façade needed to be moved to make room for the railroad to Mecca.

After Bismarck's dismissal in 1890, foreign policy under Caprivi focused even more on worldwide concerns. Colonial politics and the fleet gained importance. William II tried to attain political recognition for the German empire by fostering strong economic ties especially in the Near and Middle East, but later also in China and Japan.

Expansion on the Spree island, which led to a multicultural museum complex, was the consequence of these successful political efforts. The sciences in Germany profited also, especially Egyptology, archaeology (particularly in the Near East), art history, and ethnology. By supporting the excavation campaigns, acquiring the finds, and not least by scholarly evaluation and publication of the results, the museums earned an internationally recognized, acclaimed role in museum and scientific history.

It is not coincidental that the term *Kulturpolitik* was coined just after 1900.[62] Cultural politics had already been practiced decades earlier. The museums were supported by the state, and in turn allowed the government public visibility of certain political goals. It is impossible to distinguish or prove which of the two initiated this. It would not suffice to accuse the monarchs of the German empire and the ministerial bureaucracy of self-aggrandizement and interference in the affairs of the museum administration. The process was much more complicated. Often, if not always, the initiative for acquisitions, excavations, or the establishment of entire departments came from the museums.[63] The pursuit of aca-

demic and artistic interests by the museum staff grew parallel to political developments. The foundation for actions taken jointly seems to have been a tacit, perhaps unconscious agreement of mutual assistance. Bode in particular, according to Stephan Waetzoldt, "felt responsible for unison between the world-political and museum-political goals of the German empire. It was he who turned Prussian state museums into institutions of worldwide acclaim."[64] However, there were boundaries by which the museum administration had to abide. Acting against the interests of the monarch and his political goals was strongly discouraged. The directors of the Nationalgalerie were especially affected by this stipulation.

The evolution of the Museum Island mirrors the evolution of Prussia, from a territorially limited dukedom to kingdom and later the German empire. From a modest, provincial ducal collection in 1830, far inferior to the treasures in the Munich Pinakothek, a museum emanated that housed cultural collections of distant countries comparable to the treasures of the Acropolis. But in stark contrast to the remarkable import of education and culture at the height of the empire stood an unusual weakness in its own cultural production. While the emperor supported and fostered the acquisition of works of art from the past for his personal glory, he suppressed every attempt at a renewed emergence of modern art in his own country.[65]

Maximilian Harden, one of the most aggressive critics of William II, recognized this conflict and commented on it repeatedly. In 1902 he wrote in *Die Zukunft*:

We have hoarded treasures from all cultures, but we have no culture of our own, we do not have the courage to close the gap between dogma and life. . . . Ideals cannot be imported; they cannot be ordered for money, not from Plato or from Krupp. Other cultures had Hellas and Rome, Florence and the Medici. That is how they shaped their ideals and were able to leave us art that impressed its essence on even the most insignificant object.[66]

William II often publicly expressed his views on art and culture. His ideals stemmed from sanctioned academic principles. Works of art should reflect the mastery of one's craft; compositions should be laid out to achieve harmony and pleasure, and their themes should be entertaining or morally uplifting. The emperor coined the famous expression "art from the gutter," which was directed at socially critical painting and sculpture as well as any modern forms of expression.

The monarch's opinions were shared by many, if not all, of his subjects. The middle class, which was especially interested in cultural matters, prized these values. It is really their accomplishment, based on their humanistic education, to have rediscovered, excavated, preserved, and studied previously lost high cultures, and promoted them in our consciousness to the present day as cultural heritage.

The achievement is tainted, however, by its dual purpose as nationalistic imperative. German cultural endeavors propagated superiority in Europe and the Near and Far East in economic matters, the sciences, the military, and the arts. This aim was at the root of the pursuit of political power and taking possession of the monuments of other civilizations. The rescue and conservation of the collected treasures occurred with the self-certainty and presumptuousness that one's own culture was superior to others. "Many German intellectuals considered it their calling to administer the cultural heritage of mankind," wrote Thomas Nipperdey.[67] This sentence accurately describes even the most qualified professional staff of the Berlin museums.

Evidently the efforts and accomplishments of rediscovering past civilizations obscured the emperor's and most citizens' ability to recognize internal tensions at home. Impressionism, foreign art in general, and specifically French art found their way into the halls supported by the official *Kunstpolitik* of the empire only with great difficulties. The museum director Hugo von Tschudi opposed the regimentation and imperial interference in his institution. With his dismissal, a conflict became apparent that would lead to fatal consequences in German museum history.

NOTES

This paper was translated by Ulrike Mills.

1. The term *Kulturpolitik* seems to have been coined only after 1900, especially in conjunction with the support of foreign politics. See Rüdiger vom Bruch, *Weltpolitik als Kulturmission: Auswärtige Kulturpolitik und Bildungsbürgertum in Deutschland am Vorabend des Ersten Weltkrieges* (Paderborn, Munich, Vienna, Zurich, 1982). For the meaning of the term culture around 1900, see *Kultur und Kulturwissenschaften um 1900: Krise der Moderne und Glaube an die Wissenschaft*, ed. Rüdiger vom Bruch, Friedrich Wilhelm Graf, and Gangolf Hübinger (Wiesbaden, 1989); Kurt Düwell, "Geistesleben und Kulturpolitik des Deutschen Kaiserreiches," in *Ideengeschichte und Kunstwissenschaft im Kaiserreich*, ed. Ekkehard Mai and Stephan Waetzoldt; Gerd Wolandt, *Kunst, Kultur und Politik im Deutschen Kaiserreich*, vol. 3 (Berlin, 1983), 15–30. An examination of the role of the museums, which play a decisive part in defining the ideas of one's own culture as well as foreign ones, is still much needed. The lack of research in this area is particularly lamentable for the era of the German empire. The publications above do not mention the museums, either as institutions with the purpose of collecting or as academic ones.

2. For architectural history see especially Paul Ortwin Rave, *Karl Friedrich Schinkel, Berlin I. Bauten für die Kunst, Kirchen, Denkmalpflege*, in Schinkel, *Lebenswerk* (Berlin, 1981); Volker Plagemann, *Das deutsche Kunstmuseum, 1790–1870* (Munich, 1967), 66–81.

3. See Reinhard Wegner, "Die Einrichtung des Alten Museums in Berlin, Anmerkungen zu einem neu entdeckten Schinkel-Dokument," *Jahrbuch der Berliner Museen* 31 (1989), 265–287.

4. Paul Wescher, *Kunstraub unter Napoleon* (Berlin, 1976).

5. Peter Böttcher, *Die Alte Pinakothek in München* (Munich, 1972).

6. Formulated by Schinkel and Waagen in the Denkschrift of 1828. See Friedrich Stock, "Urkunden zur Vorgeschichte des Berliner Museums," *Jahrbuch der Preussischen Kunstsammlungen* 51 (1930), 206.

7. Alfred Woltmann, *Die Baugeschichte Berlins bis auf die Gegenwart* (Berlin, 1872), 179; see also Renate Petras, *Die Bauten der Berliner Museumsinsel* (Berlin, 1987), 42.

8. It would be worthwhile to examine separately how the self-imposed assignment of the authoritarian state to promote educational goals was an incentive for cultural politics. See Hagen Schulze, "Die preussischen Reformen und ihre Bedeutung für die deutsche Geschichte," in *Wir sind was wir geworden sind* (Munich, 1987), 63–87.

9. Petras 1987, 49.

10. *Festschrift zur Feier ihres 50jährigen Bestehens am 2.8.1880: Zur Geschichte der Königlichen Museen in Berlin* (Berlin, 1880), 53.

11. Petras 1987, 54–76.

12. For the history of Egyptology in Germany, see Hannelore Kischkewitz, "Die Ägyptologen Richard Lepsius, Heinrich Brugsch und Georg Ebers und ihre Stellung zu Zeitfragen," *Forschungen und Berichte* 20–21 (1980), 89–100.

13. For the interpretation of Kaulbach's frescoes, see Werner Busch, "Wilhelm von Kaulbach—peintre-philosophe, und modern painter: Zu Kaulbachs Weltgeschichtszyklus im Berliner Neuen Museum," in *Welt und Wirkung von Hegels Ästhetik*, ed. Annegret Gethmann-Siefert and Otto Pöggeler (Bonn, 1986), 117–138.

14. Paul Ortwin Rave, *Die Geschichte der Nationalgalerie Berlin* (Berlin, 1968); Dieter Honisch, *Die Nationalgalerie Berlin* (Recklinghausen, 1979); Petras 1987, 78–92.

15. Cited in Petras 1987, 78. See also the reference to an anonymous critic in 1832 who regretfully said, "there is no room for a modern gallery."

16. Rave 1968, 4.

17. The project evidently failed for financial reasons. See Rave 1968, 10; Petras 1987, 79.

18. Petras 1987, 79–80.

19. Karl Scheffler, *Berliner Museumskrieg* (Berlin, 1921), 105–106.

20. The reasons for his resignation are not completely clear. The official word was that Jordan left office for health reasons. This is probably only half true, as must be concluded from several sources. Ludwig Pallat, *Richard Schöne, Generaldirektor der Königlichen Museen zu Berlin* (Berlin, 1959), 249; Petras 1987, 128.

21. Regarding these events, see especially Peter Paret, "The Tschudi Affair," *Journal of Modern History* 53 (1981), 589–618. About the role and influence of Tschudi as director of the Nationalgalerie, especially his policy of acquisitions, see Barbara Paul, *Hugo von Tschudi und die moderne französische Kunst im Deutschen Kaiserreich* (Mainz, 1993).

22. Unfortunately there is no extensive examination available for the activities of Frederick III as protector of the Berlin museums, based on existing sources. See Peter Bloch, Henning Bock, et al., *Kaiser Friedrich III. und sein Museum* [exh. cat., Gemäldegalerie] (Berlin, 1988).

23. See Pallat 1959, 130–132.

24. See Sigrid Westphal-Hellbusch, "Hundert Jahre Museum für Völkerkunde Berlin: Zur Geschichte des Museums," *Baessler-Archiv, Beiträge zur Völkerkunde*, Neue Folge 21 (1973), especially 2–6. Richard Schöne, the general director, clearly stated this realization in his contribution to the Festschrift for the royal museums in 1880:

Even the ethnologic and prehistoric collections, which may have seemed like an accumulation of curiosities fifty years ago, have now been elevated as study materials, analogous to our collections of

natural history, and promise to produce knowledge the potential of which it was then not possible to estimate.

Richard Schöne, "Die Gründung und Organisation der Königlichen Museen," in *Zur Geschichte der Königlichen Museen in Berlin. Festschrift zur Feier ihres 50jährigen Bestehens am 3. August 1880* (Berlin, 1880), 49.

25. *Festschrift* 1880, 56.

26. Westphal-Hellbusch 1973, 4.

27. A good overview of the history of the expansion of the collections can be found in *Die Berliner Museen* (Berlin, 1953), 125–136.

28. Bismarck's colonial efforts not coincidentally also began in the 1880s. See Klaus Hildebrand, "'System der Aushilfen'? Chance und Grenzen der deutschen Aussenpolitik im Zeitalter Bismarcks (1871–1890)," *Jahrbuch der Stiftung Preussischer Kulturbesitz* 27 (1990), 452–463.

29. For the further development of the Museum für Völkerkunde, plans for its expansion in Dahlem and its refurbishing after World War II, compare Westphal-Hellbusch 1973, 6–99.

30. Scheffler (1921, 8) even spoke of the "correct instinct that the ethnographic and the artistic interests are irreconcilable."

31. See Wilhelm von Bode, *Mein Leben* (Berlin, 1930), 2:168–171.

32. Westphal-Hellbusch 1973, 27. In contrast, Scheffler (1921, 16) stated: "Works of art do not belong in the Museum für Völkerkunde, no matter which time or nation they stem from; they must be isolated and combined with their own."

33. Compare in this context the informative discussion about the exhibition *High and Low: Modern Art and Popular Culture* [exh. cat., Museum of Modern Art] (New York, 1990), as well as the essays in the catalogue and the reader *Modern Art and Popular Culture: Readings in High and Low*, ed. Kirk Varnedoe and A. Gopnik (New York, 1990).

34. *Die Berliner Museen* 1953, 97–108. Compare especially Barbara Mundt, *Die deutschen Kunstgewerbemuseen im 19. Jahrhundert* (Munich, 1974).

35. See V. Scherer, *Deutsche Museen: Entstehung und kulturgeschichtliche Bedeutung unserer öffentlichen Kunstsammlungen* (Jena, 1913), 209–216.

36. Since 1879, however, areas of responsibility changed in the ministries; see Pallat 1959, 128.

37. *Concurrenzentwürfe wegen Bebauung der Museumsinsel zu Berlin* (Berlin, 1884); Pallat 1959, 164–170. The competition deserves an in-depth monograph. Essential is the description of the situation at its inception and the analysis of selected projects by Stephan Waetzoldt, "Bauten der Museumsinsel," in *Berlin und die Antike* [exh. cat.] (Berlin, 1979), 361–374.

38. Bode 1930, 1:190.

39. Bode's description of the events was questioned in Pallat 1959, 165.

40. Compare Bode's description of the events in Bode 1930.

41. Petras 1987, 122–126.

42. Petras 1987, 138–150.

43. Cited after Max Kunze, "Carl Humann—Vom Ruhm und Nachruhm eines deutschen Ausgräbers," in *Forschungen und Berichte* 31 (1991), 154.

44. Peter Bloch, "Die Berliner Bildhauerei des 19. Jahrhunderts und die Antike," in *Berlin und die Antike* [exh. cat.] (Berlin, 1979), volume of essays, 395–429.

45. Kunze 1991, 154; see also Hans-Joachim Schalles, *Der Pergamonaltar: Zwischen Bewertung und Verwertbarkeit* (Frankfurt, 1986).

46. Pallat 1959, 137. Ernst Ludwig Curtius visited Humann in Pergamon in October and saw the excavation sites. See *Ernst Curtius: Ein Lebensbild in Briefen*, ed. Friedrich Curtius (Berlin, 1903), 615–617.

47. Pallat 1959, 138.

48. Compare Bode 1930, 1:178.

49. Bode 1930, 1:178–179.

50. Cited after Schalles 1986, 10.

51. Petras 1987, 122–126.

52. A. Boetticher, *Olympia: Das Fest und seine Stätte, nach den Berichten der Alten und den Ergebnissen der deutschen Ausgrabungen* (Berlin, 1886), 3.

53. Boetticher 1886, 4.

54. Pallat 1959, 236–238.

55. Theodor Wiegand, "Halbmond im letzten Viertel," Archäologische Reiseberichte, *Kulturgeschichte der Antiken Welt* 29 (Mainz, 1985), 25.

56. The excavations in Milet were begun with the consent of the emperor in 1899, using imperial funds. Compare Wiegand 1985, 40.

57. Scheffler 1921, 47.

58. If one follows Wiegand, the German Orient Society seems to have been far less considerate of Turkish national sentiments. See Wiegand 1985, 76–77, and Bode 1930, 2:189–190.

59. An extensive report, of theological orientation, however, can be found in *Das deutsche Kaiserpaar im Heiligen Land im Herbst 1898* (Berlin, 1899).

60. Bode 1930, 2:239.

61. The excavations, which spanned years, are described in Robert Koldewey, *Das wieder erstehende Babylon: Die bisherigen Ergebnisse der deutschen Ausgrabungen* (Leipzig, 1913).

62. See Manfred Abelein, *Die Kulturpolitik des Deutschen Reiches und der Bundesrepublik Deutschland: Ihre verfassungsgeschichtliche Entwicklung und ihre verfassungsrechtlichen Probleme* (Cologne and Opladen, 1968); "Interne Faktoren auswärtiger

Kulturpolitik im 19. und 20. Jahrhundert," in *Materialien zum Internationalen Kulturaustausch*, ed. Kurt Düwell (Stuttgart, 1981). A thorough analysis of the museums as institutions for cultural politics remains to be undertaken. Compare also note 1.

63. See Wilhelm Waetzoldt, "Die Staatlichen Museen zu Berlin 1830–1930," *Jahrbuch der Preussischen Kunstsammlungen* 51 (1930), 191:

The Berlin museums are governmental institutions. The state supports them, considers them one of the noblest forms of representing its cultural politics; they are for the enjoyment and education of the public. The museum professional is a civil servant; some of the spirit of governmental order pervades his daily work and sharpens his sense of responsibility toward the public. The firm organizational structure of the Berlin museums can be understood considering their character as "state organizations."

64. Stephan Waetzoldt, "Museumspolitik—Richard Schöne und Wilhelm von Bode," in *Kunstverwaltung, Bau- und Denkmalpolitik im Kaiserreich*, ed. Ekkehard Mai and Stephan Waetzoldt (Berlin, 1981), 490. It would be a worthy topic of research to examine this cooperation, with the help of the now more easily accessible archives.

65. See especially Peter Paret, *Die Berliner Secession, die moderne Kunst und ihre Feinde im Kaiserlichen Deutschland* (Berlin, 1981).

66. Maximilian Harden, "Kaiserpanorama, literarische und politische Publizistik," *Die Zukunft* (4 January 1902), ed. Ruth Greuner (Berlin, 1983), 244–245.

67. Thomas Nipperdey, *Deutsche Geschichte, 1866–1918*, vol. 1, *Arbeitswelt und Bürgergeist* (Munich, 1990), 814.

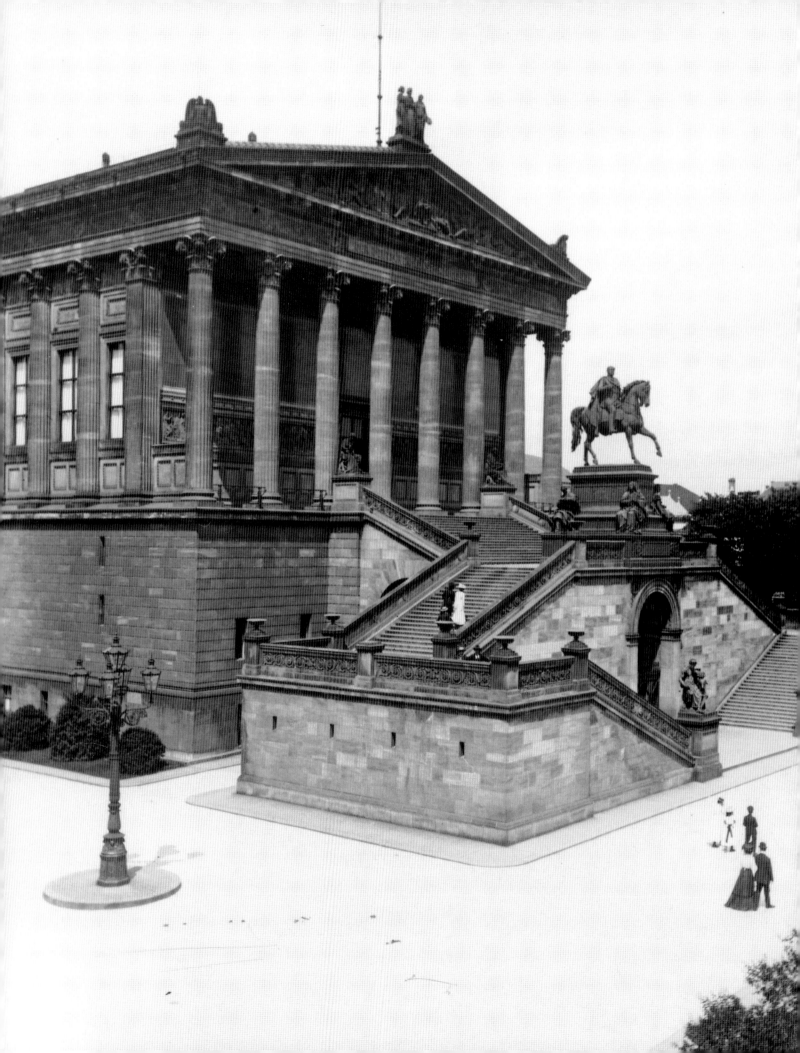

FRANÇOISE FORSTER-HAHN
University of California, Riverside

Shrine of Art or Signature of a New Nation? The National Gallery(ies) in Berlin, 1848–1968

At a time when recent events in eastern Europe, the former Soviet Union, and specifically in Germany, have stirred heated debate about the values and meaning of nationalism and the nation-state, it seems timely to focus the lens of critical analysis on the complex interrelationships between a country's notions of nationalism and its cultural institutions.

During the past twenty years, historical discourse on the ideas, origin, and history of *nationalism* and *nation-state* has not only reexamined their philosophical roots, but has also emphasized the driving forces these ideological constructs exercised in the building of nineteenth-century Europe. As products of Enlightenment philosophy, the concepts of *nation* and *nationalism* demarcate the conjunctions of political and social structures in late eighteenth-century Europe, the science and writing of history, and the rapid emergence of the cultural institutions that came to represent these new concepts. An intellectual artifact, an invention of the human mind and imagination, the concept of nationalism could only play its dominant role in the shaping of modern Europe because it is rooted in the concrete reality of its history, as Eric Hobsbawm so succinctly formulated it in his recent book, *Nation and Nationalism since 1780*: "Concepts, of course, are not part of free-floating philosophical discourse, but socially, historically, and locally rooted, and must be explained in these realities."[1] Basing his definition on Ernest Gellner's now classic book, *Nations and Nationalism*, Hobsbawm emphasizes the congruence between political and national unit[2] and "the element of artifact, invention and social engineering,"[3] but also recognizes the fluctuations and transformations in any national identification; national identification, he insists, "can change and shift in time, even in the course of quite short periods."[4] Since the concept of nationalism is not constant, but rather shifts in response to ideological fluctuations and political transformations, its specificity is demarcated only by a certain moment in history within a distinct geographical location. If nationalism as intellectual construct shapes political thinking and ultimately political action, the politics of nationalism in turn effect continuous ruptures and shifts in the interpretation of national consciousness. If we understand nationalism not as a fixed and static principle but as a fluid process determined by its interdependency on both political theory and practice, we must also read national institutions as part of this fluid state. Hence the dynamics of nationalism shape and reshape the cultural institutions that represent national identity.

The impact upon institutions of these dynamics within the definition of nationalism and national identity has perhaps been nowhere greater and more convoluted than in modern Germany. Sixteen years ago at a

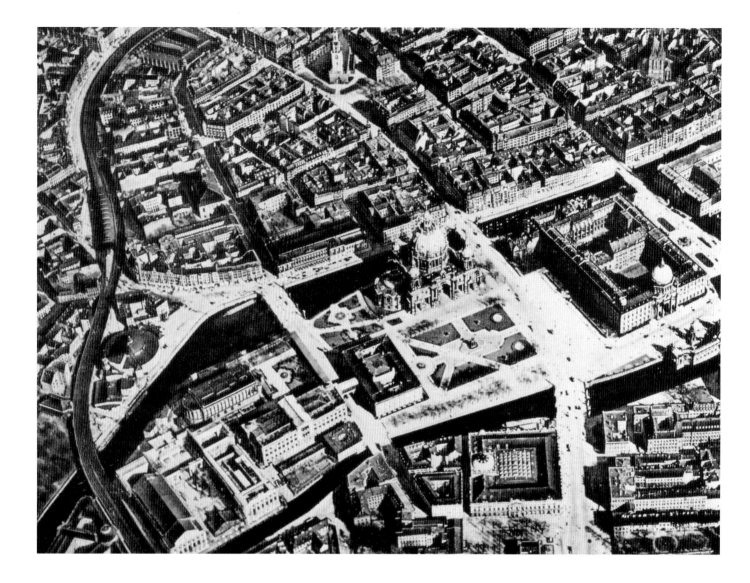

1. Museum Island, Berlin, c. 1920
Author's archives

conference on "Das kunst- und kulturge-schichtliche Museum im 19. Jahrhundert," the intellectual historian Rudolf Vierhaus mapped out the crossroads between the sci-ence and writing of history, social structure, educational system, and politics, demon-strating how new cultural institutions were part of a process in which Germans—frag-mented into many and diverse states—came to interpret national identity primarily as a cultural one, as a "Nationalkultur," which united them.[5] More recently, Thomas Nip-perdey traced the transformation that German nationalism underwent from the eighteenth to the closing decades of the nineteenth cen-tury, a period when nationalism became in-extricably intertwined with the process of unification, and with the shift from the con-cept of a nation united by its culture and

language to the ever more powerful objec-tive of political nation-state in the wake of the Napoleonic Wars. Thereafter, a liberal-national interpretation around 1848 gave way to an increasingly aggressive imperialist chauvinism that culminated in 1914.[6] The debates, planning, and ultimately the concep-tual and architectural design of the National-galerie in Berlin all bore the mark of this radical transformation in national self-un-derstanding. Through the course of a cen-tury and a half, political strategies as well as aesthetic ideals and prejudices shaped not only ideas about the *kind* of national gallery the Germans should have, but also actually determined the museum's architectural de-sign, the content of its collections, and the display of the artifacts.

Today's visitor who ventures to explore

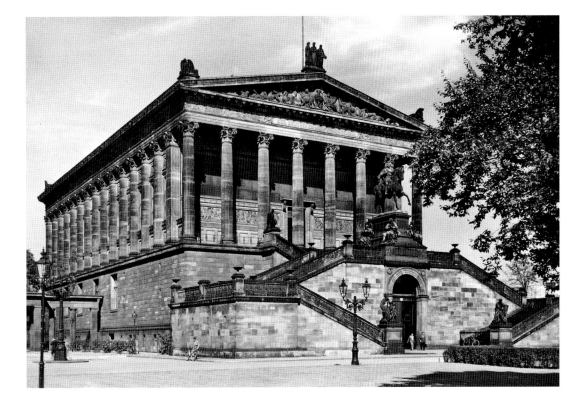

2. Friedrich August Stüler
and Heinrich Strack,
Nationalgalerie, Berlin,
1866–1876
Staatliche Museen, Preussischer
Kulturbesitz, Nationalgalerie,
Berlin

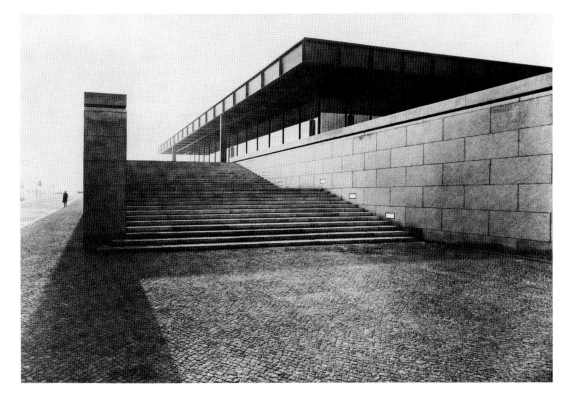

3. Ludwig Mies van der
Rohe, Neue Nationalgalerie,
Berlin, 1962–1967
Author's archives

Berlin's art collections faces two separate museum sites: the old Museum Island, formerly in East Berlin, and the new cultural center in West Berlin (fig. 1), both located at equally short distances from the former wall. When the city was divided in 1945, the art collections of the former State Museums shared the same fate. Whereas the old Museum Island still exhibits the deep scars of wartime destruction, the new cultural center, with Hans Scharoun's Symphony Hall and State Library, Mies van der Rohe's New National Gallery, and the new Museum of Arts and Crafts, resembles a construction site at the periphery of the old western section of the city. The two national galleries, August Stüler's building on the Museum Island (fig. 2) and Mies van der Rohe's in the former West (fig. 3), built a century apart and separated further by the dramatic events of world history, curiously enough share those key characteristics of their architectural concepts that conversely set them apart from their respective cultural environments. Each structure is elevated on a high base, is approached by way of elaborate stairs, centers on a giant hall, and is surrounded by open, yet firmly demarcated, space in celebration of monumentality. Indeed, Mies' design reiterates in modern terms the old idea of the national gallery as *monument*. That

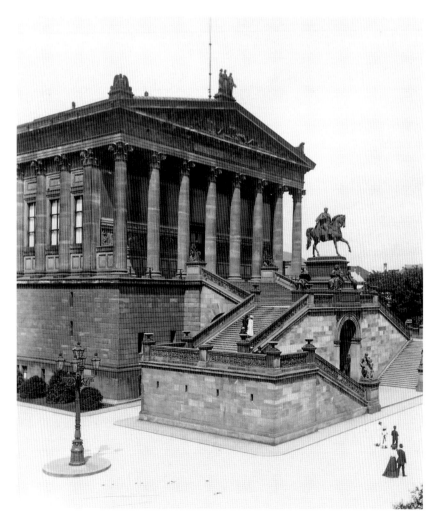

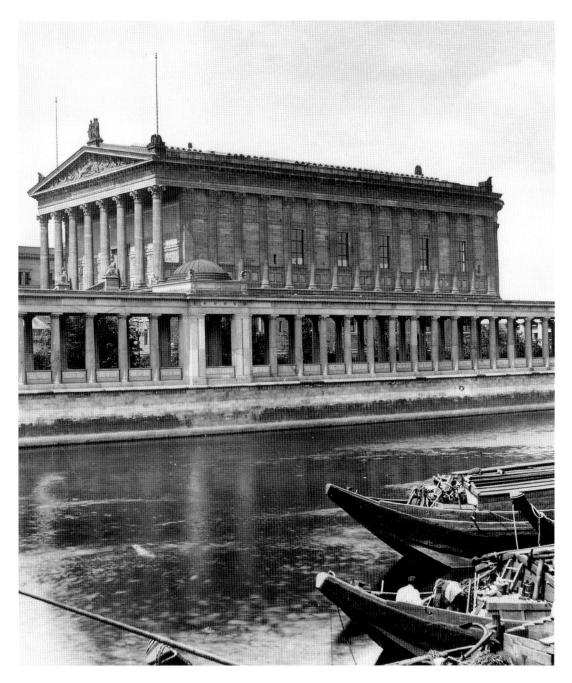

idea is prominently stated below the pediment of the old National Gallery in the controversial inscription: *Der deutschen Kunst 1871* (fig. 4). This dedication, which has miraculously and ludicrously survived the devastation by bombing that erased so many other traces of the past, links the museum to the founding year of the German Reich. From the first moment of its appearance, this motto triggered a heated debate over the meaning of the term *Nationalgalerie*: Was such a museum expected to become a shrine to national or a showcase of international art? For the modern visitor, the words *Der deutschen Kunst* immediately evoke an association with the Haus der deutschen Kunst in Munich, another columnated monument inaugurated by Hitler in 1937 as a shrine to art of the Third Reich, then the only officially sanctioned art of the nation.

When the National Gallery in Berlin was inaugurated on the birthday of Emperor

William I, 21 March 1876,[7] most critics immediately recognized the odd discrepancy between the architecture—based as it was on an ideal Corinthian temple—and its modern adaptation to the purposes of an art gallery (fig. 5). "What does the exhibition of modern art have to do with such a pompous building?" asked one of the critics.[8] The incongruity between the architecture and its function was heightened by the disturbing inconsistency of the displays in the galleries. Even though the installation was far from being complete at the time of the opening, it nonetheless set a specifically German tone, a tone, moreover, that was at odds with the idea of a national gallery as it had first been discussed in the 1840s: a museum dedicated to contemporary art within a more liberal-international framework. The disparity between the connotation of temple architecture and the function of the building as a museum was further aggravated by the ideological ambiguities articulated in the decorative programs and displays. While the figure of the king signified Prussian liberalism, the façade of the building communicated to the public of 1876 the new nationalistic agenda of the empire. This contrast, I propose, was the product of the shifting interpretations of nation and nationalism. Already from afar—since 1886—the visitor was alerted to the Prussian character of the gallery by Alexander Calandrelli's bronze equestrian statue of King Frederick William IV on the outside (fig. 6), and upon entry was immersed in the patriotic atmosphere signaled by Bernhard Plockhorst's twin portraits of *Emperor William I* (fig. 7) and *Empress Augusta* (fig. 8), which had been donated in time for the inauguration in 1876.[9]

The pseudo-antique architecture of the National Gallery and its location in the center of Berlin were largely due to King Frederick William IV himself, who nourished plans for an ensemble of classicizing buildings grouped in the manner of an antique *forum*.[10] To the northwest of Karl Friedrich Schinkel's Altes Museum, to the west of August Stüler's Neues Museum, and in the immediate vicinity of the Royal Palace and the Cathedral, the king envisaged a group of classical structures: art administration buildings, museums, and academies, all of which would gradually form the cul-

7. Bernhard Plockhorst,
Emperor William I, 1873,
oil on canvas
Staatliche Museen, Preussischer
Kulturbesitz, Nationalgalerie,
Berlin

tural center of Prussia's capital (fig. 9). Its prominent centerpiece was to be a peripteral temple, elevated on a monumental base and housing lecture rooms on the ground floor and a festive hall for celebrations on the second floor (fig. 10). When the king died in 1861, the idea of the temple as *monument* was at once adapted to the new project of a

8. Bernhard Plockhorst,
Empress Augusta, 1872,
oil on canvas
Staatliche Museen, Preussischer
Kulturbesitz, Nationalgalerie,
Berlin

of the building was dominated by the equestrian statue of Frederick William IV, which was mounted on a high pedestal in the center, leading the visitor's eye to the inscription below the pediment—*Der deutschen Kunst 1871*—and on to the sculptures mounted in the pediment itself, which depict Germania protecting the arts. Thus elevated on a massive base and girded by a colonnade, the National Gallery dominated the entire Museum Island, set off at a distance from neighboring buildings and dramatically displaying its character as a monument. Critics were quick to point to Friedrich Gilly's *Project for a Monument to Frederick the Great* of 1797 (fig. 11) and Leo von Klenze's *Walhalla* (1831–1842) near Regensburg (fig. 12) as the decisive models for this conception. Both the design for the royal monument and the architectural plan for the *Ruhmeshalle*, or hall of fame, reveal the underlying ideology that determined Stüler's conception. Only the most precious materials, such as differently colored marbles, mosaics, and gilded stucco, were used on the interior, making this the most costly public building the Prussian state had erected up to this time. The ostentatious vestibule and hall of stairs originally occupied as much space as the galleries themselves, creating the impression of a *Ruhmeshalle* rather than meeting the requirements of a museum.

The second floor was mainly dedicated to Peter von Cornelius' large cartoons, an ensemble of designs for the *Campo Santo* commissioned by King Frederick William IV. In order to accommodate these large works of Cornelius, Stüler designed two massive exhibition areas rising through two floors toward the skylights (fig. 13). The Cornelius galleries formed the conceptual core of the museum and offered the most prominent exhibition space.[11] The apsidal space at the northern end of the gallery displayed a colossal portrait bust of Cornelius himself by August Wittig (fig. 14). Because of his choice of predominantly "Germanic" subject matter and neogothic mode, Cornelius' art had long been interpreted as typically "German;" and because his designs for the *Campo Santo* were associated with the Prussian monarchy, the Cornelius galleries were granted a central location within the

national gallery. From its very inception, the paradigm for this museum was *monument* and not *galleria*. The architect August Stüler completed the plans in 1865, construction began a year later, and the building was finished in 1876, with Heinrich Strack overseeing the construction and furnishing the design for the interior. Since 1886 the exterior

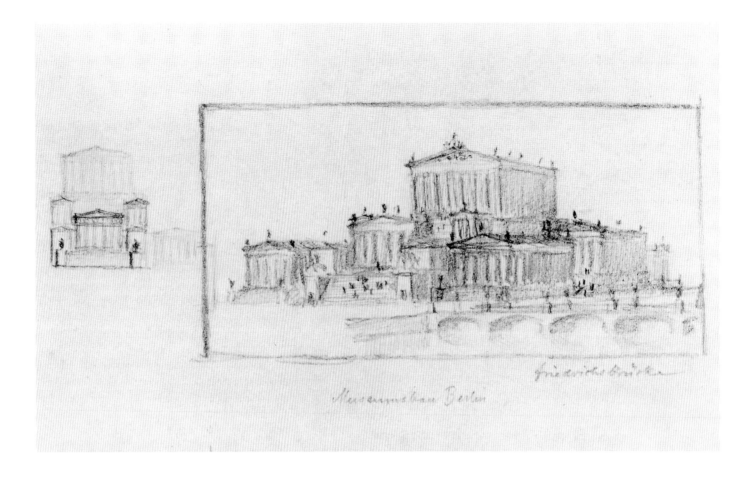

Muraumshau Berlin friedrichsbrücke

architectural scheme for reasons more power-
ful than merely aesthetic ones. Throughout
the building, the interior decoration was re-
plete with themes from German medieval
art and legend, and therefore entirely in tune
with Alfred Rethel's cartoons of the *History of
Charlemagne* as well as those of Cornelius.
Thus, in architectural design as well as in
the display of the artifacts, the historical and
monarchical messages were forcefully artic-
ulated for the audience of 1876.

This representation of an unabashed na-
tionalism placed the institution at great re-
move from its original conception. The ear-
liest efforts to create a "patriotic" gallery in
Berlin go back in time as far as 1835,[12] but
the most forceful initiative came from an as-
sociation of artists in Düsseldorf. Their ideas
were clearly inspired by the democratic
movement of 1848, and were also linked to
the express political goal of German unifica-
tion.[13] While political unification would
elude Germany for another quarter of a cen-
tury, art became one of the most powerful
vehicles for the propagation of national

unity. But it was a long way from *National-
kultur* to political nation-state. Two years
after the parliamentary debates in Frankfurt,
F. R. Fischer published a pamphlet in 1850
regarding the "founding of a National Gallery
in Berlin," a lucid investigation of the pur-
pose and effect of such a museum.[14] Partly
guided by the liberal-bourgeois ideals of these
years, Fischer stressed the educational role
of the arts, that is, "to elevate man and na-
tion through art to their true dignity and
destiny and to shape life in all its aspects so
as to make it truly beautiful as well as moral.
This is what a national gallery is, ought to
be, and should accomplish."[15] Fischer's pro-
gram for a national gallery as an educational
institution of international scope was cou-
pled with the vision of Prussia's capital as a
metropolis. Every "truly educated citizen of
the world" (*Weltbürger*), argued Fischer,
"should look with pride in the name of hu-
manity" upon such an endeavor. While the
vision of a gallery "of European importance"
and of Berlin as "a metropolis of art and sci-
ence" seems to indicate at first the interna-

9. Frederick William IV,
*Sketch for a Cultural
Forum*, c. 1841, pencil
Staatliche Museen, Preussischer
Kulturbesitz, Nationalgalerie,
Berlin

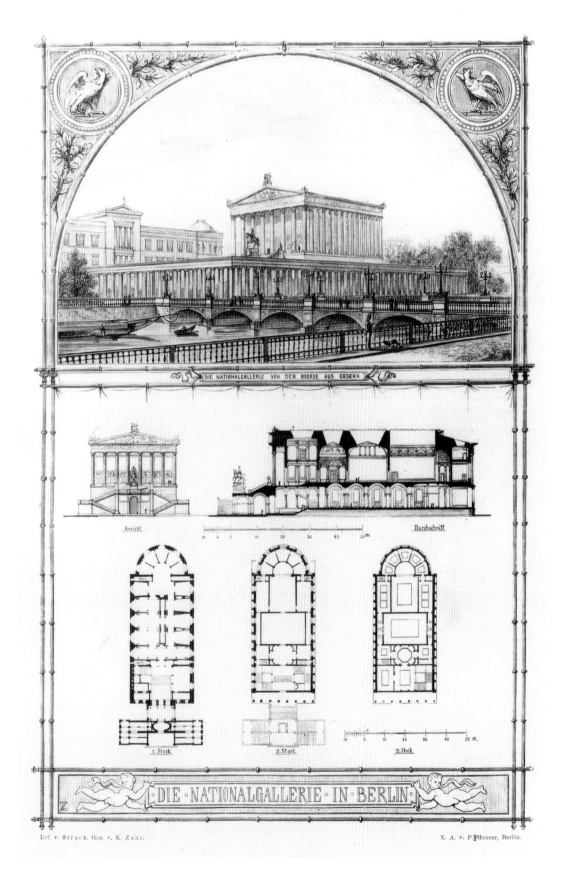

DIE NATIONALGALLERIE VON DER BOERSE AUS GESEHN

Ansicht Durchschnitt

I. Stock II. Stock III. Stock

DIE · NATIONALGALLERIE · IN · BERLIN

Erf. v. Strack. Gez. v. K. Zaar. X. A. v. P. Meurer, Berlin.

10. Nationalgalerie, Berlin
From *Deutsche Bauzeitung* 10,
no. 37 (1876)

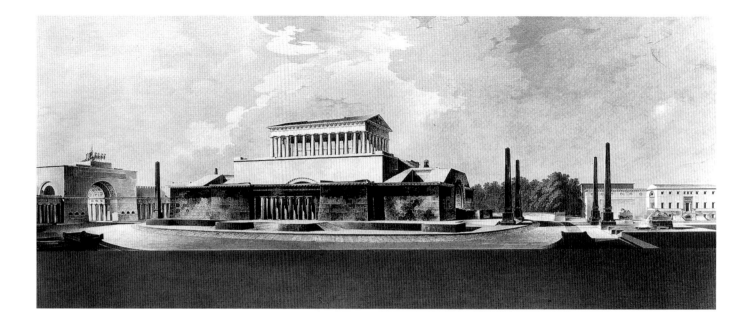

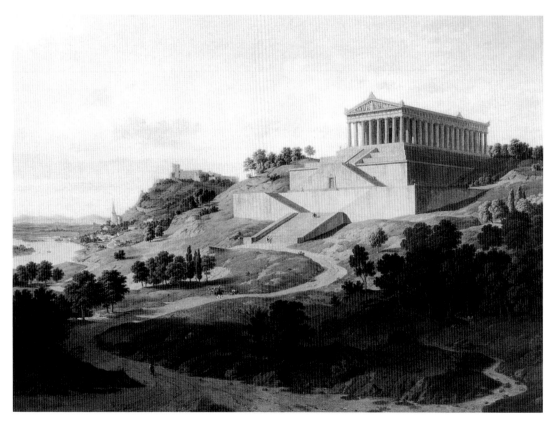

11. Friedrich Gilly, *Project for a Monument to Frederick the Great*, 1797
Author's archives

12. Leo von Klenze, *Walhalla*, 1831–1842
Author's archives

13. Cornelius Gallery, Nationalgalerie, Berlin
Staatliche Museen, Preussischer Kulturbesitz, Nationalgalerie, Berlin

14. Cornelius Gallery with the portrait bust of Cornelius, Nationalgalerie, Berlin
Staatliche Museen, Preussischer Kulturbesitz, Nationalgalerie, Berlin

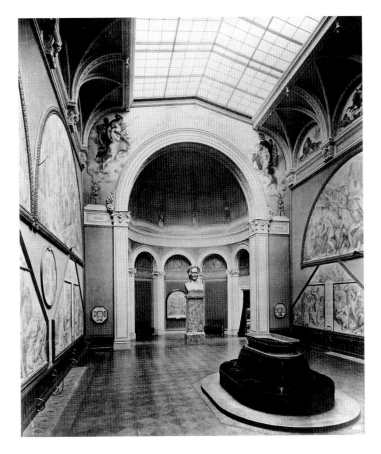

tionalism of the Enlightenment, the implied political ideology of Prussian hegemony already at this moment rings more aggressively nationalistic:

It is after all Prussia's political mission to lead and fulfill Germany's destiny through the general furthering of intelligence, enlightenment, and the education of the people, thereby increasing her own power. Prussia and Prussia's capital have above all the duty, the power, and the calling to establish such a praiseworthy monument dedicated to German art and thus to the culture of the mind in general for the sake of her own glory.[16]

Thus in 1850 the ideals underlying such a modern museum in Berlin were already displaced from their original philosophical location and effectively combined with a far more compelling political agenda: the promotion of cultural unity under Prussian leadership.

When the public clamor for a national gallery reached a new pitch in 1859, the centenary of Schiller's birthday, it joined forces with the vigorous call for political unification in a climate of nationalistic fervor. Ultimately it was a private citizen, Consul Wagener, who took the crucial step in the founding of the National Gallery when he donated his collection of several hundred paintings and sculptures to the king in 1859, with the express stipulation that the collection be exhibited in a special building. Upon Wagener's death, the king accepted the donation as the cornerstone of a "patriotic gallery of works of modern artists."[17] This was no coincidence: Wagener's gift was made at a time of intense debates and efforts to coax the Prussian government into creating a national gallery. When suddenly, to its great surprise, the Prussian state became the owner of quite a substantial collection of modern—primarily German—works of art, it was thrust into a unique position among German states. Even Munich's Neue Pinakothek, which had opened in 1853, could not yet boast of such a comprehensive collection.

Wagener had built his collection primarily during the second quarter of the nineteenth century.[18] Of his 262 paintings, 211 were by Prussian artists and 51 were by Austrian and other foreign artists. Wagener's taste was quite conventional: he preferred

medium-size anecdotal genre scenes and landscapes, such as Peter Hess' *The Feast of Saint Leonard*, Johann Christian Dahl's *Storm at Sea*, or Johann Peter Hasenclever's and Adolph Schrödter's scenes of winetasting. He did, however, also buy two paintings by Caspar David Friedrich, *The Lone Tree* and *Moonrise over the Sea*, a typical townscape by Eduard Gaertner, the *Parochialstrasse* (fig. 15), and several of Karl Friedrich Schinkel's landscapes. These relatively small canvases were hung in the narrow exhibition galleries around the solemn Cornelius galleries or in the small apsidal compartments at the northern end of the galleries.

While Wagener's collection was exhibited in the Academy of Fine Arts from 1861 onward, the Prussian Parliament agreed to the annual expenditure of 25,000 Thaler but simultaneously established the *Landeskunstkommission*, the State Art Committee, consisting of nine members, to administer the funds.[19] Construction was begun in 1866, the year of Prussia's victory over Austria in the battle of Königgrätz, which brought the country a step closer to unification. In keeping with Bismarck's increasingly nationalistic politics and the general atmosphere of patriotic pride and self-confidence, the committee commissioned and bought monumental battle scenes glorifying the wars that finally led to national unification, a decorative scheme perhaps inspired by the model of Versailles.[20] Immediately after the victory over Austria, the committee invited Prussian artists to submit sketches dealing with "the actions of the armies in the victorious campaign of 1866." Georg Bleibtreu's *Battle at Königgrätz*, Christian Sell's *At Königgrätz* (fig. 16), Wilhelm Camphausen's popular battle scenes, and Emil Hünten's *Battle at Wörth 6 August 1870* of 1877 (fig. 17), all glorified the military campaigns that secured Prussia's position of power. When finished, these large theatrical battle paintings[21] were all to be hung in the National Gallery, whose exhibition space was already severely restricted by the Cornelius galleries and the state's commitment to the Wagener collection.

Whereas the works of foreign artists made up approximately one-fifth of Wagener's collection, not even half a dozen pictures by foreigners had been purchased by the State Art Committee during the fifteen years prior

to the opening of the gallery. By and large, the committee favored the typical mid-nineteenth-century genre and landscape scenes by Berlin and Düsseldorf artists. Its first clamorous purchase was a famous picture by the Düsseldorf painter Friedrich Lessing, *Huss at the Stake*, a canvas that had just returned from the United States and had been snatched up at a London auction. But the committee's greatest efforts went toward the commission of monumental history paintings.[22] One of the most popular responses to this new government patronage was Wilhelm Gentz's *The Crown Prince's Entry into*

15. Eduard Gaertner, *Parochialstrasse*, 1831, oil on canvas
Staatliche Museen, Preussischer Kulturbesitz, Nationalgalerie, Berlin

16. Christian Sell, *At Königgrätz*, 1872, oil on canvas
Staatliche Museen, Preussischer Kulturbesitz, Nationalgalerie, Berlin

17. Emil Hünten, *Battle at Wörth, 6 August 1870*, 1877, oil on canvas
Staatliche Museen, Preussischer Kulturbesitz, Nationalgalerie, Berlin

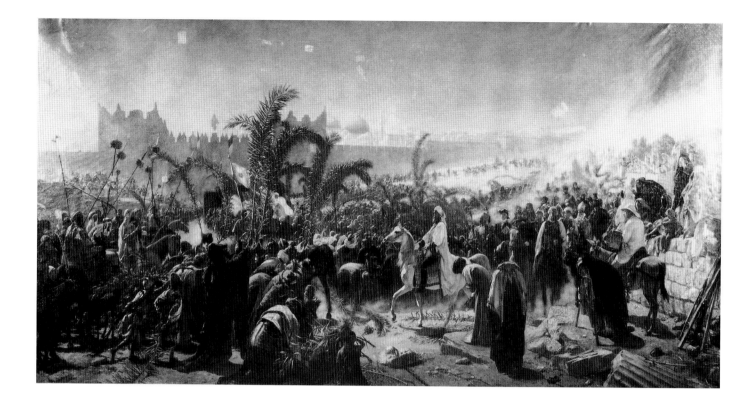

Jerusalem, 1869 (fig. 18), commemorating the visit of Crown Prince Frederick to Jerusalem on the occasion of the opening of the Suez Canal. After victory over France, the committee hastened to commission scenes that would complete the historical cycle, even though many of these gigantic paintings were still unfinished at the time of the opening.

To reinforce this representation of a new national self-assurance, the emperor simultaneously promoted the inclusion of official portraits of Prussian generals and leading statesmen in the permanent exhibitions. This proposal led to a new controversy about the purpose of the National Gallery and the role of the government in its administration. Because the Prussian Diet had to grant all funds, the minister of cultural affairs played a decisive role himself. Equally important, however, was the fact that Wagener had donated his collection to the king, who in turn had accepted it for the state. From the very beginning, therefore, the National Gallery was seen as a governmental enterprise identified first with the monarchy and then with the empire. The Enlightenment ideal of educating and elevat-

ing man through art was now effectively subverted by a program of political indoctrination. This dependence of the museum and its collections on the state was maintained after 1871, despite repeated efforts to protect the gallery administration from direct state interference. Already in the 1860s, the art critic and editor Max Schasler warned against nationalistic tendencies that threatened to turn the new museum into a "national junk pile."[23] In 1873 the conflict about the National Gallery reached such intensity that the aged historian Leopold von Ranke (1795–1886) was consulted on the matter. As the nation's foremost scholar, responsible for forging the new interpretation of Prussian history, he enthusiastically supported the emperor's idea of a historic portrait gallery that would have transformed the museum into a Prussian hall of fame, but these plans were aborted in 1873 when—ironically—the Royal Building Committee insisted that construction had gone too far to accommodate such a historic portrait gallery.[24] Thus, in the 1870s and 1880s, an increasingly imperial nationalism displaced the bourgeois ideals of an earlier generation. This subversion was brutally ex-

18. Wilhelm Gentz, *The Crown Prince's Entry into Jerusalem, 1869,* 1876, oil on canvas
Staatliche Museen, Preussischer Kulturbesitz, Nationalgalerie, Berlin

posed with the hanging of Ferdinand Keller's celebratory painting, *Emperor William the Victorious*, 1888, directly on top of the cartoons of Cornelius (fig. 19).[25]

When the museum's second director, the Swiss Hugo von Tschudi, attempted to purify the National Gallery of the oppressive mass of bombastic battle scenes, and bought the first French impressionist paintings, he probably did so under the illusion that he was operating in the neutral domain of art. The emperor's powerful personal intervention, however, left no doubt that he regarded the museum as a public arena for the display of the empire's art, as signature of the new nation.[26] If the first director, Max Jordan, had to cope with the installation of three eclectic exhibits, each representing a different facet of German nationalism, Hugo von Tschudi manifested his conception of modern art as entirely divorced from any historical or social context in his installations of paintings and sculpture (figs. 20, 21).

Together with Julius Meier-Graefe's writings, Tschudi's installations shaped the canon of modernism well beyond the borders of Germany and served as models for future museums dedicated to modern art. The collision between the nationalist politics of the government and Tschudi's first truly modern exhibition designs ultimately forced his resignation in 1909. Only the clever maneuvering of his successor, Ludwig Justi, succeeded in clearing the gallery of its most chauvinist history paintings. It was he who managed to persuade the emperor that the nearby Armory would be an even more congenial setting for the artistic celebration of German supremacy (fig. 22).[27] Only after the defeat of the empire was Justi able to realize his own vision of a modern museum.[28] In 1919 he organized a new department, the gallery of twentieth-century art, in the Kronprinzenpalais, modeled upon Tschudi's narrative of modern art. Fourteen years later, however, the takeover by the Third Reich

19. Ferdinand Keller, *Emperor William the Victorious*, 1888, oil on canvas
Staatliche Museen, Preussischer Kulturbesitz, Nationalgalerie, Berlin

20. Nationalgalerie, Berlin, installation of French impressionist paintings, 1908
Staatliche Museen, Preussischer Kulturbesitz, Nationalgalerie, Berlin

21. Nationalgalerie, Berlin, installation of Menzel Collection, 1908
Staatliche Museen, Preussischer Kulturbesitz, Nationalgalerie, Berlin

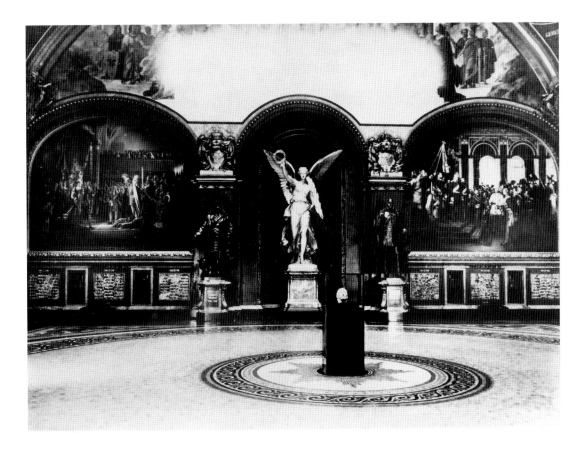

22. Zeughaus, Berlin, Ruhmeshalle with Fritz Schaper's marble sculpture *Victoria*, 1880–1885, and Anton von Werner's painting *The Proclamation of the Empire*, 1882
Author's archives

resulted in the most radical intervention of political power. In 1933 the Nazis dismissed Justi from his position as director of the National Gallery, and in 1937 closed the Kronprinzenpalais, this "breeding place of cultural Bolshevism," which had been a target of their vicious campaign against modern art ever since they had come to power.[29] This most extreme shift of nationalism led to the "Entartete Kunst" campaign, which destroyed the twentieth-century collection and effectively reduced the displays to their "pre-Tschudi" state. Appropriating German history painting for their own national mission, Nazi critics held up Adolph Menzel's images from the history of Frederick the Great as centerpieces of the collection: paintings that had been connected to the ideology of bourgeois liberalism were now heralded as icons of the nation's heroic past. The politics of display once more came to correspond to the rereading of the artifacts themselves.

The destruction of the Second World War left the museum building in ruins, while the subsequent division of the country into East and West in 1948 physically separated works in the collection. While the Democratic Republic reconstructed the old National Gallery, the Federal Republic developed new political strategies that would result in the founding of the New National Gallery designed by Mies van der Rohe and dedicated in 1968. But already in 1961—the year the wall was constructed—Leopold Reidemeister had organized the exhibition *The National Gallery and Its Patrons* not only to commemorate the museum's centenary, but also to revive the tradition of Tschudi and Justi. Mies' steel-and-glass construction elevated on a socle at once echoes the idea of the national gallery as monument and represents the revival of this tradition in the cultural politics of the 1950s and 1960s: the masterworks, the canon of modernism, are encased in a transparent shell and suspended in an aestheticized setting only a short walk from the Berlin wall. Mies' building and Werner Haftmann's exhibitions became symbols for West Germany's attempt to link the present with the early heroic phase of modernism, thereby

conveniently eradicating the period in between, the twelve years of the Third Reich.[30]

The current scheme to convert one of Berlin's oldest railroad stations, the Hamburger Bahnhof (figs. 23, 24), into a vast space for the display of the art of the present and future—the newest department to be added to the National Gallery—is an idea that goes back to the years before the wall came down and Germany was reunited as a nation-state.[31] Now the National Gallery will be organized in three departments: the art of the nineteenth century in the Corinthian temple, works of the "classical" modern period in Mies' glass case, and the art of our own time in the Hamburger Bahnhof. Amid increasingly fervent discourse on the possibility or impossibility of nationhood in the postmodern world, the vast space of the reconstructed railroad station installed with works by artists such as Joseph Beuys—but also with the flickering images of Nam June Paik—does not conjure up allusions to a static, permanent temple of art. Here, trains and railroad station come to signify mobility and connections, and seem to contradict the very idea of a national gallery. The National Gallery's new project therefore evokes the vision of a museum in a global rather than in a national context, producing a new narrative for the architecture of the railroad station as well as for the art it contains.

23. Hamburger Bahnhof, Berlin, dedicated 1847
Staatliche Museen, Preussischer Kulturbesitz, Nationalgalerie, Berlin

24. Hamburger Bahnhof, Berlin, interior, reconstruction, 1989
Staatliche Museen, Preussischer Kulturbesitz, Nationalgalerie, Berlin

NOTES

Scholarly preparation for this article was supported by an Intra-Mural Research Grant of the University of California. Annegret Janda, formerly in the Archives of the Nationalgalerie, Staatliche Museen, Berlin, generously assisted my work in the former East Berlin. I gratefully acknowledge Denise Bratton's research and editorial assistance. The research for this paper was completed in 1991.

1. Eric J. Hobsbawm, *Nation and Nationalism since 1780: Programme, Myth, Reality* (Cambridge, 1990), 9.

2. Ernest Gellner, in *Nations and Nationalism* (Oxford, 1983), 1, had insisted upon the political definition of the term as "primarily a principle which holds that the political and national unit should be congruent."

3. Hobsbawm 1990, 10.

4. Hobsbawm 1990, 11. This is the direction, he believes, which studies on nationalism will take in the future.

5. Rudolf Vierhaus, "Einrichtungen wissenschaftlicher und populärer Geschichtsforschung im 19. Jahrhundert," in *Das kunst- und kulturgeschichtliche Museum im 19. Jahrhundert: Vorträge des Symposiums im Germanischen Nationalmuseum, Nürnberg*, ed. Bernward Deneke and Rainer Kahsnitz, *Studien zur Kunst des 19. Jahrhunderts* 39 (Munich, 1977), 109–117. The literary historian Conrad Wiedemann is revising this identification of a nation primarily through its cultural production by focusing on the national subtext in the literature of the "Deutsche Bewegung." He emphasizes *Kulturnation* rather than *Nationalkultur*; see his project "Aufgang der Kulturnation 1750–1800," in "Europäischer Nationalgeist und deutsche Kulturnation," *Arbeitsberichte, Jahrbuch des Wissenschaftskollegs zu Berlin* (1987–1988), 121–124.

6. See Thomas Nipperdey's chapter on nationalism in his book *Deutsche Geschichte, 1800–1866: Bürgerwelt und starker Staat* (Munich, 1983), 300–313.

7. Documents regarding the visit of the emperor and empress (21 March 1876) and the official inauguration the next day are in the archives of the Nationalgalerie: *Acta betreffend: Feierlichkeiten in der Nationalgalerie*, March 1876, *Generalia* 27, vol. 1.

8. *National-Zeitung*, morning edition, no. 147 (28 March 1876). The numerous reviews that appeared on the occasion of the inauguration all criticized the sharp discrepancy between the architecture as a temple and the function of the building as a museum. The author of this article blankly states: "Es ist das Gebäude von vorneherein eine architektonische Unwahrheit. . . ." Perhaps the most detailed and thorough description of the building and critical discussion of the displays was written by Adolf Rosenberg in four parts for *Zeitschrift für bildende Kunst, Kunstchronik* 11 (Leipzig, 1876), 425–431, 457–462, 507–511, 542–548. A thorough architectural discussion, with illustrations, is in *Deutsche Bauzeitung* 10, no. 37 (1876), 182–184 and no. 39 (1876), 193–195; see also *Berlin und seine Bauten* (Berlin, 1877), 151, 162–165.

9. In the last (third) part of a series of detailed articles on the architecture and the displays in the *Vossische Zeitung* the author writes: "Die beiden lebensgrossen Bildnisse des Kaisers und der Kaiserin von Plockhorst, welche ein patriotischer und kunstfreundlicher Geber neuerdings hieher gestiftet hat, dürften . . . schwerlich für immer den ihnen jetzt zugewiesenen Platz vor den zwei Nischen des Kuppelsaales behaupten sollen." L. P. [probably Ludwig Pietsch], *Vossische Zeitung* 81 (5 April 1876).

10. A good early history of the collection and description of the galleries with fifty illustrations is provided by Max Jordan, *Katalog der Königl. National-Galerie zu Berlin, Fest-Ausgabe mit fünfzig Illustrationen. Zum 25. Januar 1883* (Berlin, 1883). For a recent discussion of the development and history of the Museum Island, including a good bibliography, see Renate Petras, *Die Bauten der Berliner Museumsinsel* (Berlin, 1987). The king's plans and August Stüler's projects are described and illustrated (54–62). See also *Die Museumsinsel zu Berlin (anlässlich der 750. Jahrfeier Berlins)* with contributions by Peter Betthausen and others (Berlin, 1987).

11. Documents regarding the integration of Cornelius' cartoons into the collection and their display are in the archives of the Nationalgalerie: *Acta betreffend: Die von der General-Verwaltung der Königlichen Museen übernommenen Kunstwerke; Generalia* 33, vol. 1. Adolf Rosenberg gives a detailed description of the Cornelius galleries in part 4 of his series of articles in *Kunstchronik* 11 (1876), 542–548. Ludwig Justi, *Die Zukunft der Nationalgalerie* (Berlin, 1910), 20, points succinctly to the equation of the inscription in the pediment of the building with the reading of Cornelius' scenes and Nazarene art as typically German:

Allmählich aber trat der Gedanke mehr und mehr hervor, dass man hier die eigene vaterländische Kunst pflegen wollte, der gewaltige politische Aufschwung jener Jahre kam hinzu und zugleich das damals noch herrschende Bewusstsein . . ., dass man in der Kunst der Nazarener, vor allem des Cornelius, eine spezifische Leistung des deutschen Geistes besässe.

12. Götz Eckardt, *Die Bildergalerie in Sanssouci: Zur Geschichte des Bauwerks und seiner Sammlungen bis zur Mitte des 19. Jahrhunderts* (Ph.D. diss., Martin Luther University, Halle and Wittenberg, n.d. [1974]), 134, traces the idea of a patriotic gallery back to 1835 when artists, scholars, and businessmen founded a society in Berlin with the purpose of establishing a "Vaterländische Gemählde-Gallerie" or "National-Gallerie" to exhibit the works of local ("einheimischer") artists. The author documents these early developments, emphasizing that the term "national gallery" was used before 1848 (Eckardt 1974, 216).

13. Wolfgang Hütt, "Zur Gründungsgeschichte der

Nationalgalerie in Berlin," *Kunstwissenschaftliche Beiträge* 7 (1980), 2–3, and *Die Düsseldorfer Malerschule, 1819–1869* (Leipzig, 1984), 231. Paul Ortwin Rave, *Die Geschichte der Nationalgalerie Berlin* (Berlin, 1968), 10.

14. F. R. Fischer, *Zur Gründung einer National-Gallerie in Berlin* (Berlin, 1850). This seems to be reprinted from the *Königlich privilegirte Berlinische Zeitung*, no. 125 (2 June 1850).

15. Fischer 1850, 4:

Ihr höchster und edelster Endzweck ist aber, . . . Mensch und Volk durch die Kunst zu seiner wahren Würde und Bestimmung zu erheben und das Leben nach allen Seiten hin zu einem wahrhaft schönen, also auch sittlich edeln zu gestalten. Das ist, das soll eine National-Gallerie sein und wirken.

16. Fischer 1850, 7:

Preussen, dessen politische Mission es überhaupt ist, durch die allseitige Förderung der Intelligenz, der Aufklärung, der Volksbildung, Deutschlands Geschick zu leiten und zu erfüllen und so seine eigene Macht immer fester zu gründen und zu erweitern, Preussen und Preussens Hauptstadt hat vor Allem die Pflicht, und die Macht, und den Beruf, der deutschen Kunst und somit auch der Cultur des Geistes überhaupt ein solch ruhmvolles Denkmal sich selbst zum Ruhme zu gründen.

17. Hütt 1980, 1–2, quotes from the documents relating to Wagener's testament and the king's acceptance of the donation. The document of 16 March 1861 states: "Zugleich will Ich, den von dem patriotischen Stifter in seinem letzten Willen ausgesprochenen Gedanken zu dem Meinigen machen, dass mit dieser Sammlung der Grund zu einer vaterländischen Galerie von Werken neuerer Künstler gelegt werde" (1). Ludwig Justi, *Der Ausbau der Nationalgalerie* (Berlin, 1913), discusses the interpretation of Wagener's testament in regard to the donor's wishes about the display of his collection, but also in regard to the reading of Wagener's term "nationale Galerie" (22) and the meaning "vaterländische Galerie" (26–27).

18. Gustav Friedrich Waagen, *Verzeichnis der Gemälde-Sammlung des Königl., Schwedischen und Norwegischen Consuls J. H. W. Wagener zu Berlin* (Berlin, 1850); a revised edition with the history of the collection's donation to the state (Berlin, 1873). Claude Keisch, *Die Sammlung Wagener: Aus der Vorgeschichte der Nationalgalerie* [exh. cat., Staatliche Museen zu Berlin, Nationalgalerie] (Berlin, 1976). Documents relating to the transfer and exhibition of the Wagener collection are in the archives of the Nationalgalerie: *Acta betreffend: Die der Königl. National Galerie geliehenen Kunstwerke vom Mai 1875*, *Generalia* 6, vol. 1, and *Acta betreffend: Die Aufstellung der Kunstwerke* (begun April 1875 to December 1899), *Generalia* 2, vol. 1.

19. Documents relating to the establishment of the *Landeskunstkommission* and the composition of its members are in the archives of the Nationalgalerie: *Acta betreffend: Berathungen der Landes Kunst Kommission* (begun 1874 to April 1879), *Generalia* 10, vol. 1. These are important documents revealing the committee's politics regarding purchases, commissions, donations, and rejections of gifts as well as containing lists of new acquisitions and the minutes of the committee's meetings from the period 1870–1879. The handwritten report of the first meeting of the "Commission zur Berathung über die Verwendung der Fonds für Kunstzwecke" with Max Jordan, the National Gallery's first director, from 3 September 1874, already maps out the strategies for the commission of historic portraits and battle paintings. On page 2 of the minutes we read:

In Bezug auf eine in der National-Galerie hierselbst anzulegende Galerie zur Aufnahme von Portraits bedeutender Männer dieses Jahrhunderts wurde angeführt, dass es sich empfehlen würde, zwischen den Portraits berühmter Männer auch historische Darstellungen, Schlachtenbilder, und dergl., durch welche die Verdienste jener Männer besonders hervorgehoben würden, aufzustellen. Die Aufträge zur Ausführung würden unter namhafte Künstler systematisch zu vertheilen sein, damit etwas Einheitliches wenigstens in einigen Theilen der Galerie erzielt werde. Die Beschränkung der Künstler auf das Einhalten gewisser Grössenverhältnisse sei zwar erwünscht, aber nicht unbedingt nöthig.

The *Jahrbuch der Königlich Preussischen Kunstsammlungen* contains reports about the state funds, the "Verwendung des Kunstfonds." For a discussion of the committee's politics, see also Ludwig Justi, *Im Dienste der Kunst* (Breslau, 1936), 201–241, and Christopher With, "The Emperor, the National Gallery, and Max Slevogt," *Zeitschrift des Deutschen Vereins für Kunstwissenschaft* 30 (Berlin, 1976), 86–94, and *The Prussian Landeskunstkommission, 1862–1911: A Study in State Subvention of the Arts* (Berlin, 1986).

20. Ludwig Justi was perhaps the first to see this relationship between Berlin and Paris. In *Die Zukunft der Nationalgalerie* (Berlin, 1910), 28, he mildly criticizes the installation of a "patriotic or battle gallery," and then refers to Louis Philippe's gallery of history paintings at Versailles: "In keiner europäischen Hauptstadt wird man in einer Kunstsammlung ersten Ranges einen patriotischen oder Schlachtensaal finden wie in unserer Nationalgalerie, auch nicht in Ländern, die auf ihre Armeen ganz ausserordentlich stolz sind." For Versailles, see Thomas W. Gaehtgens, *Versailles, de la résidence royale au musée historique: La Galérie des batailles dans le musée historique de Louis-Philippe* (Antwerp, 1984).

21. Cited in Hütt 1980, 4, from the *Denkschrift über Entstehung und Verwaltung des Fonds zu Ankäufen von Kunstwerken für die National-Galerie sowie zur Beförderung der monumentalen Malerei und Plastik und des Kupferstiches.*

22. A recent dissertation at the Humboldt University Berlin deals extensively with these monumental history paintings: Jörn Grabowski, *Die politische und kunstpolitische Konzeption der Nationalgalerie behandelt anhand der Erwerbungen historischer*

Darstellungen in der Zeit von 1861 bis 1896 und deren Präsentation in Berlin und Potsdam (Ph.D. diss., Humboldt-Universität zu Berlin, 1990). See also Monika Wagner, *Von der Cornelius-Schule zur Malerei der Wilhelminischen Aera* (Tübingen, 1989).

23. The German term used is "nationale Rumpel-kammer;" quoted from Rave 1968, 39. Max Schasler, "Über die Gründung einer National-Galerie moderner Kunstwerke in Berlin," *Dioskuren* 4 (1859), 1, 2, 9; (1864), 29–33.

24. Hütt 1980, 5.

25. The monumental painting that celebrates the victorious entrance of the emperor through the Brandenburg Gate on 16 June 1871 has recently been exhibited at the Berlin-Museum. See *Das Brandenburger Tor 1791–1991*, ed. Willmuth Arenhövel and Rolf Bothe (Berlin, 1991).

26. Ludwig Justi wrote repeatedly about the political and cultural conflicts that erupted between the Nationalgalerie, and especially Hugo von Tschudi, and the emperor, most candidly in his unpublished memoirs, *Memoiren*, typescript in the archives of the Nationalgalerie, inventory no. E 3836, especially 272–288. He describes the hostile differences between the Landeskunstkommission, Anton von Werner, and the emperor on one side and Tschudi on the other. Paul Ortwin Rave, ed., *Richard Schöne, Generaldirektor der Königlichen Museen zu Berlin: Ein Beitrag zur Geschichte der preussischen Kunstverwaltung 1872–1905 von Ludwig Pallat* (Berlin, 1959), 92–96, 249–253, 326–327; With 1976, 87–90; Peter Paret, "The Tschudi Affair," *Journal of Modern History* 53 (1981), 589–618.

27. On the plans for the reorganization of the gallery, see Justi 1910, 23–29. Ludwig Justi, *Der Ausbau der Nationalgalerie: Zwei Denkschriften* (Berlin, 1913); Ludwig Justi, *Der Umbau der Nationalgalerie* (Berlin, 1914). For the display in the Zeughaus, see Monika Arndt, *Die "Ruhmeshalle" im Berliner Zeughaus: Eine Selbstdarstellung Preussens nach der Reichsgründung* (Berlin, 1985); see also Thomas Gaehtgens, *Anton von Werner: Die Proklamierung des Deutschen Kaiserreiches* (Frankfurt, 1990), 66–71.

28. Ludwig Justi, *Die Nationalgalerie und die moderne Kunst: Rückblick und Ausblick* (Leipzig, 1918). Staatliche Museen zu Berlin, Nationalgalerie, *Die Neue Abteilung der Nationalgalerie im ehemaligen Kronprinzen-Palais: Das Schicksal einer Sammlung* (Berlin, 1986). This documentation with three essays (ed. Annegret Janda) was published in conjunction with the exhibition *Expressionisten—Die Avantgarde in Deutschland 1905–1920*, Staatliche Museen zu Berlin, 1986.

29. Annegret Janda, "The Fight for Modern Art: The Berlin Nationalgalerie after 1933," in *Degenerate Art: The Fate of the Avant-Garde in Nazi Germany*, ed. Stephanie Barron [exh. cat., Los Angeles County Museum of Art] (Los Angeles, 1991), 105–119.

30. For the separate histories of the old national gallery in the East and the new national gallery in the West of Berlin after 1945, see Günter Schade, *Die Berliner Museumsinsel: Zerstörung, Rettung, Wiederaufbau* (Berlin, 1986). Staatliche Museen zu Berlin, ed., *Die National-Galerie: Wiederaufbau und Entwicklung seit 1945*. Documentation by Annegret Janda in the series *Das Studio* published in conjunction with the exhibition in the Nationalgalerie (Berlin, 1974). Werner Haftmann, *Die Neue Nationalgalerie, Staatliche Museen Preussischer Kulturbesitz*, Berliner Forum 3 (Berlin, 1969).

31. Wulf Herzogenrath, "Der Hamburger Bahnhof von 1845 bis heute," *Jahrbuch Preussischer Kulturbesitz* 27 (1990), 199–213.

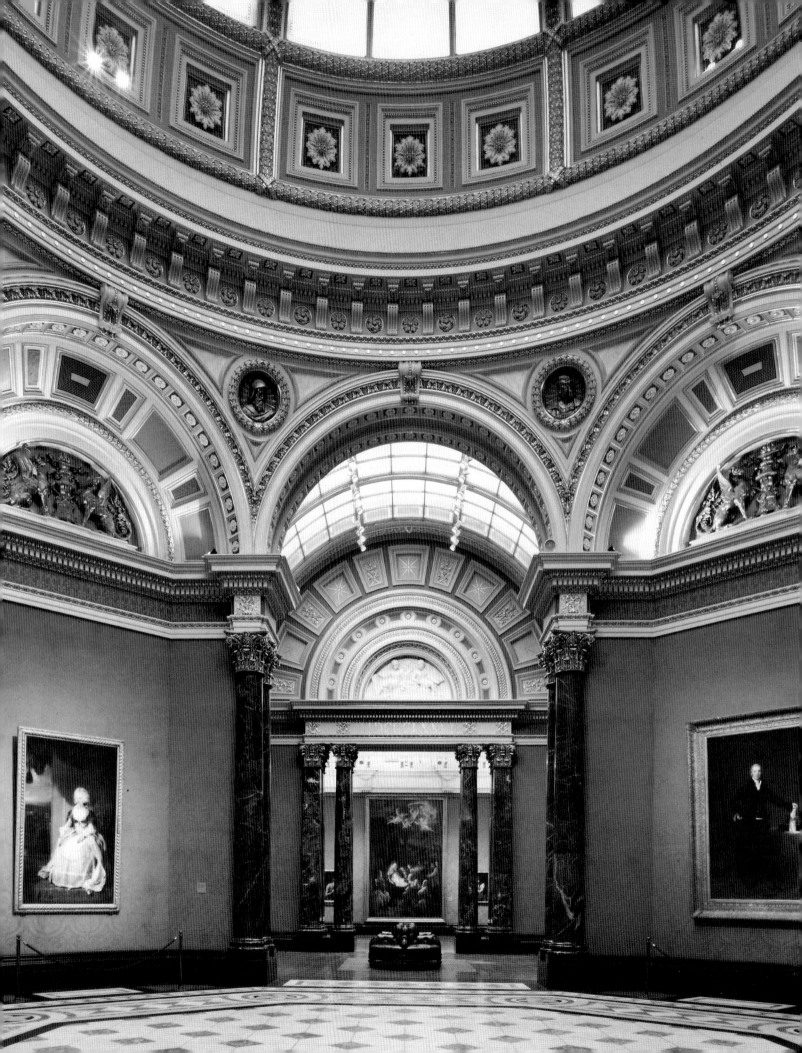

CAROL DUNCAN
Ramapo College of New Jersey

Putting the "Nation" in London's National Gallery

It is the Louvre Museum in Paris, not the National Gallery in London, that holds title as the prototype of the public art museum, the example that gives meaning to similar institutions everywhere. Its founding commemorates the French Revolution, as an inscription above the door to the Apollo Gallery makes explicit. The very site of the Louvre is saturated with revolutionary meaning. Once royal property, it is now public treasure. The citizenry, acting through its new Assembly, forcibly seized the king's collection and made it theirs. This significance of the Louvre as the product of a democratic revolution continues to inform later definitions of the public art museum. Thus Nathaniel Burt's history, *Palaces for the People*, emphasized this model of the royal palace opened up to the people. For him as for others, the Louvre is "the original Great Museum."[1]

How, then, are we to understand the National Gallery in London, whose founding, next to the French example, seems sorely lacking in political and historical fullness? The decisive events and powerful symbolic ingredients that made the French example so much the archetype of the European public art museum are simply not present. The first missing ingredient is a significant royal art collection of the kind that seventeenth- and eighteenth-century monarchs had often assembled and which then became the core of a national gallery. Certainly, England had once known such royal treasure: Charles I's famous and much envied collection of paintings. Broken up and sold when Charles fell, the story of this collection—its destruction as much as its creation—must figure as the beginning of the story of public art museums in England.

Charles came to the English throne in 1625, bringing with him ideas about monarchy that were shaped by continental models and continental theories of the divine right of kings. Especially impressed by the haughty formality and splendor of the Spanish court, Charles sought to create on English soil similar spectacles of radiant but aloof power. He commissioned Inigo Jones to design a properly regal palace, complete with a great hall decorated by Rubens (in 1635). A show of power in the seventeenth century also demanded a magnificent picture collection; elsewhere in Europe, church and state princes such as Cardinal Mazarin or Archduke Leopold-Wilhelm paid fortunes for the requisite Titians, Correggios, and other favorites of the day. Charles understood fully the meaning of such ceremonial display. So did his Puritan executioners, who pointedly auctioned off a large part of the king's collection. Not only did they feel a Puritan discomfort with such sensually pleasing objects; they also wished to dismantle a quintessential sign of regal absolutism.[2] Thus the absence of a significant royal collection in England is as much a monument, albeit a negative one, to the end

of English absolutism as the Louvre Museum is to the end of French absolutism.

This is only to say that the process of English state building was English, not French, as was the development of the symbols and public spaces which culturally articulated that process. In the England after Charles I, monarchs might collect art, but political realities discouraged them from displaying it ceremonially in ways that recalled too much the regal shows and absolutist ambitions of the past. In fact, after Charles and a very few other grand seventeenth-century art collectors—in particular the Earl of Arundel and the Duke of Buckingham— there would be no significant English collections for some time.[3] It was only in the late seventeenth and eighteenth centuries that large-scale English picture collecting would be resumed, most notably by the powerful aristocratic oligarchs to whom state power now passed. Meanwhile, British monarchs kept rather low public profiles as art collectors and art patrons.

Kensington Palace is a telling reminder of the modesty in which monarchy was expected to live, at least in the later seventeenth century. The residence of King William III and Queen Mary (installed on the throne in 1689), the building began as an unpretentious dwelling, certainly comfortable and dignified enough for its noble occupants—as seen in its two "long galleries" filled with art objects—but not in any way palatial. It lacked the ceremonial spaces of an empowered royalty, spaces that would appear only later under Kings George I and II. William's picture gallery held a fine collection, but it remained a source of private pleasure, not regal display.[4] In fact, various royal residences would accumulate considerable holdings, but these were never institutionalized as "The British Royal Collection." Until this day, these holdings remain private; indeed, their public display in the new Sainsbury Wing of the National Gallery in 1991–1992 attracted attention precisely because the work is so unfamiliar to the art-viewing public.[5]

Besides the want of a royal collection properly deployed as such, eighteenth-century British history lacks a potent political event that could have dramatically turned that collection into public property—in short, an eighteenth- or nineteenth-century type of democratic revolution. Of course, another way to get a public art museum (short of being occupied by a French army) was through the monarchical gesture one saw on the continent, in which a royal collection was opened up as a public space in symbolic recognition of the bourgeois presence. Indeed, the French crown was planning such a move at the time of the Revolution. When the Revolution transformed the monarchy into the nation, it also took over, redefined, and completed this museum project. What would have been a privileged and restricted space became a truly open, public one. The legacy of absolutist symbols and ceremonies was intact enough to be appropriated by the revolutionary state and put to new ideological use; it could now represent the Republic and its ideal of equality.

English ruling power, on the other hand, had rejected the use of a royal art collection as a national symbol just as deliberately as it had blocked the development of absolutism in the monarchy. There was no political room either for the kind of art collection that the people could meaningfully nationalize or for the kind of monarch who could meaningfully nationalize it himself.

The British did not lack impressive art collections. The absence of a ceremonially important royal collection was more than made up for by those of the aristocracy. In fact, the British art market became the most active in eighteenth-century Europe as both the landed aristocracy and a newly arrived commercial class sought the distinctive signs of gentlemanly status. Whether defending older class boundaries or attempting to breach them, men of wealth (but hardly any women) deemed it socially expedient to collect and display art, especially paintings. Italian, Flemish, and other old master paintings of the kind prescribed by the current canons of good taste poured into their collections. As Iain Pears argues, art collecting, by providing a unifying cultural field, helped the upper ranks of English society form a common class identity: "They increasingly saw themselves as the cultural, social, and political core of the nation, 'citizens' in the Greek sense with the other ranks of society scarcely figuring in their understanding of the 'nation.'"[6] In short, here were the social

elements of the "civil society" of seventeenth- and eighteenth-century political philosophy, that community of propertied citizens whose interests and education made them, in their view, most fit to rule.[7]

To modern eyes, the social and political space of an eighteenth-century English art collection falls somewhere between the public and private realms. Our notion of the "public" dates from a later time when, almost everywhere in the West, the advent of bourgeois democracy opened up the category of citizenship to ever broader segments of the population and redefined the realm of the public as ever more accessible and inclusive. What today looks like a private, socially exclusive space could, in the eighteenth century, have seemed much more open. Indeed an eighteenth-century picture collection (and an occasional sculpture collection) was contiguous with a series of like spaces that together mapped out the social circuit of a class. Certainly access to these spaces was difficult if one did not belong to the elite.[8] But from the point of view of their owners, one's pictures were accessible to everyone who counted, the "finite group of personal friends, rivals, acquaintances and enemies who made up the comparatively small informal aristocracy of landed gentlemen, peers or commoners, in whom the chains of patronage, 'friendship,' or connection converged."[9] Displayed in galleries or reception rooms of town or country houses, pictures were seen by numerous visitors, who often toured the countryside expressly to visit the big landowners' showy houses and landscape gardens.[10] Art galleries were thus "public" spaces in that they could unequivocally frame the only "public" admissible: well-born, educated, men of taste, and, more marginally, well-born women.[11]

If art galleries signified social distinction, they could do so precisely because they were seen as more than simple signs of wealth and power. Art was understood as a source of valuable moral and spiritual experience. In this sense, it was cultural property, something to be shared by a whole community. Eighteenth-century Englishmen as well as Frenchmen had the idea that an art collection could belong to a nation, however they understood that term. The French pamphleteers who called for the nationalization of the royal collection and the creation of a national art museum[12] had British counterparts who criticized rich collectors of their day for excluding a larger public, especially artists and writers, from what by right should have been accessible.

Thomas Lawrence, Benjamin West, and Joshua Reynolds, all prominent Royal Academicians, were among those who called for the creation of a national gallery or, at the least, the opening up of private collections. Even before the creation of the Louvre in 1777, the radical politician John Wilkes proposed that Parliament purchase the fabulous collection of Robert Walpole and make it the beginning of a national gallery. The proposal was not taken up, and the collection was sold to Catherine the Great.[13] A few years later, the creation of the Louvre Museum intensified the wish for an English national collection, at least among some. Thus in 1799 the art dealer Noel Joseph Desenfans offered the state a brilliant, ready-made national collection of old masters, assembled for King Stanislav of Poland just before he abdicated. Desenfans, determined to keep the collection intact and in England, offered it to the state on the condition that a proper building be provided for it. According to the German art expert Johann David Passavant, the offer "was coolly received and ultimately rejected." Desenfans' collection was finally bequeathed to Dulwich College. For years, it was the only public picture collection in the vicinity of London.[14]

In the years between the founding of the Louvre in 1793 and the fall of Napoleon in 1815, almost every leading European state acquired a national art museum, if not by an act of the reigning monarch, then through the efforts of French occupiers, who began museum-building on the Louvre model in several places. Why did the ruling oligarchs of Great Britain resist what was so alluring in Milan, Madrid, Amsterdam, and many other places? I believe that the answer to this question lies in the meaning of the art gallery within the context of eighteenth-century patrician culture.

Eighteenth-century Britain was ruled by an oligarchy of great landowners who presided over a highly ranked and strictly hierarchical society. Landed property, mainly in the form of rents, was the basic source of wealth

and the key to political power and social prestige. Although landowners also engaged in commercial and industrial capitalist ventures, profits were normally turned into more land or land improvement, since that form of property was considered the only gentlemanly source of wealth. Living off rents was taken to be the only appropriate way to achieve the leisure and freedom necessary to cultivate one's higher moral and intellectual capacities and thereby develop the wisdom, independence, and civic-mindedness necessary for the responsible exercise of political power. Spokesmen for the oligarchy also argued that a stake in land made their interests identical with the general interest and well-being of society as a whole.

The great landowners, both old and newly arrived, thus justified their monopoly of political rights on the basis of their landholdings. Yet, contrary to the claims of their apologists, they exercised power according to narrow self-interest. The business of government was largely a matter of buying and selling influence and positioning oneself for important government appointments, lucrative sinecures, and advantageous marriages for one's children. The more land one owned, the more patronage, influence, and wealth one was likely to command and the better one's chances to buy, bribe, and negotiate one's way to yet more wealth and social luster.[15]

To be even a small player in this system required a great show of wealth, mediated, of course, by current codes of good taste and breeding. A properly appointed country house with a fashionably landscaped garden was an absolute necessity; the higher a man's ambitions, the more grandiose the spectacle he was required to provide. If few landowners could compete with Horace Walpole's Houghton, the Duke of Marlborough's Blenheim, or the Duke of Bedford's Woburn Abbey, they could nevertheless assemble the essentials of the spectacle. As Mark Girouard has described it: "Trophies in the hall, coats of arms over the chimneypieces, books in the library and temples in the park could suggest that one was discriminating, intelligent, bred to rule, and brave."[16]

Art collections, too, betokened gentlemanly attainments, and marked their owners as veterans of the grand tour (mandatory for any gentleman). Whether installed in purpose-built galleries or in other kinds of rooms, collections provided a display of wealth and breeding that helped give point and meaning to the receptions and entertainments they adorned. Compared to today's academic discourse, the critical vocabulary one needed to master was decidedly brief, and the number of canonized old masters few: the Carracci, Guido Reni, Van Dyck, and Claude were among the most admired.[17] However shallow one's understanding of them, to display them in one's house and to produce the right clichés in front of them served as proof that one was cultivated and discerning, conversant in a discourse that identified members of the ruling elite. Whatever else they might have been, pictures were prominent artifacts in a ritual that marked the boundary between polite and vulgar society.[18]

Given the structure of the British oligarchy, the notorious self-interest of its higher-ranking magnates, and the social uses of art collecting, the unwillingness to create a national gallery until 1824 is not surprising.[19] Absorbed in a closed circle of power, patronage, and display, the ruling oligarchy had no compelling reason to form a national collection. Indeed, at this historical moment, it had good reason *not* to want one, since national galleries tended either to signal the advent of republicanism or to give a liberalized face to surviving monarchies attempting to replenish their waning prestige. In the late eighteenth and early nineteenth centuries, the men who dominated Parliament saw no reason to send either of these signals. In any case, their existing practices of collection and display already marked out boundaries of viable power and reinforced the authority of state offices.

Parliament claimed to represent the interests of the whole society, when in fact self-enrichment had become the central operating principle of its members. This contradiction became ever more glaring and ever less tolerable to growing segments of the population over the first few decades of the nineteenth century. Groups of industrialists, merchants, middle-class professionals, disgruntled gentry locked out of power, and religious dissenters often joined together to mount well-organized attacks on the structure and

policies of the government. They not only pressed the question of what class should rule, but also challenged aristocratic culture, contested its authority, and discredited some of its more prestigious symbols. Their most scathing and effective attacks on the culture of privilege would come in the 1820s and 1830s, when, among other radicals and reformers, the Benthamites, including the brilliant teenager John Stuart Mill, gave voice to widely felt resentments.[20]

From those decades date proposals for public art galleries, campaigns to increase the visiting hours of existing public museums, and attempts to abolish entrance fees to monuments. In the context of early nineteenth-century Britain, these efforts were highly political in nature and directly furthered a larger project to expand the conventional boundaries of citizenship. The cultural strategy involved opening up traditionally restricted ritual spaces and redefining their content. This struggle to protect and advance the claims of "the nation" by controlling its ritual spaces would build as the nineteenth century wore on.

The concern for "the nation" easily shaded into feelings of a broader nationalism, appearing elsewhere in western Europe in the early nineteenth century, as well as patriotic sentiments, which the wars with France intensified. The opening of the Louvre Museum and its spectacular expansion under Napoleon sharpened these feelings of English-French rivalry and gave them a cultural focus. The marvels of the Louvre caused acute museum envy not only among English artists and writers like Hazlitt, Lawrence, and West, but also among some of the gentleman collectors who sat in Parliament and felt the lack of a public art collection as an insult to British national pride.[21] Both during and after the wars, however, the state was diffident about projects that might have fostered national pride. As the historian Linda Colley has argued concerning late eighteenth- and early nineteenth-century England, to encourage nationalism was to encourage an inclusive principle of identity that could too easily become the basis of a political demand to broaden the franchise. It is no surprise that the expression of nationalist feeling came from outside the circles of official power.

Typically, it took the form of proposals for cultural and patriotic monuments, as well as charitable institutions and philanthropic gestures.[22]

Thus in 1802 the wealthy and self-made John Julius Angerstein, the creator of Lloyds of London, set up a patriotic fund for dependents of British war dead and contributed to it generously. He then published the names of all those who gave to the fund, noting exactly how much each gave. This tactic both exposed the landed aristocracy as selfish and unpatriotic and publicized commercial City men like himself as civic-minded and generous. Indeed, Angerstein clearly saw himself as the equal, if not the better, of any lord of the realm, and he lived accordingly. With his immense fortune and the help of artist friends like Thomas Lawrence, he amassed a princely art collection of astonishing quality, installed it in magnificently decorated rooms in his house in Pall Mall, and—again, in pointed contrast to many aristocratic collectors—opened his doors wide to interested artists and writers. But not all doors were open to Angerstein. As a Russian-born Jew who lacked formal education and was reputedly illegitimate, he could not gain position and status in the higher realms of society.

It seems especially fitting that, after Angerstein's death in 1823, his art collection would become the nucleus of the British National Gallery. In a move promoted by Thomas Lawrence, the state was allowed to purchase the best of Angerstein's collection—thirty-eight paintings—at a cost below their market value. (The Prince of Orange had been willing to pay more, and the fear of losing the collection to a foreigner was a factor in prompting Parliament's approval of the purchase.) At the same time, Sir George Beaumont, a gentleman artist and active patron of the arts, made known his intention to donate paintings from his collection, on condition that the state provide suitable housing for them.[23] Beaumont's offer, combined with the prestige of the Angerstein Collection, tilted the balance in favor of a national collection.

In any case, by 1823 there was considerable Parliamentary support for such a collection. Lord Liverpool, the prime minister, and his Home Secretary Sir Robert Peel, both of whom were art collectors, backed the idea.

Working out just where it would be and who would oversee it occasioned considerable political skirmishing. The trustees of the British Museum clearly expected to take in the new collection. They had already earmarked a space for the anticipated Beaumont bequest in their proposed plans for a new building. In the face of fierce Parliamentary opposition, that plan fell through. The problem was solved when the government was allowed to buy the remainder of the lease on Angerstein's house in Pall Mall, and the new National Gallery opened there in May 1824. Thus, intentionally or not, Angerstein posthumously provided both the substance and the site for a prestigious new symbol of the nation.

There is every indication that Angerstein would have heartily approved and supported this transformation of his property. Both his son and executors thought so. As the latter wrote to a representative of the government: "Well knowing the great satisfaction it would have given our late Friend that the Collection should form part of a National Gallery, we shall feel much gratified by His Majesty's Government becoming the purchasers of the whole for such a purpose."[24] Indeed, Angerstein's son believed that, had it been proposed to his father that he contribute to a National Gallery, "he might have given a part or the whole [of his collection] for such a purpose."[25]

This brings me back to the larger, historical issue with which I began. Although the story of the founding of the National Gallery lacks a decisive revolutionary triumph, it nevertheless resulted in the creation of a monument that both acknowledged and celebrated a new concept of the nation in Britain. The term "nation" was often used in the context of a middle-class campaign to dispute the claim of the privileged few to be the whole of the polity. In political discourse the nation could even be a code word for the middle class itself. In any case, it asserted that British society consisted of more than those presently enfranchised.[26] The founding of the National Gallery did not change the distribution of real political power—it did not give more people the vote—but it did take a portion of prestigious symbolism from an elite class and give it to the nation. An impressive art gallery, a type of ceremonial space deeply associated with social privilege and exclusivity, became national property and was opened to all. The transference of the property as well as the shift in its symbolic meaning came about through the mediation of bourgeois wealth and enterprise, legitimated by a state that had begun to recognize the advantages of such symbolic space.

The story, far from ending, was only at its beginning when the National Gallery opened in 1824. The struggle between nation and class was still heating up politically. Years of resentment against the aristocracy, long held in by the wars, had already erupted in the five years following Waterloo. If the violence had subsided, the political pressures had not. Throughout the 1820s a strong opposition, often Benthamite in tone and backed by a vigorous press, demanded middle-class access to political power and the creation of new cultural and educational institutions. This opposition ferociously attacked hereditary privilege, protesting the incompetency of the aristocratic mind to grasp the needs of the nation, including its cultural and educational needs, and the absurdity of a system that gave aristocrats the exclusive right to dominate the nation. After the passage of the Reform Bill in 1832, elections sent a number of radicals to Parliament, where, among other things, they soon took on the cause of the National Gallery.

Debate was immediately occasioned by the urgent need to find a new space for the collection, since the lease on Angerstein's old house in Pall Mall would soon end and the building was slated for demolition. In April 1832 Sir Robert Peel proposed to the House of Commons that the problem be solved by the erection of a new building. He had in mind a dignified, monumental structure ("ornamental" was the term he used), designed expressly for viewing pictures. The proposal passed easily, but not before it sparked a lively discussion, with many members suggesting alternatives. A few even toyed with the possibility of a British Louvre: instead of spending public money on a new building, they argued, why not put the collection in one of those royal buildings already maintained at public expense? Indeed, as one speaker noted, Buckingham Palace would make a splendid art gallery—it already had a gallery space and, as a public art

museum, it would be bigger and better than the Louvre! It was Joseph Hume who took the idea to its logical and radical conclusion. Since the nation needed a new art gallery, and since the government spent huge sums to maintain royal palaces which royalty rarely or never occupied, why not pull down a palace and build an art gallery in its place? In Hume's view, Hampton Court, Kensington Palace, or Windsor Castle would all make fine sites for a new public space.[27] Hume's proposal could hardly have been serious. But it does expose, if only for an instant, an impulse in the very heart of Parliament to demolish venerable symbols of British royalty and claim their sites for the public.

In the 1830s, as the new building on Trafalgar Square progressed, radical and reforming members of Parliament became increasingly interested in the arts, especially in the ways they might benefit society. In 1835 a select committee of the House of Commons was created and charged to discover "the best means of extending a knowledge of the Arts and of the Principles of Design among the People . . . (and) also to inquire into the Constitution, Management, and Effects of Institutions connected with the Arts."[28] The committee, chaired by the renowned politician William Ewart, included other well-known radicals: Thomas Wyse, Henry Thomas Hope, and the Benthamite John Bowring, long an editor of the famous *Westminster Review*.

The committee's main task was to discover ways to improve the taste of English artisans and designers and thereby improve the design and competitiveness of British manufactured goods. It was also intent on uncovering the ineptitude of the privileged gentlemen to whom the nation's cultural institutions were entrusted. For this committee, the management of the national collection was a matter of significant political import. Most of the members were convinced that art galleries, museums, and art schools, if properly organized, could contribute to social unity and order. Experts of all kinds affirmed the belief that the sight of art could improve the morals and deportment of even the lowest social ranks. Accordingly, there was much zeal attached to the cause of removing fees and other obstacles to the nation's improving monuments. All of these issues were aired not only in the Select Committee Report of 1836 and its published proceedings, but also in subsequent Parliamentary proceedings, in other public meetings, and in the press at large.

Reforming politicians were not only concerned with the utilitarian benefits of art. They also believed that culture and the fine arts could improve the quality of national life. To foster and promote a love of art in the nation at large was political work of the highest order. As practical politicians, they were usually more ready to exploit the issue politically than to explore it theoretically, but their political writings and speeches sometimes show considerable thoughtfulness. Thus in 1837, at a gathering for the purpose of promoting free admission to all places in which the public could see works of artistic and historical importance, a number of politicians made speeches, including the radical Members of Parliament Joseph Hume, John Bowring, and John Angerstein, son of John Julius.

Perhaps the most interesting speech was delivered by Thomas Wyse, a member of the Select Committee of 1835 and well known as an Irish reformer. The real issue in the question of free admission, argued Wyse, was the conflict between the needs of the nation and the interests of a single class. The outcome was important because art, far from being a mere luxury, was essential for a civilized life. Art is "a language as universal as it is powerful," said Wyse; through it, artists leave "an immediate and direct transcript" of moral and intellectual experience that embodies the full nature of man. The broad benefits of art therefore belong by natural right to everyone—the nation as a whole—and not just to the privileged few.[29] As Wyse argued on a similar occasion, however great English commercial achievements, no nation is whole without the arts: "Rich we may be, strong we may be; but without our share in the literary and artistic as well as scientific progress of the age, our civilization is incomplete."[30]

For Wyse, as for many other reformers of his day, progress toward this goal could be brought about only by removing from power a selfish and dull-witted aristocracy and replacing it with enlightened middle-class leadership. These ideas run through the

Select Committee hearings of 1835 and its report of 1836. Radical committee members, led by Ewart, pounced on anything that could demonstrate the ill effects of oligarchic rule, anything that showed, as Ewart put it, the "spirit of exclusion in this country," which has allowed art-collecting gentlemen to monopolize the enriching products of moral and intellectual life.[31]

It was just now that the National Gallery, having lost its house in Pall Mall, was on the point of moving into its new building on Trafalgar Square. Paid for by the government, the building would have to be shared with the Royal Academy. This situation, in the opinion of the committee, amounted to government support for a body that was the very soul of oligarchic patronage, an institution that actually retarded the cultivation of the arts in England. It was for this reason, Bowring insisted, that a separate National Gallery was so needed.

But *was* the National Gallery a truly *national* institution? Here, certainly, was an entity purporting to serve the cultural needs of the whole nation. But did its planners and managers understand those needs? Alas, as so many testified, prompted and prodded by Ewart, Bowring, and the others, the National Gallery was a sorry thing compared to the Louvre, to Munich's Pinakothek, to Berlin's Royal Gallery. As the eminent picture dealer Samuel Woodburn said, "from the limited number of pictures we at present possess, I can hardly call ours a national gallery."[32]

It was not simply the small size of the collection that was wrong. As the committee made plain, it was not enough to take a gentleman's collection and simply open it up to the public. In order to serve the nation, a national collection had to be formed on different principles than a gentleman's collection; it had to be organized and hung differently. And that was the crux of the problem: the British National Gallery had been managed by the same gentlemen who put the interests of their class ahead of national needs. So testified Edward Solly, a former timber merchant whose famous picture collection had been formed around advanced art-historical principles. Solly noted that, whereas other nations gave purchasing decisions to experts, in England the "gentlemen of taste" who made them had no idea of

what to put in a national gallery. Indeed, there were two entirely different sets of "requisites . . . for a person who is to form a national gallery of pictures, and for a gentleman who is to form a private cabinet for himself." With Ewart drawing him out, Solly advised the committee that gentlemen—creatures of fashion with no deep knowledge of art—were hardly up to the serious business of planning an acquisition program for a national collection worthy of the name.

Solly's opinion was inadvertently backed by the testimony of William Seguier, the first keeper of the National Gallery. Grilled at length by Ewart, his ignorance of current pedagogical theories and museological practices was of great political value to the committee. No, admitted Seguier, there was no plan for the historical arrangement of pictures according to schools. No, nothing was labeled, although he agreed it would be a good idea to do so. And no, he had never visited Italy, even though, as everyone now knew, Italy was the supreme source for a proper, publicly minded art collection. Nor was there any rationalized acquisitions policy, so that, as keeper, Seguier had been helpless to watch the buildup of Murillos and other things inappropriate to a national collection while nothing whatsoever by Raphael was acquired.

And what should a national collection look like? The committee had expert witnesses lined up to answer this question, and its members were well informed about developments in Munich, Paris, Vienna, Dresden, Berlin, and elsewhere—as officials of the National Gallery were not.[33] The Louvre was frequently cited as a model of museum arrangement and museum management in that art experts, and not just wealthy collectors, ran it.[34] Although no one from the Louvre testified at the hearings, the committee did have two star museum experts on hand. One was Baron von Klenze, director of Munich's new museum. His descriptions of its art-historical arrangements and labeling, not to mention its fireproofing, air heating, and scientifically researched lighting and color schemes, inspired much admiration and envy. The other star witness was Gustav Friedrich Waagen, a leading art-historical authority and director of the Royal Gallery in

Berlin. He told the committee that a public collection had to be historically arranged because "following the spirit of the times and the genius of the artists would produce a harmonious influence upon the mind of the spectator." Waagen also insisted that Renaissance art from the time of Raphael would form the best taste, but that Raphael's fifteenth-century Italian predecessors were also necessary, as were representative works from earlier times.

The point to be made (and the committee made it repeatedly) was that the traditional favorites among gentleman collectors, what still passed among them as "good taste," would no longer do. The committee therefore recommended that the National Gallery change its course and focus its efforts on building up the collection around works from the era of Raphael and his predecessors, "such works being of purer and more elevated style than the eminent works of the Carracci."[35] Needless to say, the aristocratic canon had placed the Carracci at the pinnacle of artistic achievement.

The committee published its report in 1836, but the objectives for which it struggled were far from won. It would in fact require decades of political pressuring and Select Committee probings before the National Gallery would conform to the type developed on the continent. And that day only arrived in the third quarter of the nineteenth century when the state fully recognized the advantages of a prestigious symbol that could stand for the nation united under presumably universal values. As the historian Edward P. Thompson has noted, it is a peculiarity of the English that the formation of the bourgeois state—and of its supporting culture—has evolved slowly and organically out of a complex of older forms. So, too, its National Gallery.

A revised version of this paper has appeared as part of a chapter in my book, *Civilizing Rituals: Inside Public Art Museums* (London and New York, 1995).

I am deeply grateful to Andrew Hemingway for his many valuable suggestions and for the careful critical reading he gave this paper. I am also indebted to Josephine Gear for her incisive comments and to Gwendolyn Wright for her fine editing.

1. Nathaniel Burt, *Palaces for the People: A Social History of the American Art Museum* (Boston and Toronto, 1977), 23. For another example of a writer who has understood public art museums in terms of the Louvre, see Alma Wittlin, *The Museum: Its History and Its Tasks in Education* (London, 1949), 132–134.

2. Peter W. Thomas, "Charles I of England: A Tragedy of Absolutism," in *The Courts of Europe: Politics, Patronage, and Royalty, 1400–1800*, ed. A. G. Dickens (London, 1977), 191–201; Francis Haskell, *Patrons and Painters: Art and Society in Baroque Italy* (New York and London, 1971), 175; and Iain Pears, *The Discovery of Painting: The Growth of Interest in the Arts in England, 1680–1768* (New Haven, Conn., and London, 1988), 134–136.

3. Pears 1988, 106 and 133–136; and Janet Minihan, *The Nationalization of Culture* (New York, 1977), 10.

4. George I and George II added lavishly decorated state rooms and a grand stair. See John Haynes, *Kensington Palace* (London, 1985), 1–8.

5. As Tim Hilton wrote of this exhibition in *The Guardian* (2 October 1991), 36, "something seems not to be right" when people must pay £4 to view works that "seem to be national rather than private treasures," and "seem so obviously to belong . . . in the permanent and free collections of the National Gallery upstairs." On the other hand, Hilton also noted that the recently established Queens Gallery has been striving to make portions of this collection available to the public—without, however, changing the status of the collection as private property.

6. Pears 1988, 3.

7. See J.G.A. Pocock, *Politics, Language and Time: Essays on Political Thought and History* (London, 1972), especially chapter 3, "Civic Humanism and Its Role in Anglo-American Thought."

8. Pears 1988, 176–178; and Peter Fullerton, "Patronage and Pedagogy: The British Institution in the Early Nineteenth Century," *Art History* 5 (March 1982), 60.

9. Harold James Perkin, *The Origins of Modern English Society, 1780–1880* (London and Toronto, 1969), 51.

10. Mark Girouard, *Life in the English Country House: A Social and Architectural History* (New Haven, Conn., and London, 1978), 191.

11. Pears (1988, 3) and others have noted that the en-tire discourse on painting was explicitly addressed to gentlemen, not ladies.

12. For example, La Font de Saint-Yenne, *Réflexions sur quelques causes de l'état présent de la peinture en France* (The Hague, 1747 [Collection Deloynes, Bibliothèque Nationale, Paris]), 2:69–83.

13. Minihan 1977, 19; and Fullerton 1982, 59.

14. Johann David Passavant, *Tour of a German Artist in England* (London, 1836), 61; and Giles Waterfield, in *Collection for a King: Old Master Paintings from the Dulwich Picture Gallery* [exh. cat., National Gallery of Art and Los Angeles County Museum of Art] (Washington and Los Angeles, 1985), 17.

15. For the social and political workings of eighteenth-century society, I consulted Asa Briggs, *The Making of Modern England, 1783–1867: The Age of Improvement* (New York, 1965); Perkin 1969; Philip Corrigan and Derek Sayer, *The Great Arch: English State Formation as Cultural Revolution* (Oxford and New York, 1985); Edward P. Thompson, "The Peculiarities of the English," in *The Poverty of Theory and Other Essays* (New York and London, 1978); and Raymond Williams, *The Country and the City* (New York, 1973).

16. Girouard 1978, 3.

17. John Rigby Hale, *England and the Italian Renaissance: The Growth of Interest in Its History and Art* (London, 1954), 68–82.

18. Pears (1988) explores this meaning of eighteenth-century collections in depth, especially in chapters 1 and 2. See also Corrigan and Sayer 1985, chapter 5.

19. For Parliament's neglect of the National Gallery after 1824, see Minihan 1977, 19–25.

20. George L. Nesbitt, *Benthamite Reviewing: The First Twelve Years of the Westminster Review, 1824–1836* (New York, 1934); Briggs 1965, chapters 4 and 5; and Perkin 1969, 287–291, 302.

21. See Minihan 1977, 13 and 22; and William Hazlitt, "The Elgin Marbles," *The Examiner*, 16 June 1816, in *The Complete Works of William Hazlitt*, ed. P. P. Howe (New York, 1967), 18:100–103.

22. Linda Colley, "Whose Nation? Class and National Consciousness in Britain, 1750–1830," *Past and Present* 113 (November 1986), 97–117.

23. For an excellent blow-by-blow account of the legal and legislative history of the founding of the National Gallery, see Gregory Martin, "The National Gallery in London," *The Connoisseur* 185 (April 1974), 280–287; 186 (May 1974), 24–31, and 187 (June 1974), 124–128. See also William T. Whitley, *Art in England, 1821–1827* (Cambridge, 1930), 64–74.

24. Whitley 1930, 66.

25. Whitley 1930, 68.

26. Because the issue of nationalism looms so large in today's political news, and because the terms *nation* and *nationalism* are now so much in currency, we must take care not to read modern meanings into early

nineteenth-century political discourse when it speaks of "the nation." In the eighteenth and early nineteenth centuries, one spoke of patriotism, not nationalism. Later ideas of the nation as a *Volk*, a community defined by unique spiritual yearnings or "racial" characteristics, are foreign to the early nineteenth-century political discourse I am describing. Although there was great concern for and interest in the uniqueness of English culture and literature, nations were generally understood and described in social, political, and economic terms, and the term *nation* was normally used as a universal category designating "society." See Benedict Anderson, *Imagined Communities: Reflections on the Origin and Spread of Nationalism* (London and New York, 1991), 4.

27. *Parliamentary Debates (Commons)*, new series, vol. 12 (13 April 1832), 467–470; and new series, vol. 14 (23 July 1832), 643–645.

28. *Report from the Select Committee on Arts, and Their Connection with Manufacturers*, in *Reports*, House of Commons, 1836, vol. 19.1, vol. 10.1.

29. George Foggo, *Report of the Proceedings at a Public Meeting Held at the Freemason's Hall on the 29th of May, 1837* (London, 1837), 20–23.

30. In a speech delivered at the Freemason's Tavern on 17 December 1842, reproduced in John Pye, *Patronage of British Art* (London, 1845), 176–185.

31. Select Committee 1836, 108.

32. Select Committee 1836, 138.

33. Select Committee 1836, 133.

34. Select Committee 1836, 137.

35. Select Committee 1836, x.

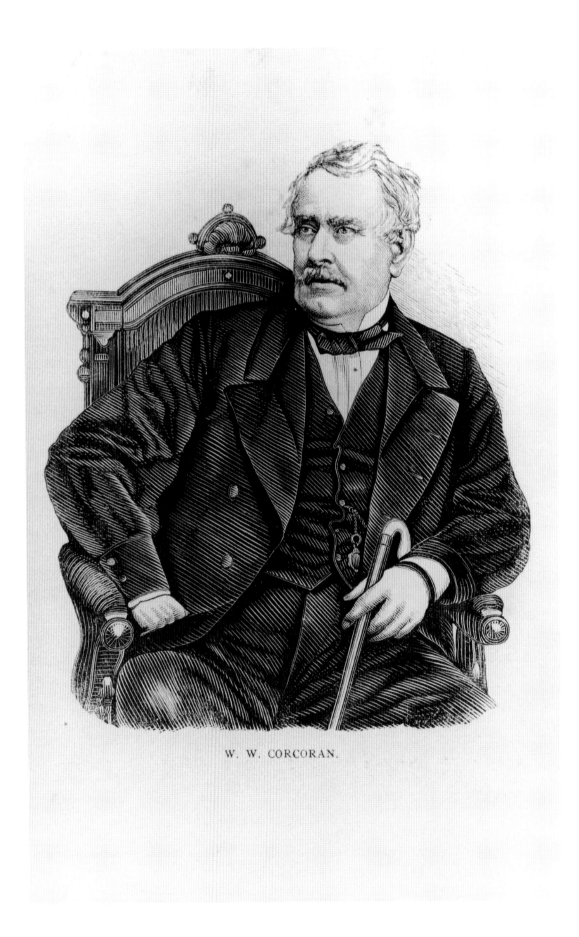

W. W. CORCORAN.

ALAN WALLACH
College of William and Mary

On the Problem of Forming a National Art Collection in the United States: William Wilson Corcoran's Failed National Gallery

How are national collections constituted? What are the general historical preconditions for establishing national museums and national galleries of art? There are, I believe, two such preconditions. They are fairly obvious, although they become perhaps somewhat less obvious when we begin to examine them in relation to historical examples.

The first precondition is that there must be a centralized state power that has the ability to create and sustain national institutions. It follows that when such power exists, particular institutions and groups may claim national status and in some situations may be capable of designating themselves "national," but their claims will in the long run be of relatively little consequence without the state's imprimatur. Second, the state must experience a need for a national gallery and a national collection. Needs of this sort vary, but they fall into two broad categories: the need to address a national audience, that is, to represent the nation to itself in a particular form and thus play a role in shaping it as what Benedict Anderson calls an "imagined community";[1] and, second, the need to address an international audience and thus represent the nation in relation to other nations.

I

Turning to the United States in the nineteenth century we encounter a situation in which neither precondition fully applies. In the period before the Civil War the country was, as Bertram Wyatt-Brown has put it, "held together largely by common memories of Revolutionary triumph and the making of the Constitution—and mutual indifference."[2] While it was possible with the Smithsonian for the state to create a national scientific institution, it can also be said that the Smithsonian was to a large degree an exception, an anomaly precipitated upon a federal government torn by sectional rivalries and notable for its general absence from cultural affairs.

Union victory in the Civil War produced the modern American state, a state whose "inheritance from the antebellum period was," in Richard Bensel's words "nil."[3] This new, centralized state, invented during the 1860s by a Republican Party juggernaut intent upon institutionalizing its program of industrial development and territorial expansion, possessed the ability to create national institutions pretty much at will. And yet, while Gilded Age capitalists amassed great collections in their palatial townhouses, and while between 1870 and 1900 municipal art museums multiplied at a dizzying rate, there was hardly any interest on the part of the federal government in the formation of a national art collection or national gallery. As Richard Rathbun, an assistant secretary of the Smithsonian and a highly interested observer of these matters, noted in 1909, "the cultivation of art, even

in directions promising practical benefits to the people, has never received encouragement from the national Government, except in the privilege of copyright and patent."[4]

Why was this the case? By the time Rathbun wrote, the idea of a national gallery and art collection had in one form or another been mooted for more than a century. In 1806 Jefferson had campaigned for a national university which, as he envisioned it, would incorporate Charles Willson Peale's Philadelphia Museum. Although known primarily for natural history collections organized in accord with the Linnaean system of classification, Peale's museum also featured portraits of heroes of the Revolution and of such figures as the naturalists Baron Cuvier and Alexander von Humboldt who presided over the glass cases displaying American mammals, birds, and fish.[5] Peale conceived of his museum as part scientific institute, part patriotic shrine, but his concept was not limiting. Peale himself had in 1789 exhibited a collection of Italian paintings, and later American museums, conceived along similar Enlightenment lines, often combined natural history displays with exhibitions of works of art. This was true for efforts in Washington, D.C., such as the Columbian Institute (1816–1838), John Varden's Museum (1829–1841), and the federally sponsored National Institution for the Promotion of Science, founded in 1840, which exhibited a collection of government-owned paintings in the great hall of the Patent Office Building during the 1850s. (The collection was known to some contemporaries as the "National Gallery.")[6] The National Institution took over Varden's Museum in 1841 and was in turn absorbed by the fledgling Smithsonian in 1862. Joseph Henry, the Smithsonian's first secretary, had no interest in running either a natural history museum or an art museum (he thought the Smithsonian should dedicate itself exclusively to scientific research), but he dutifully carried out the terms of James Smithson's will, which called for the creation of an art gallery, and thus in 1858 set up an exhibition of paintings in the Smithsonian building's west wing, only to abandon it in 1865 after a fire destroyed much of its contents.[7] This put an end to the Smithsonian's "National Gallery" for the remainder of the century.

The temples of art that began to appear in the large cities of the northeast and middle west after the Civil War bore little resemblance to what had earlier passed for a museum in the United States. Although Peale's Philadelphia Museum and the Washington predecessors of the Smithsonian were primarily devoted to educational scientific displays, for most of the antebellum public the word "museum" signified a form of popular entertainment, a collection of freaks and curiosities that could by no stretch of the imagination be described as scientific or enlightening. For example, Gardiner Baker's "American" or "Tammany Museum," which opened in New York in 1789, featured among other things a haphazard assortment of natural history specimens, a waxworks, Indian, African, and Chinese artifacts, a menagerie, a steamjack, a Scottish threshing machine, and a Gilbert Stuart portrait of George Washington.[8] Baker's museum later passed into the hands of George Scudder and was eventually sold to P. T. Barnum, who also bought up a number of Peale family museums.[9]

The elites that built big city art museums in the years between 1870 and 1900 were at pains to distance themselves from Barnum-like enterprises. Boston Brahmins, parvenu New York merchants, and Chicago industrialists labored for the institutionalization of high culture. Their efforts, as sociologist Paul DiMaggio has argued, involved the sacralization of certain cultural forms via definitions that rigorously distinguished between high art and its opposite, low or popular entertainment.[10] Although the definition of high art proved capacious enough to accommodate such elite preoccupations as collections of arms and armor and accumulations of antique musical instruments, it nonetheless served the purpose of delimiting cultural property. High art belonged to the elite and to a segment of the middle class. The institutionalization of high art meant "the acknowledgment of that classification's legitimacy by other classes and the state."[11]

The great magnates of the Gilded Age purchased culture by the carload. Matthew Josephson has described unforgettably how the robber barons "ransacked the art treasures of Europe, stripped medieval castles of their carvings and tapestries, ripped whole

1. *W. W. Corcoran*, c. 1874, wood engraving

From M.E.P. Bouligny, *A Tribute to W. W. Corcoran of Washington City* (Philadelphia, 1874), frontispiece. Corcoran Gallery and School of Art Archives, Washington

W. W. CORCORAN

staircases and ceilings from their place of repose through the centuries to lay them anew amid settings of a synthetic age and a simulated feudal grandeur." [12] Yet their acquisition of cultural property played across the divide between monopolization and hegemony, exclusivity and legitimation. As individuals these men practiced conspicuous consumption, vying to outdo one another in the richness and value of their holdings; as members of a class, they cooperated in creating civic institutions over which they exercised exclusive control. Torn between building monuments to their personal fortunes and monuments to their civic-mindedness, they found themselves caught up in local politics and local society.

The history of the art museum in the United States in the late nineteenth century was thus intertwined with the peculiar histories of urban elites, the rise and fall of different groups within them, and their efforts to achieve cultural hegemony at the local level. [13] Consequently, while robber barons and captains of industry boldly hijacked the national economy, they displayed an uncharacteristic reticence when it came to the question of a national art museum or gallery.

II

There was one exception: William Wilson Corcoran, financier, political operator, and founder of the Washington art museum that bears his name (fig. 1). For a brief historical moment, the Corcoran Gallery was the nation's premier art museum—and, as I shall argue, a would-be national gallery.

Although he lived to 1888, Corcoran was no robber baron but belonged instead to an earlier generation of bankers and financial speculators. [14] Born in 1798 into a well-to-do Georgetown family (his father was both a businessman and local politician), he went to work as a teenager for a Georgetown dry goods merchant and at the age of nineteen founded his own firm with help from his brothers. Although the company failed in the Panic of 1823, Corcoran had by then cemented lifelong ties with two other Georgetown dry goods merchants, Elisha Riggs, who went on to become a leading Wall Street banker, and George Peabody, Riggs' partner, who later made a fortune working in London with the financier Junius Morgan. Corcoran's career languished until 1837 when he opened a brokerage firm in Washington; two years later, with capital supplied by Elisha Riggs, he formed a banking partnership with Riggs' son George.

In the next few years, the firm of Corcoran & Riggs assumed the role of the defunct Bank of the United States as a repository of government funds. (With fitting symbolism, in 1845 Corcoran & Riggs also took over the bank's building, located diagonally across the street from the White House.) In addition, the firm played a profitable role as chief intermediary between the United States Treasury and the Wall Street money markets. In 1846 Corcoran arranged the financing of the Mexican War, taking on, over a period of two years, close to $24,000,000 in government bonds. When in 1848 the United States securities market declined, Corcoran successfully sold United States bonds in London and Paris. This was risky business, causing Corcoran's more conservative partner to withdraw from the firm, but in the end it brought Corcoran a bonanza.

At this point Corcoran could have retired, but he stayed on until Franklin Pierce's reform-minded Treasury secretary, James Guth-

rie, removed the federal deposits from the firm, thus depriving it of its favored position as the nation's leading "pet" bank. Yet even after leaving Corcoran & Riggs early in 1854, Corcoran remained in business as a large-scale investor and private banker, which meant that more or less as a matter of course he continued his deep involvement in politics. (He was, for example, part of the cabal that secured James Buchanan's election to the presidency in 1856.)[15]

Corcoran became known as the "American Rothschild," but he was not remembered as being especially brilliant or quick-witted. His outstanding traits as a businessman were "a keen opportunism" and a knack for diplomacy.[16] A Democrat at a time when the banking community tended to be Whig, Corcoran made the most of his connections with the dominant party. But he also knew how to get along with the opposition, and his bank maintained the same special relationship with the Whig administrations of Zachary Taylor and Millard Fillmore that had brought it prosperity with the Democrats. As a successful banker Corcoran "relished the authority, the prestige, and above all the sense of being in the center of things."[17] In 1849 he bought Daniel Webster's former residence at 1 Lafayette Square, directly across from the White House. He was, as Henry Cohen has written,

the Capital's outstanding host. His annual ball for the Congress and his weekly gourmet dinners were practically institutions, as well as useful instruments of goodwill. When Jenny Lind, the famous singer (and shrewd business-woman), appeared in Washington, it was natural that he was chosen to entertain her, and so with other eminent visitors.[18]

In 1854, when Corcoran was on the verge of retirement, George Peabody wrote from London urging him to reconsider: "It is true you don't want more money; but if you retire, I think you will sigh for that particular occupation and excitement which both you and myself have been accustomed to all our business lives."[19]

Yet if Corcoran gave up "that particular occupation," he did not want for excitement. Politics and private investing provided it in abundance, as did the creation of an art gallery which in effect was for Cor-

coran politics by other means.

Corcoran pursued his interest in art with the same combination of diplomacy and opportunism that marked his business career. Taking a cue from his European associates, he began, in the late 1840s, to collect European landscape and portrait paintings in a serious manner. In 1850 he expanded operations, buying the work of American artists and, as one contemporary observed, was always on the lookout for "conspicuous examples."[20] Among his early purchases were Daniel Huntington's *Mercy's Dream* of 1850, a fashionable work at the time; Thomas Cole's 1837 series the *Departure and Return*, which Corcoran obtained for $6,000 from William Van Rensselaer, scion of an ancient, aristocratic New York family; and Hiram Powers' *Greek Slave* (fig. 2), antebellum America's most popular sculpture (Powers made five replicas; Corcoran's was the first), a work that many at the time interpreted as a representation of the quintessential woman and some saw as the quintessential slave.[21] More than any other acquisition, *The Greek Slave* secured Corcoran's reputation among his contemporaries as "a righteous man and a true critic of art, who would never purchase a work of art that was of inferior quality or in poor taste."[22] (Beyond the issue of "taste," one wonders what Powers' *Greek Slave* actually signified for Corcoran and his circle of financiers and politicians, especially since he was, like so many who were close to him, a slaveholder.)

As his collection of American art grew, so did his reputation as patron and benefactor. He bought not only "name" works but works by unknown American artists. He was also in 1856 a founding member of the Washington Art Association, which he supported by buying works from its artist members, providing exhibition space and paying exhibition expenses. William MacLeod, a landscape painter and later curator of the Corcoran Gallery, vividly recalled the "sumptuous dinner" Corcoran held at his house for members of the association at the close of their 1859 exhibition, where Corcoran, with "his fine personal appearance . . . [and] with the dignity of years struck his friends as the ideal of a courteous, wealthy friend of art."[23]

There was in all these activities an almost inexorable expansionist logic. Corcoran's grow-

2. *The Greek Slave. From
the Original Statue by
Hiram Powers*, c. 1877,
stereoscopic photograph
Corcoran Gallery and School of Art
Archives, Washington

ing art collection required a gallery of its
own, and in the early 1850s he hired James
Renwick, the architect who had designed
the Smithsonian Institution building, to re-
model his house on Lafayette Square to ac-
commodate a gallery, which he then opened
to the public two days a week.

There was nothing particularly unusual
in this development: earlier American col-
lectors and patrons, for example, Luman Reed,
had set up galleries of European and contem-
porary American works and, as a matter of
noblesse oblige, opened them to a polite au-
dience. But by the mid-1850s, Corcoran's
ambition had enlarged even further. He vis-
ited Paris in 1855 and was deeply impressed
with the additions to the Louvre being built
under the direction of Louis Bonaparte's ar-
chitect, Hector Lefuel. (Renwick was in Paris
at the same time and may well have viewed
the "new" Louvre with Corcoran.) Back in
Washington, Corcoran became, as we have
seen, the éminence grise of the Washington
Art Association. The association was not
only dedicated to exhibiting local artists; it
also embodied a larger aim which a writer in
1859 described as establishing "a 'National

Gallery of the Fine Arts' in the metropolis of
the nation, to call the attention of the gov-
ernment to the neglects, the narrowness,
and the caprices of national patronage; to
ask protection for genius; to excite our pub-
lic men to constitute themselves the true
patrons of the living genius of the land."[24]

Corcoran committed almost none of his
thoughts on art to paper; consequently, this
description is probably the closest approxi-
mation available of his ideas on the subject
of a national gallery and a national program
for the arts. Having seen the Louvre in Paris—
and in all likelihood having been impressed
by the French tradition of government pa-
tronage—Corcoran now contemplated an
American Louvre, a national institution ded-
icated to the history of art and to the promo-
tion of national "genius." Such a vision re-
quired prompt action. Skilled at operating
behind the scenes, Corcoran probably at first
intended a national gallery to be the work of
the Washington Art Association; but if that
was the case, he evidently changed his mind.
Impatient, accustomed to having his way, in
the end he bypassed the association and set
out on his own. Renwick was engaged, land

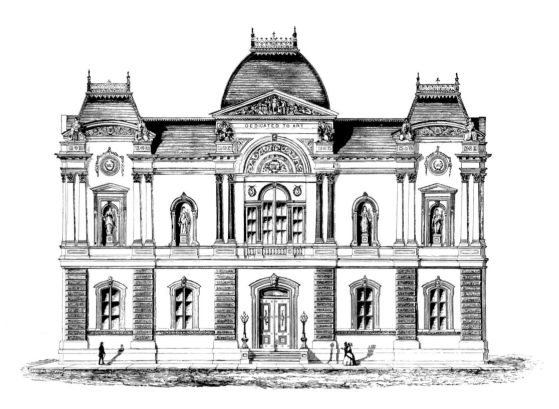

3. *The New Gallery of Art, Washington, D.C.*, c. 1860, wood engraving
Corcoran Gallery and School of Art Archives, Washington

acquired at the corner of Seventeenth Street and Pennsylvania Avenue (diagonally across from the White House and directly across from the War Department), and in 1859 work was begun. By 1861 Renwick had almost completed the exterior of the Louvre-like Renaissance revival building, and the words "Dedicated to Art" had been inscribed over the entrance. In the process, the national gallery became the Corcoran Gallery of Art (fig. 3).[25]

III

At this point things began to go seriously awry. Corcoran opposed the Civil War, but when it came, his loyalties, like those of many Washingtonians, were with the South.[26] Resentment against him grew. It was known that he handled financial matters for several Confederate leaders including Jefferson Davis, and that he entertained Southern sympathizers in his home. He began to take precautions. In the fall of 1861 he shipped his fortune abroad. A year later he went into exile in Europe. Many never forgave him this desertion.[27] He returned to Washington in 1865 to find his gallery

turned into a Union Army clothing depot and the Republicans out for revenge. Secretary of State Edwin Stanton spent a year harassing him with tax evasion proceedings. Corcoran worked to rebuild his position but did not attempt to conceal his sympathies. He gave money to Virginia colleges damaged by the war. He built a home in Washington for genteel Confederate widows down on their luck. In 1870 he presided over a memorial meeting for Robert E. Lee. In 1873 he helped found the Southern Historical Society, an organization dedicated to promoting the Confederacy's version of the Civil War.

Yet if Corcoran publicly supported the defeated South, he also exhibited a zealous patriotism as part of his effort to reconstitute his position as a national figure. He became an "extremely active member," as Davira Taragin notes, of the Washington Memorial Society. He also involved himself in the building of a monument to Thomas Jefferson and gave generous support to the restoration of Mount Vernon.[28]

But it was his art gallery that was to be the main vehicle for his national aspirations, and it presented difficult problems. Having

confiscated it during the Civil War, the federal government at first refused to restore it to him. There was first a wrangle over rent. Eventually agreements were reached. The sequence of events can be summarized as follows: in May 1869 Corcoran deeded the gallery to a board of trustees consisting mainly of business allies and associates including his old banking partner George W. Riggs.[29] In September the government returned the gallery, and in May 1870 Congress granted the trustees a charter of incorporation. Work on the building resumed a month later, and in February 1871 Corcoran celebrated its completion with a ball that was, according to a contemporary newspaper account, "the most magnificent . . . ever held in Washington."[30] The ball took place on Washington's Birthday and was meant to raise funds for the Washington Monument Society; it also marked the reconciliation of Washington's indigenous elite, which had sided with the South during the Civil War, and Republican officialdom, which on this occasion included not only President Ulysses

S. Grant and Vice President Schuyler Colfax but also General William Tecumseh Sherman who stood shoulder-to-shoulder with Corcoran at the head of the receiving line. Three years later, the Corcoran Gallery opened its first exhibition with the president and other high officials once again in attendance.

In his 1869 letter to the gallery's future trustees, Corcoran stated his intention of creating an institution "to be 'Dedicated to Art,' and used solely for the purpose of encouraging American genius in the production and presentation of works pertaining to the 'Fine Arts,' and kindred objects."[31] Corcoran's language is reminiscent of the Washington Art Association's call more than a decade earlier for "the protection of [American] genius." In other words, Corcoran continued to adhere to a belief, characteristic of the period 1825–1860, that a truly patriotic art collector would be primarily concerned with fostering the development of contemporary American art. This idea, for the most part, determined the Corcoran Gallery's organization and its collecting policies during the

4. *The Sculpture Hall*,
c. 1880, photograph
Corcoran Gallery and School of Art
Archives, Washington

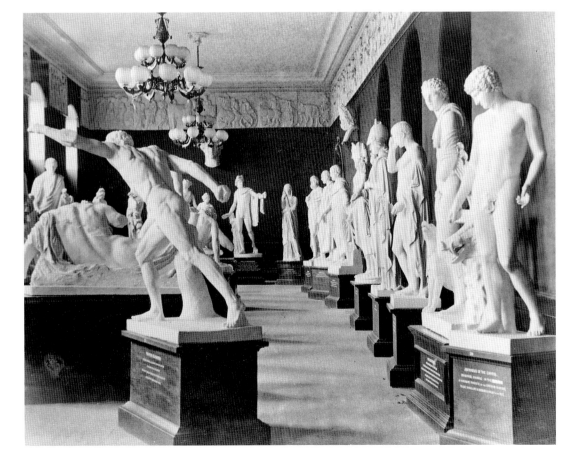

first decade of its existence.

The gallery projected a version of the history of art in which American art was seen as a continuation of a Western fine arts tradition stretching back to the ancient Greeks.[32] Visitors to the gallery in 1877, three years after it opened, encountered on the ground floor a stupendous collection of plaster casts, electrotype reproductions, and original works in marble, bronze, and ceramic.[33] The sculpture hall (fig. 4) at the back included full-size casts of the Elgin Marbles, the Discobolus, the Venus de Milo, the Medici and Capitoline Venuses, the Laocoön, the Apoxyomenos, the Apollo Belvedere, and dozens of other replicas of works belonging to the Louvre, the British Museum, the Vatican Museums, and so on. Other rooms contained copies of Renaissance sculpture, including casts of Ghiberti's *Gates of Paradise* and Michelangelo's *Slaves* (from the Louvre); electrotype reproductions of ninety objects from the South Kensington Museum as well as armor from various collections; and a number of original works including 114 bronzes by Antoine Louis Barye, majolica vases, and Japanese vases. Ascending the impressive main stairs (fig. 5), visitors found themselves moving along a north-south axis running from the Octagon Room, specially designed to display the *Greek Slave* (fig. 2), to the Main Picture Gallery, the Corcoran's own Salon Carré, where eighty-eight European and American paintings were exhibited in the closely packed manner characteristic of the period (fig. 6). This gallery was the heart of the collection, the culmination of the canonical history set forth on the lower level, and it displayed an indiscriminate mix of European and American paintings, almost all by contemporary artists, as if to demonstrate that American art could hold its own in international company—an important point for middle-class Americans in the nineteenth century, who tended to a prickly defensiveness when it came to the products of American culture.

To a degree Corcoran succeeded in his aims. As Taragin observes, "the role of the Corcoran Gallery of Art as a repository in the nation's capital of American masterpieces caused artists to believe it was a great honor to have their works included in the collection."[34] Indeed, the Hudson River

5. *Ground Plan of Gallery of Art*, c. 1877, wood engraving
Corcoran Gallery and School of Art Archives, Washington

School painter Albert Bierstadt went so far as to offer for sale a painting of an entirely fictitious "Mount Corcoran" in an effort to have his work included in the gallery.

But success in creating a gallery of American art was one thing, achieving national gallery status another. Although the Smithsonian made a loan during the 1870s of most of the paintings that had survived the fire of 1865, the loan did nothing to advance the gallery toward official status. Corcoran persisted. He began assembling a collection of portraits of presidents and other American notables, and in 1879 curator MacLeod made known Corcoran's idea that the gallery's "main objective was to collect portraits of national heroes."[35] But this was a move more appropriate to the age of Luman Reed and Charles Willson Peale than to that of Carnegie and Frick.

IV

Corcoran's initial plan for a national gallery may have seemed grandiose at the time, but he was probably the only person in the United States in the 1850s who could have reasonably entertained such an idea. Like the robber barons of a later generation, Corcoran achieved national influence while working his way up a local social ladder. However, because Corcoran was a Washingtonian, he faced two distinct although sometimes overlapping social hierarchies, one consisting of old Washington families, the other a government hierarchy extending from senators and representatives to cabinet members and the president. As part of a quasi-permanent shadow government, Corcoran identified with federal power and was capable of seeing that power in an international context. The plan for his gallery was thus a perfect symbolic vehicle for his position as the "American Rothschild." Not that the situation evolved as simply or as unambiguously as the previous sentence implies. Still, Corcoran's ambition—never directly articulated, although steadily pursued—took an entirely conventional form. As Pierre Bourdieu reminds us, a love of art, while it may mean many things, signifies above all else the quest for the only type of "distinction" bourgeois society allows.[36] That Corcoran sought such distinction is beyond doubt: not for nothing was his gallery "Dedicated to

6. *View of the Main Gallery*, c. 1880, photograph
Corcoran Gallery and School of Art Archives, Washington

Art." Yet his project was premature since its success required achieving on a national level a form of cultural hegemony that barely existed anywhere on a local level.

Perhaps Corcoran sensed as much. The particular type of national gallery he envisioned would have, in the words of the Washington Art Association's program, "excite[d] our public men to constitute themselves the true patrons of the living genius of the land." But such "true patrons" were not available before the Civil War—or after.

By then, Corcoran's ideas for a national gallery were rapidly becoming anachronistic. Despite his continuing efforts to win federal support, his gallery, like other big city museums of the period, functioned primarily as a monument to the cultural aspirations of a local, not a national, elite. When, almost a decade after his death, the gallery moved to its present location, it relinquished in symbol as well as in fact any lingering claim to national gallery status.

NOTES

My thanks to Barbara Dawson, former archivist at the Corcoran Gallery, for her help and encouragement, and to Paul Mattick and Phyllis Rosenzweig for criticism and advice.

1. Benedict Anderson, *Imagined Communities*, rev. ed. (London and New York, 1990).

2. Bertram Wyatt-Brown, "The South against Itself," review of William W. Freehling, *The Road to Disunion. Vol. 1: Secessionists at Bay, 1776–1854* (New York, 1991), in *The New York Review of Books* 38 (10 October 1991), 35.

3. Richard F. Bensel, *Yankee Leviathan: The Origins of Central State Authority in America, 1859–1877* (New York, 1990), ix.

4. Richard Rathbun, *The National Gallery of Art, Department of Fine Arts of the National Museum*, Smithsonian Institution United States National Museum, Bulletin 70 (Washington, 1909), 10.

5. See the correspondence between Thomas Jefferson and Charles Willson Peale in Lillian B. Miller, ed., *The Selected Papers of Charles Willson Peale and His Family*, 2 vols. (New Haven, Conn., and London, 1988), 2:974–975, 990–993. I am indebted to David Brigham, who is writing a doctoral dissertation on Peale's Museum at the University of Pennsylvania, for these references and for insight into Peale's enterprise. The standard text for this subject is Charles Coleman Sellers, *Mr. Peale's Museum* (New York, 1980).

6. Joshua C. Taylor, *National Collection of Fine Arts, Smithsonian Institution* (Washington, 1978), 5–12, gives a brief account of these institutions. For additional detail, see Rathbun 1909, 9–75.

7. Taylor 1978, 12–13; Rathbun 1909, 25–70; also see Wilcomb E. Washburn, "The Influence of the Smithsonian Institution on the Intellectual Life in Mid-Nineteenth Century Washington," in Francis Coleman Rosenberger, ed., *The Records of the Columbia Historical Society, 1963–1965*, 66 (1966), 96–121; and Wilcomb Washburn, "Joseph Henry's Conception of the Purpose of the Smithsonian Institution," in *A Cabinet of Curiosities: Five Episodes in the Evolution of American Museums* (Charlottesville, Va., 1967), 106–166. It should be noted that not all of the paintings owned by the National Institution ended up in the Smithsonian's collection.

8. See Robert M. and Gale S. McClung, "Tammany's Remarkable Gardiner Baker, New York's First Museum Proprietor, Menagerie Keeper, and Promoter Extraordinary," *The New-York Historical Society Quarterly* 42 (April 1958), 142–169; Lloyd Haberly, "The American Museum from Baker to Barnum," *The New-York Historical Society Quarterly* 43 (July 1959), 272–287.

9. See Sellers 1980, 276–307.

10. Paul DiMaggio, "Cultural Entrepreneurship in Nineteenth-Century Boston: The Creation of an

Organizational Base for High Culture in America," in Richard Collins, James Curran, and others, eds., *Media, Culture, and Society: A Critical Reader* (London, 1986), 196. In what follows I am indebted to DiMaggio's analysis and to arguments set forth in Pierre Bourdieu and Alain Darbel, *The Love of Art*, trans. Caroline Beattie and Nick Merriman (Stanford, Calif., 1990; originally published 1969).

11. DiMaggio 1986, 196.

12. Matthew Josephson, *The Robber Barons* (New York, 1962; originally published 1934), 332.

13. See DiMaggio 1986 for an account of how Boston's Brahmin elite built high cultural institutions in the period under consideration. For a study that reveals much about the ways in which local circumstances conditioned elite behavior, see Frederic Cople Jaher's monumental *The Urban Establishment: Upper Strata in Boston, New York, Charleston, Chicago, and Los Angeles* (Urbana, Ill., 1982).

14. For biographical information about Corcoran, see Roland T. Carr's anecdotal *32 President's Square* (Washington, 1980); Henry Cohen's excellent business biography, *Business and Politics in America from the Age of Jackson to the Civil War: The Career Biography of W. W. Corcoran* (Westport, Conn., 1971); William Wilson Corcoran, *A Grandfather's Legacy, Containing a Sketch of His Life and Obituary Notices of Some Members of His Family, Together with Letters from His Friends* (Washington, 1879); and Davira Spiro Taragin, *Corcoran* (Washington, 1976).

15. Cohen 1971, 228, graphically describes how Corcoran practiced the sort of casual corruption and chicanery typical for the period:

Corcoran ramified his political influence by loans, bribes, employment of agents, investments, and campaign contributions. Sometimes a specific quid pro quo was the important consideration; always there was the banking of good will. Out of the logrolling over scores of particular issues were improvised informal overlapping alliances that endured through successive controversies and influenced presidential politics. Most far-reaching was the chain opportunistically forged by Corcoran, Bright, and others through claims, Texas debt, [Lake] Superior speculation, railroad land grants, and other collaborations, leading in 1856 to the frustration of [Stephen A.] Douglas' presidential ambition, the election of the disastrous Buchanan, and the advancement of [John C.] Breckinridge.

16. Cohen 1971, 225.

17. Cohen 1971, 98–99.

18. Cohen 1971, 99.

19. Letter of 13 January 1854, cited in Carr 1980, 155–156.

20. Unattributed quotation in Taragin 1976, 14.

21. Taragin 1976, 13–14. I have here relied on Jean Fagan Yellin's incisive study of Powers' statue. See Jean Fagan Yellin, *Women & Sisters* (New Haven,

Conn., 1989), 99–124.

22. Taragin 1976, 14, paraphrasing a comment made about Corcoran in response to dismay over the figure's nudity.

23. William MacLeod, "Some Incidents in the Life of the Late Wm. Wilson Corcoran" (unpublished essay, n.d., MacLeod Papers, Columbia Historical Society, Washington), 1.

24. Mary J. Windle, *Life in Washington, and Life Here and There* (Philadelphia, 1859), 147.

25. In a letter of 5 October 1860, J. Goldsborough Bruff, "Recording Secretary," informed Corcoran that "at the first annual meeting of the 'NATIONAL GALLERY AND SCHOOLS OF ARTS,' held at Willard's Hotel, on the 2d instant, you were unanimously elected President of said institution" (William Wilson Corcoran Papers, Library of Congress, container 9). This new grouping was probably meant to supplant the Washington Art Association as the gallery's organizational base; however, Bruff's letter is the only record of its existence that I have come across. Presumably the group dispersed with the beginning of the Civil War.

Corcoran made no secret of his ambitions, and in letters to him numerous casual correspondents as well as friends and business associates refer to his gallery as the "National Gallery" or "National Art Gallery" or "National Gallery of Great Painting." For example, in a letter from London of 16 June 1869, George Peabody thanked Corcoran for his "kind note dated 11th inst., covering cuttings from the newspapers giving an interesting account of your magnificent donations to establish a national gallery of painting and sculpture in the city of Washington, connected therewith a Widow's Home" (in Corcoran 1879, 297–298).

By the late 1870s, Corcoran's reputation as the founder of a United States equivalent to a national gallery was fairly widespread. Thus Edward Strahan, author of a lavish series of volumes describing United States art collections, listed Corcoran as first among American collectors and observed that "The name of Mr. Corcoran . . . is on the most prosaic construction fit to go down with that of Mr. Vernon, who presented his picture-collection to England, and may be said to have founded the National Gallery; and with those of Augustine Sheepshanks, and Sir George Beaumont, who made equally generous dedications of their private hoards of pictures." See Edward Strahan (pseud. Earl Shinn), *The Art Treasures of America*, 3 vols. (Philadelphia, 1879–1882), 1:4.

26. In what follows, I have relied mainly on Taragin 1976 for information about Corcoran's activities during the 1860s.

27. For example, more than fifty years later the formidable Mary Smith Lockwood, historian general as well as founder of the Daughters of the American Revolution, recalled the stratagem Corcoran employed in 1862 to prevent the government from confiscating his house, and then made the following observation: "Those are days we would gladly forget.

We never want to think of a man turning his back on his country when she is in distress—especially one whom fortune had so kindly favored in his mother-land." See Mary Smith Lockwood, *Yesterday in Washington*, 2 vols. (Rosslyn, Va., 1916), 2:99.

28. Taragin 1976, 19–21.

29. Corcoran's letter to his board of trustees, the trustees' response, and the deed itself were immediately published. See the *National Intelligencer* (19 May 1869). These documents are preserved as part of the Corcoran Gallery's *Journal of the Official Proceedings of the Trustees of the Corcoran Gallery of Art*, Corcoran Gallery Archives.

30. *The Daily Patriot* (21 February 1871).

31. *National Intelligencer* (19 May 1869).

32. A series of eleven-foot statues on the building's façade complemented this program. Produced during the 1870s by the Richmond sculptor Moses Ezekiel, the statues represented Phidias, Michelangelo, Raphael, da Vinci, Titian, Dürer, Rubens, Rembrandt, Murillo, Canova, and Thomas Crawford, not coincidentally Ezekiel's teacher and today best remembered for the figure of *Armed Freedom* which surmounts the Capitol dome.

33. Information about the Corcoran's contents is derived from William MacLeod, *Catalogue of the Paintings, Statuary, Casts, Bronzes, & c. of the Corcoran Gallery of Art* (Washington, 1877).

34. Taragin 1976, 25.

35. Taragin 1976, 23.

36. See Bourdieu and Darbel 1990, 109–113; and Pierre Bourdieu, *Distinction: A Social Critique of the Judgment of Taste*, trans. Richard Nice (Cambridge, Mass., 1984; originally published 1979).

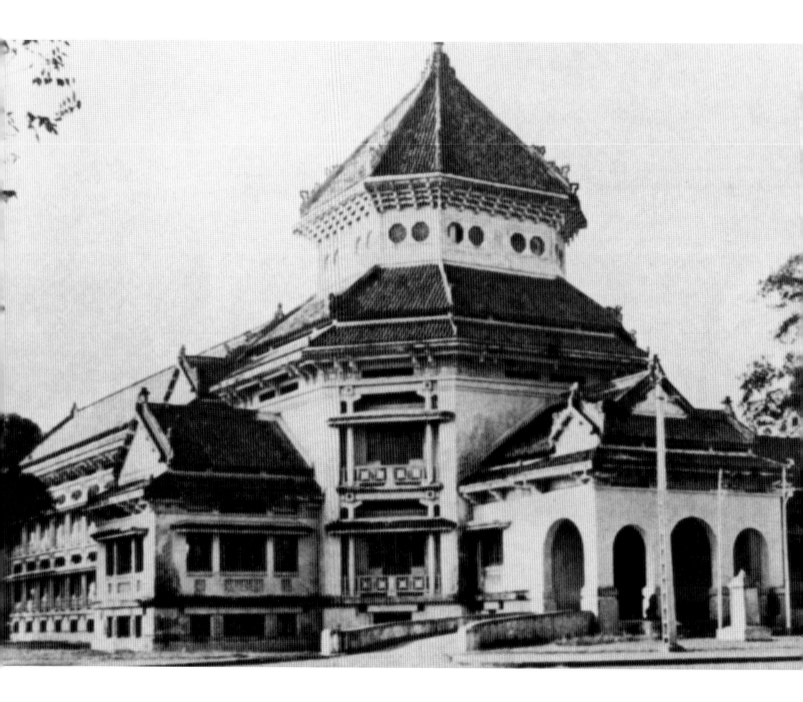

GWENDOLYN WRIGHT
Columbia University

National Culture under Colonial Auspices: The École Française d'Extrême-Orient

In a speech of 1929, inaugurating the École Française d'Extrême-Orient's capacious new museum in Saigon (fig. 1), Louis Finot, director of the École, acknowledged, "Some persons of a practical bent might ask what could be the usefulness of this museum. We answer that it will be threefold: scientific, educational, and touristic."[1] Indeed, this national collection represented deliberate attention to each of these three spheres. In doing so, the museum expressed French attitudes about culture—and culture's role in politics. The choice of objects, the methods of display and identification, even the design and location of the building, in turn revealed underlying premises about hierarchy and totalizing theories about art within the particular circumstances in colonial Indochina.

Historians of art in a postcolonial world have much to learn from the museums of French Indochina. These provincial institutions should not be seen in isolation from European counterparts. In both the metropole and the colony, we confront the issue of state power as well as state sponsorship. Is the representation and spatial geography of culture directly political? Questions might also be raised about the nature of collecting and classifying. How is it that certain artistic characteristics were honored and others ignored, certain patterns of lineage were included and others banished? Who made these decisions? On what criteria? And what were the repercussions of such purposes and

procedures outside the walls of the museum?

The École Française d'Extrême-Orient sought to study and display the art of a nation, but that nation—and therefore the "culture" being presented—was itself an artificial creation. France assembled the colony it called Indochina during thirty years of conquest. Piece by piece it first reconstituted the former Empire of Vietnam, although the French insisted on using the Chinese appellation "Annam," which alluded to Vietnam's long period of domination by China.[2] The three provinces they designated Cochinchina (Nam Bo, to the south) were conquered in 1862, followed by Tonkin (Bac Bo, to the north) and Annam (Trung Bo, in the center). To these were added large parts of the kingdoms of Laos and Cambodia—each quite distinct in terms of language, religion, and culture—and the leased Chinese territory of Kwang-Chou Bay.[3] In 1893 the French brought these various "states" together under the aegis of the Indochinese Federation, while maintaining somewhat different military and political conditions of rule in each one.

During these same years, European Orientalists were gathering knowledge about the classical civilizations of the area. If the economic opportunities of colonization stimulated national rivalries, so, too, did the opportunities for scholarship. A German linguist initiated the first comparative grammar of the Cham language (used in the central region of Vietnam, most notably in the fif-

teenth century), and a Dutchman began the first translation of Khmer temple inscriptions. Competitive French scholars openly admitted that the École was created, at least in part, "to remedy this humiliating situation."[4]

Governor-General Paul Doumer initially established a Mission Archéologique de l'Indochine in December 1898, then, a year later, changed its name to the École Française d'Extrême-Orient. (His model was obviously the prestigious French Schools at Rome, Athens, and Cairo, where renowned specialists studied the great classical civilizations of the Western past.)[5] A museum was mandated from the initial decree, and eventually five museums came under the École's auspices. Each one used Western ethnographic and aesthetic classifications to establish its principles for location and display. The museum staffs did not try to replicate distinctive protocols of presentation and beholding, nor functional or ceremonial use—how these objects had been or were still seen, experienced, understood, or judged by indigenous Asian peoples, whether scholars or monks, emperors or artists. They had something altogether different in mind.

Three small regional collections were created in major cities near the colony's most notable historic settings. For these the École collected "stage sets." First, in 1909 the new Cambodian Emperor Sisovat gave Governor-General Albert Sarraut a small, recently built palace; the French had it moved to the new commercial center of Phnom Penh's *ville nouvelle*, where the Khmer Museum finally opened in 1919, showing sculpture and casts from nearby temples, together with royal jewels and relics (fig. 2). The museum's official name was changed a few years later to honor the French official who had acquired the edifice.

The Cham Museum at Tourane was acquired in 1916. This collection used a building in a distinctly "assimilationist" style of architecture, that is to say, evoking the nineteenth-century colonial policy which had asserted the universality of French cultural norms. Under the supervision of the architect and art historian Henri Parmentier, the museum staff added a few Cham motifs to the façade before the official opening in 1919. The building was officially renamed in Parmentier's honor a few years later.

In 1914 the "Annamite" Emperor Khai Dinh donated the highly ornamented Tan Tho Vien Palace from the citadel in Hué. Originally built for his predecessor, the Emperor Thieu-Tri, in 1845, its relocation and conversion into a French museum was completed in 1919.[6]

Simultaneously the École also organized two national collections, one in the political capital at Hanoi, the other in Saigon, the colony's major commercial entrepôt and port of entry. The successive buildings that housed these collections were larger and more creolized in their architectural design, representing a broad spectrum of "Oriental" influence in the colony itself and in the intellectual purview of the École.

The École's earliest headquarters in Saigon, then the colony's capital, had housed a small private collection of artifacts and a library. When the capital of the Indochinese Federation was shifted to Hanoi in 1902, in an effort to escape pressures from powerful French commercial interests in Saigon, as well as that city's stifling heat and humidity, the École quickly set up a second office. There it opened a small museum to the public.

A typhoon destroyed the building only a year later, prompting the staff to send many of the objects that survived to the Louvre. In 1910 the École reopened its Hanoi collection, displaying artwork that had been stored in basements for seven years, for what had been sent to Paris was not repatriated—even to a colonial government. The new museum was created by adapting a residence that had served the early French legation to Tonkin for the ten years that preceded the military assault of 1883.[7] In his 1915 *Guide* to the collection, Henri Parmentier reflected that colonial history stood appropriately at the center of the institution, in the form of this "historic" French building.[8]

A burgeoning collection soon exceeded the space available. Hanoi's second museum building was demolished in 1925, as construction began on the École's major institution, completed in 1932 (fig. 3). Here, "logically classified and carefully labeled," the public could see "the most varied and most typical examples of the ancient arts of Indochina and its neighboring countries."[9] The riverside location, including a sizable sculpture garden, offered greater visibility as

well as historic eminence, at least in imperial chronology, for the French legation's headquarters and the first colonial offices had once stood on the site. This new museum was named for Louis Finot, who had recently retired as director of the École to take up a chair in Indochinese history and philology at the Collège de France, funded by the colonial government.

Ernest Hébrard, the colony's chief architect and first director of urbanism, drew upon the Vietnamese tradition of the village *dinh* as a temple and gathering place for the Finot Museum. He also suggested the École's broad sweep over all of Asia. While the structure used reinforced concrete, the style anticipates postmodernism with its hodgepodge of architectural motifs: the polychrome façade evoked Chinese temples; steep tiled porch roofs recalled Hindu temples in India; while the two-tiered roof of the central core alluded to temple structures from Cambodia, Laos, and Siam (today's Thailand). Hébrard was appealing precisely to French archaeologists and historians, to their knowledge of a diverse range of Asian stylistic traditions. *Colons* felt that French influence pervaded the composition, embodied in Hébrard's integration of all these separate architectural references. As an account in an early *Bulletin* of the École explained, "these coordinated elements cannot, all the same, fail to make us recognize the French inspiration of the whole."[10]

After decades of thwarted efforts, the Blanchard de la Brosse Museum was finally authorized in Saigon in 1927 and inaugurated two years later. It was named for the French governor of Cochinchina who donated a building already under construction near the Municipal Zoo in the Public Garden. No longer so conspicuously French, the structure achieved the desired effect in French colonial aesthetics during the epoch of "associationist" policy which had taken hold early in the twentieth century. This approach touted tolerance, even the encouragement of cultural difference: "Architecture of Asiatic inspiration," explained the catalogue, "adapted in the most subtle ways possible to modern needs."[11]

Inside the building (fig. 4), several minor adaptations sought "to give the cultivated public a taste for travel and the desire to deepen their curiosity about the world of the Orient."[12] Patios alluded to Chinese courtyards for mandarin scholars. Evoking both the timeless ideal of fine art and the unyielding grasp of colonialism, as well as the conventional entrance scroll, an immense Chinese character signifying "longevity" stood over the main entrance.[13]

The specialized museums at Phnom Penh, Tourane, and Hué presented characteristic examples of sculptural and architectural traditions from these regions. Hanoi and Saigon addressed the culture and cultural meaning of the colony as a whole; indeed, they offered a broader survey, situating Indochinese cultural artifacts and traditions within a wider spectrum of "Oriental" art from China, Japan, Thailand, and India. Each museum contained some rooms that emphasized a picturesque "exotic" simulation, grouping voluptuous objects for visual effect; other rooms relied on more "scientific" art-historical taxonomies, using display cases to facilitate comparisons.

Throughout the history of the École, the French divided Indochina according to historic spheres of influence. The two floors of Hanoi's museum and the two wings of Saigon's, as well as the two-volume guide to that collection, separated artifacts along a major axis: those arts "within the Chinese family" were grouped together in one place; those "within the Indian family" (Cham and Khmer art) in another.

"Prehistoric" bronzes stood in the entry halls at Hanoi and Saigon. "Sino-Annamite" bronzes, ceramics (fig. 5), and woodwork, mostly from central Vietnam, were aligned with Chinese art from the Han through the Ming dynasties, suggesting a more derivative—and overly decorated—aesthetic. Elsewhere Cham sculptures from central Vietnam, relics of an empire that flourished during the fifteenth century, received special attention as the "undiscovered" vestiges of a "forgotten" civilization—at least from the European perspective.[14] Nearby the principal displays grouped Khmer art into three periods, roughly chronological and overtly biological in concept: pre-Angkorian or "primitive" art of the Funan period (again borrowing a Chinese appellation of domination); "classic" Angkorian art of the eleventh and twelfth centuries; and "decadent" art from the past

seven centuries.

Overlapping these developmental principles one finds other hierarchies of meaning and authority in the École's museums. Each room honored a French military hero, government official, or scholar who had served in Indochina (fig. 6). Supposedly, this system would make it easier to remember the names of rooms, although the vast majority of visitors to these museums were Asian rather than French.[15] Each artifact was labeled according to the "art to which it belongs," using Western categories of influence, epoch, and locale. The objects, whether freestanding or in cases, were briefly identified, first in French, then in *quoc ngu* (a Latinized transcription of Vietnamese) or Khmer—but never in Chinese. After 1895, when the writings of Chinese reformers and nationalists like Sun Yat-sen began to seep into the colony, the French government and Catholic Church intensified their hostility toward the Chinese mandarin traditions that had prevailed in Vietnam before colonization.[16] Indeed, as the Chinese language was eliminated from official use, the museums intensified their focus on Cambodian and Cham art, which derived from Hinayana Buddhist sources in India.

Further amplifying the foreign domination of such pedigrees, the labels indicated the French donor or scientific mission whence the object had come, for this trajectory of ownership indicated provenance in colonial terms. Neither the artist nor the original (that is, Asian) owner was identified by name, with the exception of emperors or other royal personages.[17] For the European, "Oriental" art represented collective, rather than individual, value: the "essential" qualities of the culture. What one art historian of the era called its "continuity with the primitive" suggested anonymous makers and uncritical patrons.[18] Artistic quality "depended on the European's gaze to be discovered."[19]

From the inception of the École Française d'Extrême-Orient, scholarship and political intentions were closely intertwined. Doumer envisioned both "research in a purely scientific vein" and "public service, such that the members [of the École] are integrated into the governmental system of the colony."[20] Public service took several forms, including governmental knowledge of tribal rivalries

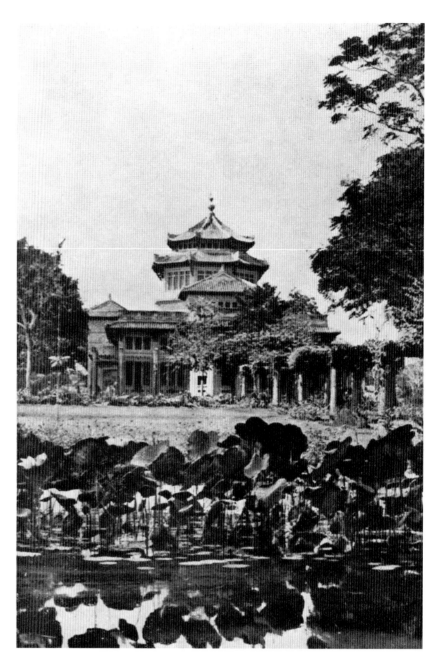

1. Blanchard de la Brosse Museum (now the National Museum), Saigon, Vietnam, 1927

From *Catalogue général des collections* (Hanoi, 1937)

and cultural precedents; the promotion of tourism; and publicity for the French *mission civilisatrice*. The École oversaw each of these domains. In return, the colony's general budget covered salaries and all other expenses, even though the École was officially responsible to the French Academy of Inscriptions and Belles Lettres in Paris.

Initially scholars concentrated exclusively on philological and archaeological research. In 1900 the École initiated efforts to protect significant historic monuments. The following

2. Albert Sarraut Museum
(now the Khmer Museum),
Phnom Penh, Cambodia,
1909–1919
From *Les arts indigènes au*
Cambodge (Hanoi, 1937)

3. Louis Finot Museum
(now the National Museum),
Hanoi, Vietnam, 1925–1932
From Louis Testeron and Maurice
Percheron, *L'Indochine moderne*
(Paris, 1932)

4. Interior of the Blanchard
de la Brosse Museum
From Testeron, *L'Indochine
moderne*

year social scientists began ethnographic
studies of various "savage" tribes. Profes-
sional librarians and curators then joined the
ranks. Some critics protested their conspicu-
ous predilection for Chinese and Indian
texts, at the expense of a deeper knowledge
about the language, history, and art of
French Indochina. One widely read journal-
ist, Jean Ajalbert, ridiculed Finot and the
"École facétieuse d'Extrême-Orient," accus-
ing them of spurious scholarship and Orien-
talist prejudices.[21]

Indeed, the École's sponsors and its staff
sought to gain both academic prestige and
popular visibility. They looked to Europe for
such validation, not to Asia. A few indige-
nous scholars were included, but none per-
mitted the autonomy of publishing under
his own name until 1939.[22] Only Western in-
tellectuals could identify and compare what
René Grousset, among others, called the
"enigmatic" patterns of "cultural genius"
that prevailed across a vast and varied ter-
rain.[23] Georges Coèdes announced proudly
that the École "defined the character of
[Laotian] art; it pierced the mystery of this
megalithic civilization."[24] If education was

indeed a goal of the École, both the instruc-
tors and the people they sought to teach
were Europeans. Such intellectual authority
in turn legitimated and assisted political con-
trol throughout the Middle East and Asia.
Orientalist scholarship was not innocent; it
involved what Edward Said has called "the
systematic accumulation of human beings
and territories"—as well as objects.[25]

The presence of the École was soon felt
throughout the colony. Official excavations
collected sculpture and bas reliefs from
abandoned temple sites. Nowhere does the
École's literature mention how its staff "ac-
quired" thousands of objects in stone, wood,
metal, porcelain, and paper. Donations, too,
were accepted without question. Disdainful
of "natives" for their failure to preserve cul-
tural artifacts and their willingness to pil-
lage for profit, the École offered no criticism
of French colonial administrators who dis-
carded objects once used to decorate their of-
fices; archaeologists eagerly gathered such
abandoned relics from basements and gar-
dens. The "scientific" value of the collec-
tions seemed beyond reproach, certainly
above the cultural value such objects might

5. Vietnamese ceramics at the Finot Museum

From *Bulletin de l'École Française d'Extrême-Orient*, 1933

6. Salle Douart de Lagrée, Parmentier Museum, Tourane, Vietnam

From Henri Parmentier, *Les sculptures chames au Musée de Tourane* (Paris, 1922)

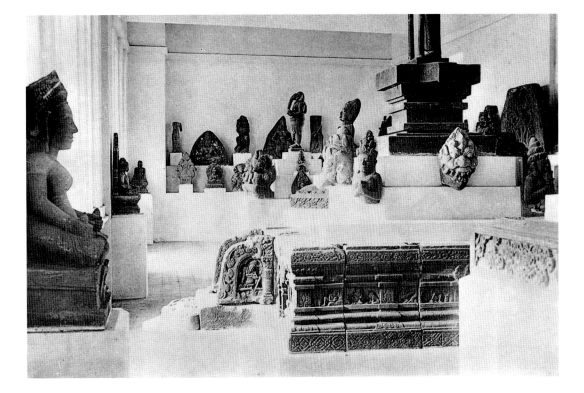

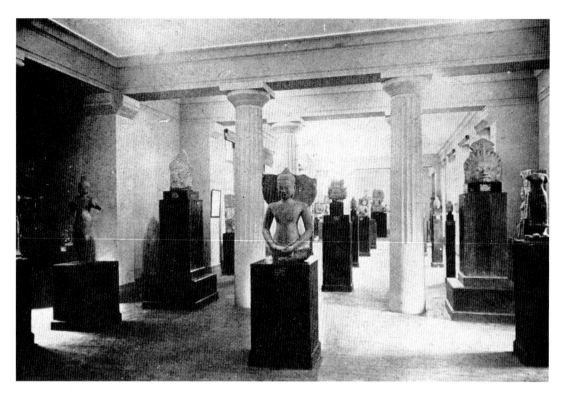

7. Interior of the Musée Guimet, Paris
From Testeron, *L'Indochine moderne*

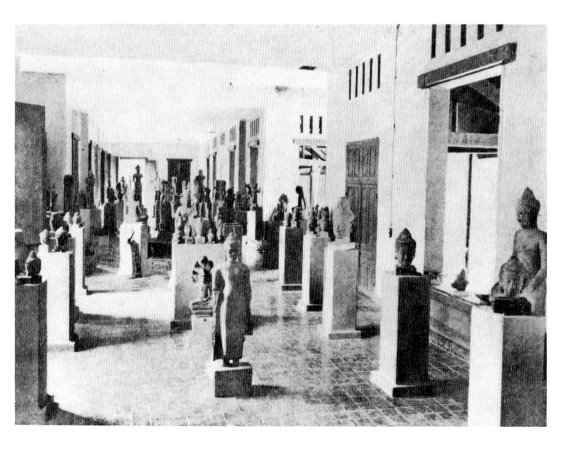

8. Sculpture gallery at the Sarraut Khmer Museum
From *Les arts indigènes*

have had in their place of origin.[26] Objects were appropriated, both literally and figuratively, and became museum property.

Asian, and especially Khmer, art had been the first non-Western category admitted into European collections, beginning in the eighteenth century. However, its place remained ambiguous, as Western scholars debated the extent to which it fit their universal categories of self-conscious refinement or revealed, in contrast, essentialist qualities of "Oriental character" and, for regional arts, particular local or dynastic tendencies. By the late nineteenth century, in the words of George Stocking,

the material culture of non-Western peoples had undergone a process of aestheticization. . . . Thus objects of "material culture"—which in traditional contexts had spiritual value [were] respiritualized (in Western terms) as aesthetic objects, at the same time that they [were] subjected to the processes of the world art market.[27]

Parisian collections of Oriental art, most notably the Musée Guimet (fig. 7) and the Louvre, were distinguished by discriminating selection and elegant installation. In contrast, the national museum of ethnography at the Trocadéro, established in 1878, showed a wider array of artifacts, grouped informally to emphasize "local color" and the exotic evocation of distant lands.[28] Both institutions stimulated the acquisitive taste of private collectors.

Indochina's museum staffs did not separate what might be called ethnographic pieces—artifacts that seemed to reveal something of the character of the peoples conquered by the French—from artistic objects that represented "universal" qualities of beauty (fig. 8). Their fervor for collecting did not allow for such discriminations. The accumulation of objects proceeded apace, with numbers doubling and sometimes tripling every decade, encompassing a wide array of types and quality.[29] The minimal labeling system assumed a language of art in which each piece would "speak for itself."

Responding to Europe's fascination with the Orient, colonial officials and museum staffs also recognized the potential for bringing tourists to Indochina by promoting visits to historic sites. Beginning in 1905 a specialized archaeological section of the École, under the leadership of the architect Henri Parmentier, initiated on-site research and restoration projects. Although Parmentier and his staff soon oversaw more than twenty sites throughout the colony, French colonial archaeology concentrated overwhelmingly on two locales: central Vietnam's monumental Cham sculptures, and the extraordinary twelfth-century remains of Khmer civilization in Cambodia. Diplomacy followed when the Franco-Siamese Treaty of 1907 gave France the rights to three northern provinces, which included the magnificent temple ruins at Angkor Wat lost to Siam in the nineteenth century.[30]

Elsewhere, numerous religious and civic monuments were demolished without protest as French commercial and residential districts developed. If the École's scholars were genuinely awed by the immense and intricate architectural legacy of Khmer civilization, they showed less appreciation for the more temporal and demure wooden temples that continued to serve contemporary Buddhists and Confucians. Besides, demolition of such structures often provided original sculpture and architectural objects for museum collections.

Colonial restoration techniques were immediately controversial. The French relied on their own imaginations, as well as the desire to complete a pleasing scene that would attract European visitors. They freely incorporated copies, even rough approximations of ornamental motifs, into reconstructions; reinforced concrete held up existing fragments of stone ceilings, walls, or lintels.[31] Archaeologists and curators recognized the need to stir the fantasies of the French public by making this distant landscape seem both enticing and familiar (fig. 9). Tropes of nature intertwined in the ruins of classical Greek and Roman antiquity, harking back to eighteenth-century aesthetic theorists, provided the basis for many photographic records of Cambodian and Vietnamese artifacts. Gigantic plaster replicas of various temple reconstructions graced the major colonial expositions in France (fig. 10).[32]

The same predilections entered museum environments. Copies did not pose a problem (so long as the labels distinguished casts and other replicas), for they smoothed the narrative of colonial history and filled gaps in the collections. It would be naive to see a

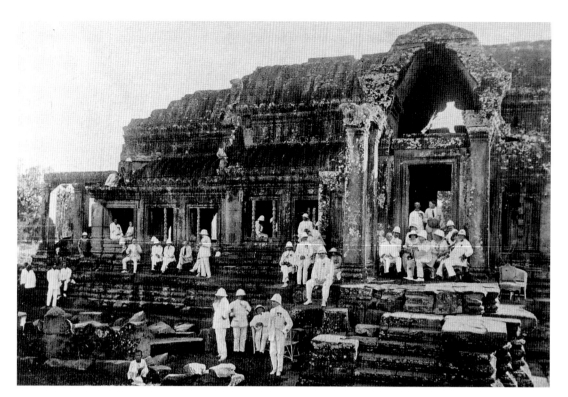

9. Tourists at Angkor Wat
From *L'Illustration* (1922)

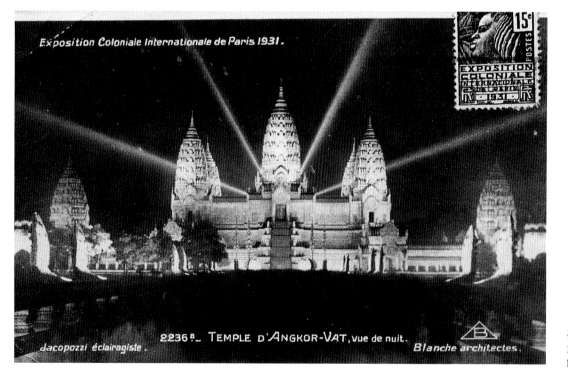

10. Recreation of Angkor Wat at the Colonial Exposition in Paris, 1931, postcard

11. Museum shop at the
Sarraut Khmer Museum
From *Les arts indigènes*

critique of the art object's "aura" in the acceptance of copies. The script of these national collections proclaimed European authority through the ability to dictate classifying systems and hierarchies of value. All of the familiar prisms for viewing both art and the culture from which it came—patronage, audience, modes of production, skill, iconography, and mnemic reference—seemed "primitive" as opposed to "evolved" in colonial contexts, at least to the Europeans who made the judgments.[33] This art had not yet reached a level that produced artists of individual genius or irreproducible objects.

The École's scholarly mission embodied a statement about the relations between art and power. France self-consciously placed itself in a line of great foreign nations which had for centuries controlled the culture and politics of Vietnam, Cambodia, and Laos. Curatorial preferences highlighted the artistic quality and sheer majesty of the Cambodian temples, the romantic appeal of monumental ruins, and the contemporary drama of geopolitics. Studying the domination of India and China in the past, which extended

from aesthetics to political control, scholars could help French administrators justify contemporary policies. "Let us not maladroitly cut the spiritual ties which join Indochina to the great powers of her Past," implored Governor-General Pasquier at the inauguration of the École's major museum in 1932; "these ties are tangled up with those of our own day, attaching her to France, a new incarnation of those Powers in the present."[34]

Admiration for the colony's august past could also contain a warning. "Only the Western nations," Pasquier continued, "which have pushed their progress to its limit, can recognize how foolish it is to break too brusquely with a past one gives up . . . under the pretext of modernization."[35] Moreover, only Westerners truly appreciated the glories of earlier Oriental civilizations. The École considered itself "the only guardian of historic relics in Indochina."[36] The French repeatedly expressed contempt for those "natives" who had allowed that legacy to fall into ruins. This attitude denied the legitimacy of permitting ancient temples

to decay if they no longer retained sacred meaning, just as it condoned the demolition of still-sacred pagodas which obstructed new development or did not fit into foreign categories of high art. All art and architecture was aestheticized, stripped of potent cultural meaning, then classified according to Western criteria of formal eloquence. Not indigenous culture, but Western aesthetics and property values determined value.

In celebrating the accomplishments of earlier eras, the French assured themselves, if not their subjects, of France's respect for a bygone way of life, their inherent superiority in the present day, and their permanent right to rule. This logic often became explicit. Governor-General Martial Merlin spoke of the French mission to "reawaken" a civilization that had been "for centuries now . . . mentally retarded, more or less asleep."[37] The majesty and accomplishments of Asia lay only in the distant past, disallowing any suggestion of eventual independence.

Decadence remained a pervasive theme in European Orientalism, from the opium fantasies of nineteenth-century poets to the formal categories of twentieth-century aesthetes.[38] The solution to "cultural decline," like the epithet itself, derived from the French. Assurance of value would come from the market, properly controlled by European experts. During the 1920s the École created village workshops to oversee "native" production of "authentic" artwork. Museum shops then offered these authorized objects for sale, alongside the historic art from which it derived (fig. 11). In Cambodia alone, the École organized sixty artists in such "corporations" between 1918 and 1920, and six hundred a decade later.[39] Together, the École, its museums, and the museum sales offices "guaranteed the necessary artistic and commercial value" of Oriental art.[40]

The very idea of a museum as an institution represented a strange intrusion in Vietnamese life: isolating objects out of their daily existence, venerating but also sterilizing—and commercializing—cultural practices. Yet museums and their collections can also encourage strong feelings of cultural and national solidarity through the display of that culture's artistic heritage, now made available beyond the mandarin elite. As Prince Buu-Lôc told a French audience in Paris in 1951, on the eve of Dien Bien Phu:

For more than twenty centuries, the Vietnamese people have always lived within the brilliant civilization that is their own, but without thinking about it. . . . Finally the École came, bringing with it a Western mode of analysis. . . . The civilization of our country . . . was then projected outside of us, brought before our eyes, . . . giving us a self-consciousness about ourselves.[41]

The École's scholars certainly enjoyed the praise, but probably missed the references, now so conspicuous, to the August 1945 Revolution when Ho Chi Minh had proclaimed the independence of the Democratic Republic of Vietnam.[42]

The aesthetics of design, the procedures for accumulating and selling, and the criteria of judgment made the École's museums into statements of cultural dominance. All the same, the artwork on display played other roles as well. Historic objects that referred to a centuries-long struggle for autonomy and cultural identity in Southeast Asia became public and accessible. The opinions of foreign scholars determined the location and organization of national collections in colonial Indochina; yet those views, no matter how strongly felt, could not preclude other potent responses to the works of art. Here, as elsewhere, every effort to control the interpretation and experience of artistic collections remains partial, whether it involves the narrative sequence of groupings and labels, or the hierarchies of façade, plan, and location.

1. Louis Finot, inaugural speech of 1 January 1929, cited in "Musée Blanchard de la Brosse," *Bulletin de l'École Française d'Extrême-Orient* [henceforth *BE*] 29 (1929), 505. On the École and its history, also see Louis Malleret, *Le cinquantenaire de l'École Française d'Extrême-Orient* (Paris, 1953), and Gwendolyn Wright, *The Politics of Design in French Colonial Urbanism* (Chicago, 1991), 193–199, 207–209.

2. After centuries under Chinese rule and then suzerainty, the Vietnamese empire had been re-founded by the Nguyen emperor Gia Long in 1802. The new capital was established at Hué. The expansionist Nguyens soon defeated the Trinh family, who ruled Tonkin, and annexed parts of Laos and Cambodia, though these cultures remained quite hostile. Independence was by no means absolute, however. Even the name Viet Nam had been ordained by the Chinese emperor. Nonetheless, reference to "Vietnam," suppressed by the French, was taken up in 1905 by the nationalist leader Phan Boi Chau. Ho Chi Minh (then Nguyen Ai Quoc) used it, too, when he founded the Vietnam Revolutionary Youth League in Canton in 1925. Two years later the Viet Nam Nationalist Party spread the term throughout the colonized population as a symbol of national liberation.

3. French Laos was assembled from a cluster of rival principalities, leaving more than half of the Lao-speaking population in Siam. Nor did the boundaries of French Cambodia conform to the distribution of the Khmer-speaking peoples. Some hundreds of thousands of them ended up trapped in Cochinchina, producing in time a distinct community known as the Khmer Krom ("Down-river Khmer").

4. "L'École Française d'Extrême-Orient depuis son origine jusqu'en 1920," *BE* 21 (1922), 3.

5. Henri Parmentier, *Guide au musée de l'École Française d'Extrême-Orient* (Hanoi, 1915), 2. If Martin Bernal's *Black Athena* is to be believed, these other Écoles not only studied the legacy of great Western civilizations; they appropriated racially complex histories from Africa and distorted their origins.

6. Henri Parmentier, "Catalogue du musée Khmer de Phnom Pen," *BE* 12 (1912); "Le Musée Khai-Dinh, Hué, Annam," *Bulletin des Amis du Vieux Hué* 16 (April–June 1929), 55–100; Pierre Jabouille, *Le Musée Khai-Dinh (Hué): Historique du musée* (Hué, 1931); Henri Parmentier, *Les sculptures chames au Musée de Tourane*, vol. 4 of *Ars asiatica* (Paris, 1922); Eugène Teston and Maurice Percheron, *L'Indochine moderne: Encyclopédie administrative, touristique, artistique et économique* (Paris, 1932), 655. A recent article that mentions the École's museums is Christian Pédalahore, "Hänoi, miroir de l'architecture indochinoise," in Maurice Culot and Jean-Marie Thiveaud, eds., *Architectures françaises outre-mer* (Liège, 1993), 293–322.

7. The structure had briefly served as a university for Indochinese students in 1909, but it was closed down during its first year because of student protests. A

separate four-story building was requisitioned in 1917 for a library and archives. See Parmentier 1915, 5, and *Indochine: Documents officiels* (Paris, 1931), 196–201.

8. Parmentier 1915, 7.

9. Georges Coèdes, "L'action de l'École Française d'Extrême-Orient au point de vue social," 9 (report of the Guernut Commission, Hanoi, 1937), Direction du Tourisme de l'Indochine, carton 22, Archives Nationales, Section d'Outre-Mer, Aix-en-Provence.

10. "Chronique: Indochine Française. École Française d'Extrême-Orient," *BE* 26 (1926), 445.

11. Louis Malleret, *Catalogue général des collections: Musée Blanchard de la Brosse, Saigon*, vol. 1, *Les arts de la famille indienne* (Hanoi, 1937), 22. The impetus was the donation of Victor Holbé's collection, given to the state on the condition that a museum be built to house it. See Bernard Philippe Groslier, "Le nouveau visage du Musée de Saigon," *Museum* 7 (1954), 225–234.

12. Malleret 1937, 23.

13. Malleret 1937, 22.

14. Parmentier 1922, 4, 7.

15. In 1920 the Hanoi museum had more than 3,000 Asian visitors, ten times the number of Europeans; by 1934 the Khmer Museum had more than 25,000 Asian visitors, compared to 2,000 Europeans. Parmentier 1915, 7; "L'École Française d'Extrême-Orient depuis son origine," 400; Gouvernement-Général de l'Indochine, *Les arts indigènes au Cambodge (1918–1936)* [exh. cat., Exposition International des Arts et Techniques, Paris, 1937] (Hanoi, 1937), 18.

16. Benedict Anderson, *Imagined Communities: Reflections on the Origin and Spread of Nationalism* (London and New York, 1983), 114–115; and David G. Marr, *Vietnamese Tradition on Trial, 1920–1945* (Berkeley, 1981), 145–146.

17. Sally Price, *Primitive Art in Civilized Places* (Chicago, 1989), 102.

18. Laurence Binyon, *The Spirit of Man in Asian Art*, the Charles Eliot Norton Lectures, 1933–1934 (Cambridge, 1935), 19. It must be said, of course, that many Asian cultures appreciate artistic objects in terms of their faithful reproduction of ancient, often mythic, forms and skills. Nonetheless, there are certainly individual differences in and adaptations to these representational modes.

19. Price 1989, 104.

20. Cited in Coèdes 1937, 1–2. Of course, much the same combination of research and service marked academic life in France, as it had since the time of Louis XIV. See George Weisz, *The Emergence of Modern Universities in France, 1863–1914* (Princeton, 1983), and Terry N. Clark, *Prophets and Patrons: The French University and Emergence of the Social Sciences* (Cambridge, 1973).

21. Jean Ajalbert, *Les nuages sur l'Indochine* (Paris,

1913), 223–293.

22. Malleret 1953, 50.

23. See Grousset's four volumes on *Les civilisations de l'Orient* (Paris, 1930), especially volume 2 on India, which included a discussion of Khmer and Cham art.

24. Speech of 3 November 1951, cited in Malleret 1953, 47.

25. Edward W. Said, *Orientalism* (New York, 1978), 3, 123.

26. Occasionally museums would acknowledge other claims on pieces they had acquired and catalogued. In 1912 Henri Parmentier noted that two such objects would rest in situ with their Cambodian "village owners," who had "reneged on their initial decision;" the Khmer Museum replaced the pieces with plaster casts (Parmentier 1912, 2).

27. George W. Stocking Jr., introduction to *Objects and Others: Essays on Museums and Material Culture*, vol. 3, *History of Anthropology* (Madison, Wisc., 1985), 6. On this theme, see also James Clifford, *The Predicament of Culture: Twentieth-Century Ethnography, Literature, and Art* (Cambridge, 1988), and Price 1989.

28. James Clifford (1988, 135) contends that "le Troca's . . . lack of coherent scientific contextualization encouraged the appreciation of its objects as detached works of art rather than as cultural artifacts" among numerous abstract and surrealist artists who frequented the museum. See also Patricia Leighten, "The White Peril and *L'art nègre*: Picasso, Primitivism, and Anticolonialism," *Art Bulletin* 72 (December 1990), 609–630, and Elizabeth A. Williams, "Art and Artifact at the Trocadéro," in Stocking 1985, 146–166. This collection was refurbished in 1937 as the Musée de l'Homme at the Palais de Chaillot, using careful methods of labeling and organization to stress anthropology's role as a "science."

29. By 1950 the École's museums had accumulated over 30,000 works of art, as well as 25,000 prints and 1,800 questionnaires about indigenous culture (Malleret 1953, 24).

30. During the 1910s and 1920s, the French architects Charles and Gabriel Blanche and the sculptor Eugène Auberlet supervised the cleaning, recording, and reconstruction of more than eight hundred temple sites at Angkor.

31. The same debate went on in France, especially after the destruction of World War I. See Paul Léon, *Les monuments historiques: Conservation, restauration* (Paris, 1917), and Léon, *La vie des monuments française, déstruction, restauration* (Paris, 1951).

32. The Frères Blanche oversaw the grandiose recreation of Angkor Wat's main temple at Paris in 1931, celebrating twenty years of restoration work at the site.

33. See, in particular, Anthony D. King, ed., *Culture, Globalization, and the World-System* (London, 1991).

34. Speech of Governor-General Pierre Pasquier at the inauguration of the Musée Louis Finot, Hanoi, 30 November 1932, reprinted in *BE* 33 (1933), 481.

35. Pasquier 1933, 481.

36. Speech of Georges Coèdes, incoming director of the École, at the inauguration of the Musée Louis Finot, reprinted in *BE* 33 (1933), 475.

37. *Conseil de Gouvernement de l'Indochine, Session Ordinaire de 1923* (Hanoi, 1923), 13.

38. See Louis Malleret, *L'exotisme indochinois dans la littérature française depuis 1860* (Paris, 1934).

39. Hanoi 1937, 35.

40. Hanoi 1937, 12.

41. S. A. le Prince Buu-Lôc, delegate from Vietnam, speech at the fiftieth anniversary celebration of the École, cited in Malleret 1953, 57.

42. All five museums (and most of their contents) were given over to local political authorities after the Geneva Conference in 1954, where they continue to attract sizable numbers of visitors. Archaeological excavations continued at Angkor until the École itself moved to Paris in 1968. They have recently been resumed under United Nations auspices. See *Travaux et perspectives de l'École Française d'Extrême-Orient en son 75e anniversaire* (Paris, 1976).

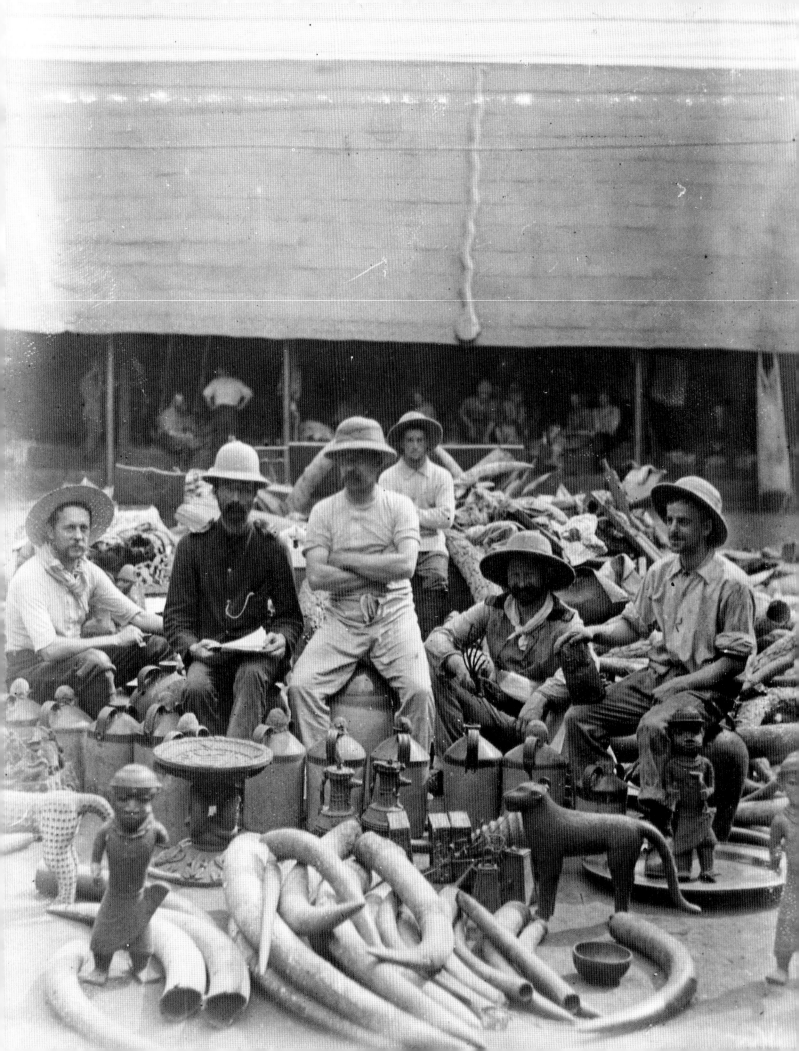

ANNIE E. COOMBES
University of London, Birkbeck College

Ethnography, Popular Culture, and Institutional Power: Narratives of Benin Culture in the British Museum, 1897–1992

During the stringent economic cutbacks characteristic of the 1980s in Britain, the local and national museum ironically came into its own. Through transformations in marketing and policy, the museum has become both a vital component in the reclaiming and defining of a concept of collective memory on the local level and an opportune site for the reconstituting of certain cultural icons as part of a common "heritage" on the national level. Such "heritage" has often been produced as a spectacle of essentialist "national" identity, with the museum frequently serving as the site for the nostalgic manufacture of a consensual past in the lived reality of a deeply divided present.[1]

Simultaneously, Western museums proclaim the internationalism of museum culture as irrefutable "proof" of their neutrality and objectivity and as justification for their self-appointed role as cultural custodians. Likewise, multicultural educational initiatives from within the Western metropolitan centers have heralded a new and possibly a more self-reflexive conception for ethnographic museums, despite debate on the relative merits of an initiative that may well be multicultural without necessarily being antiracist.[2] Resultant questions about constituency have been taken on by some anthropologists and ethnographers. Such questions have revived a concern in museums with the political implications of anthropological practice and the way anthropological

knowledge is used that has been dormant since Kathleen Gough's and others' searing critiques of their own discipline at the height of American intervention in Vietnam.[3]

I

For some time now the so-called Benin "bronzes" have shared center stage with the Parthenon marbles in the restitution debate.[4] In both Nigeria and Greece, this cultural property is considered an indispensable component in the formation of a national identity.[5] Successive British governments, on the other hand, have argued for their continued custody of this property on the basis of the internationalism of museum culture, while at the same time asserting the significance of the "bronzes" and marbles as part of a British national heritage.

The contradictory and ambiguous status attributed to the Benin "bronzes" in 1897, after the British sacked and looted the royal court of Benin, has a continuing relevance today. The complex trajectory of these prestigious court objects provides a useful means of exploring the peculiar way in which museum ethnography and its attendant concern with questions of authenticity and cultural value, its preoccupation with taxonomic, disciplinary, and institutional boundaries, has often been at the center of definitions of race and national identity in the popular consciousness.

British officers of the Benin punitive expedition with bronzes and ivories taken from the royal compound, Benin City, 1897

Photograph: British Museum, London

143

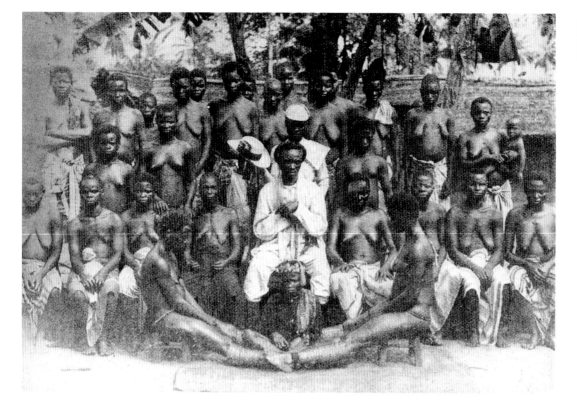

1. "A Native Chief and His Followers"
Illustrated London News
(23 January 1897), 123

In 1897 anthropology was still in the process of making its debut as a discipline in Britain, a situation which made it expedient to court opinion on three fronts: the state, the general public, and academia.[6] The complex and often antagonistic national, institutional, and disciplinary interests invested in the development of material culture studies in Britain, and the corresponding rise of anthropology as a professional domain between 1890 and 1920, ensured its ambivalent role, even in this early period, as both perpetrator and fracturer of certain racial stereotypes. Nowhere is this more clearly demonstrated than over the battle for the acquisition of the Benin ivories and bronzes, and the ensuing debate over the degree and nature of their aesthetic merit.

The history of British relations with Benin City, prior to and including the punitive expedition of February 1897, is essentially a narrative of claims over trading rights and frustrated British efforts to break the back of the monopoly on palm oil and various other commodities held by the Oba (king) of Benin. The intricacies and significance of this history warrant much greater attention than I have space for in this essay. Other historians

have elaborated this particular instance of colonial incompetency and brutality elsewhere.[7] It is perhaps enough to relate that after initial acquiescence by the Oba agreeing to certain concessions regarding relaxing trade restrictions, the situation was reversed again in November 1896, when he closed all markets to outside trade. During the crucial period of this latest development, the Consul-General Moor had gone to England on leave. In charge as acting consul-general was an inexperienced official by the name of Phillips. Finding the situation thus worsened and with Moor away, Phillips seized the opportunity of making a name for himself and determined to solve the dilemma in Moor's absence. Initially advocating a violent offensive on Benin City, Phillips finally marched on the city with an unarmed party. Despite repeated warnings to his party to retreat, both from the Oba's messengers and from the Itsekiri Chief Dogho, they continued to advance. As a result the entire party, bar two survivors, were killed before they reached the city.

If the Oba had been anxious about the prospect of war with the British in 1892—the occasion of another incursion into Benin trading territory—by 1897 grounds for such

concern had escalated. After the murder of the Uwangue in 1895 and following reprisals against the Iwebo chiefs, Oba Ovonramwen's prestige among his own people and his confidence in their support had waned. A rebellion in Agbor compounded his problems on the home front. The example of his vassal Nana, exiled by the British for opposing their expansionist trading policies, was a clear indication of how far the Oba could trust the British. Nonetheless, despite these considerable grounds for the Oba's suspicion as to the motives of Phillips' consular mission in 1897, there is evidence to suggest that the Oba made persistent attempts not only to stall Phillips' party, but to stop the war party organized from Benin.

Reprisals for the killing of the British contingent were extremely speedy. The district commissioner at Sapele received word of Phillips' death on 7 January 1897. Three days later news had reached London. By the beginning of February some 1,500 men were readied for the attack on the city, and by 18 February, Benin City was taken by the British punitive force.

In September 1897 the British Museum put on public exhibition some three hundred cast brass plaques from Benin. Intrigued and perplexed that work of such technical expertise and naturalism had been found in such quantities in Africa, the national, local, scientific, and middle-class illustrated press all postulated hypotheses to "explain" the paradox. Indeed, a factor which made the Benin incident such a perfect vehicle for anthropologists' campaign for academic and state validation was precisely its currency for a broad spectrum of the literate public in Britain.

Opinion about the "bronzes" oscillated between two extremes. On the one hand, the discovery of the bronzes and ivories looted by the British from the royal court of Benin inspired such statements as: "The discovery of these treasures resembles that of a valuable manuscript. They are a new *Codex Africanus*, not written on fragile papyrus, but in ivory and imperishable brass."[8]

Other assessments, however, dismissed Benin society in altogether different terms:

Although little authentic knowledge of the Benin people is current, the main characteristics of the surrounding tribes are thought to be theirs also in an intensified degree, finding

expression in habits of disgusting brutality and scenes of hideous cruelty and bloodshed, ordained by the superstitions of a degraded race of savages.[9]

This article is about the conditions that make possible the coexistence of such apparently mutually exclusive observations.

The emphasis on Benin as a "degraded" race is an important feature of the representation of certain peoples prior to and during colonization. It was a concept already familiar in Britain, in relation to the representation of what was euphemistically referred to as the "Orient."[10] The terms "decay," "deterioration," and "degradation" were mobilized in the Benin context, partly because they were a convenient means of undermining the all too substantial evidence of an ancient and thriving society in Africa which displayed all those signs associated with European definitions of civilization. To enhance the idea of Benin as a "degraded" society, the popular narratives and "firsthand" accounts of the punitive expedition made use of a particularly calculating and effective juxtaposition of text and image in the middle-class illustrated press. Though often not explicit, these images had the effect of implicitly reinforcing the sense of Benin as degraded and degenerate. A brief discussion of just two aspects of this far-reaching preoccupation—the representation of Benin women and of Benin City itself—gives some idea of the ways in which the discourse on degeneracy surfaced at this time.[11]

Immediately after Benin forces ambushed and killed the Acting British Consul-General Phillips and some of his entourage, the *Illustrated London News* of 23 January 1897 published an article denouncing Benin society as having "a native population of groveling superstition and ignorance." Alongside was an apparently unrelated photograph entitled "A Native Chief and His Followers" showing a group of women sitting around the central figure of a man (fig. 1). The group of figures seem, from a contemporary European perspective, to be impassive and static. In the foreground two women are literally "arranged" to "frame" the image. The whole represents a posed ensemble which does not fit easily into the "ethnographic" racial "type" category nor yet a formal portrait. It is in fact a confusion of both taxonomies.

2. "Benin Girls with Aprons of Bells"
The Reliquary 6 (October 1900), 227

While the "native chief" is the central figure compositionally, it is the women who predominate and who arrest the eye. The nudity of the foreground women is both masked and accentuated because their objectification was reinforced by the fact that this was clearly not a "natural" posture. They had evidently been "put" there. To clinch this objectification their bodies signified as the human equivalent of the "trophy" display, so popular at this time with both ethnographer and big game hunter alike.

This is a recurrent feature of representations not only of Edo but other African women in the British illustrated press. Similar compositional devices were used in many different contexts. For example, a photograph in the *Reliquary*, a serious antiquarian publication with a readership of archaeologists, ethnographers, and folklorists, employed the same motif, ostensibly to illustrate bells on Benin women's girdles (fig. 2). The bells seem a rather precarious alibi for such voyeurism since they are difficult, if not almost impossible, to make out.[12] It is again the body which is actually held up for inspection here. The "scientific" aegis of the journal operated here in a specific way in relation to the

image. The photograph's additional status as "document" rendered even more respectable such overt nudity and any sexual connotation implied, in much the same way that the convention of mythologizing the nude in Western fine art supposedly masked the sexuality of the sitter sufficiently to render nudity inoffensive to bourgeois sensibilities. In the context of the representation of Benin as a degenerate society, it is as significant as it is banal that all the women in these close-up photographs were naked from the waist up, while illustrations of those West Africans who had acknowledged British sovereignty were pointedly shown fully clothed (fig. 3). For example, in another article in the *Illustrated London News* extolling the virtues of the British-held "Old Calabar" and its prosperous transformation under British "guardianship" (as opposed to the apparent dissolution further upriver in Benin), all the women in the photograph of "Old Calabar Market" are notably fully clothed.[13] This is not necessarily to suggest that the camera was not reproducing what was visible in this instance. Rather I want to emphasize that this is a reiteration of the old adage that while nakedness signified "uncivilized," clothing

was an obvious appurtenance of "civilization." Consequently such juxtapositions reinforced this distinction. The fact that such assumptions could be made visible through the medium of the photograph lent a veracity that the old lithographs which had, until recently, been the mainstay of the illustrations in the popular press, could not match.

Similarly, although the title of the first illustration suggests nothing about the relationship of the women to the central male figure of the chief, it was presumed that they were his wives. While that favorite topic of Orientalist paintings, the harem, was a familiar sign linking Islam and degeneracy, the practice of polygamy in African societies was not a ready-made genre. And yet as a sign it was irrevocably tied to African degeneracy. Debates and discussion on the topic of polygamy in African society were common in a variety of public arenas. An attack on polygamy was often at the heart of arguments against the slave trade from the Anti-Slavery Society and the Aborigine Protection Society, particularly when Arab slavers were involved, since this provided the perfect alibi for a dual assault on slavery and Islam. Similarly the various missionary societies with interests in Africa (or indeed in India)

never missed an opportunity to launch an offensive on Islam (or in the case of India, Hinduism), and polygamy was a key pawn in their defense of Christian values.[14]

At the same time, the debate was fueled by others with the ear of different publics who were busy defending the practice of polygamy. Mary Kingsley, inveterate traveler, champion of British trading enterprise in West Africa, entomologist, and self-styled ethnographer, was adamant about the cause of any so-called "degeneration" on the West African coast. In a statement that echoed the criticism of many West African "patriots" of the colonial government, she claimed: "I know perfectly well that there is a seething mass of infamy, degradation, and destruction going on among the Coast natives. I know, humanly speaking, what it comes from . . . for it is the natural consequence of the breaking down of an ordered polygamy into a disordered monogamy."[15] The practice of polygamy in representations of the colonized subject in Britain is more complex than I have space to deal with here. For the moment it is enough to point out that the representation of polygamous relations frequently functioned as an unspoken indictment of certain African societies, while the

3. "The Benin Expedition: Old Calabar Market"
Illustrated London News
(27 February 1897), 292

comment in the *Illustrated London News* article that accompanied the photograph—"the women develop, as usual in these regions, at a very early age"—positions the African woman ambiguously in the category of both victim of pagan practice and libidinous degenerate. Thus, from the complacent vantage point of moral high ground, the colonial gaze could scrutinize with impunity.[16]

Firsthand accounts also mapped a degenerate topography for Benin City itself. T. B. Auchterlonie's narrative of a voyage to Benin City on New Year's Day 1890, delivered to the Royal Geographical Society in the wake of the 1897 expedition, starts by clarifying his use of adjectives such as "new" and "old" or "black" to describe different aspects of Benin. "Old" Benin was distinguished from "New" chiefly because of its refusal to accept British trading links. In common with most accounts of Benin City directly after the punitive raid, Auchterlonie introduced the sights and smells of human sacrifice early in the narrative, and implied a state of crumbling decrepitude.[17] On the other hand, "Old Calabar," Warri, and Sapele, in what is called "New Benin," were held up as examples of the prosperity that supposedly came with British trade. The recurrent use of the adjective "black" is of course a historically familiar device for emphasizing the malevolent character of "Old" Benin.[18] That it also happens to be the color ascribed to the African's skin ensured the derogatory connotations of the term.[19] Similarly, another *Illustrated London News* account of the preparations for the punitive raid showed drawings of a European boat (entitled the "Hindustan Government Hulk at Benin") together with the ordered ranks of "loyal" African troops on the main deck of the *George Shotton* and at the British trade post "Old Calabar," juxtaposed with a rambling and dilapidated local town (fig. 4).

Drawings and photographs published in the illustrated press often circulated beyond their own readership. Different versions of the same illustrations appeared in specialist and scientific journals to accompany eyewitness accounts or ethnographic studies. Through this repetition they gained particular currency as "objective" visual documentation.[20] Consequently, these representations played a crucial role in providing a context

for the Benin ivories and bronzes that were later displayed to a British public which had already consumed Benin through such reports and images.

While the popular narratives and firsthand accounts tended for the most part to use the concept of "degeneration" to reinforce a series of predictable cultural stereotypes, the term took on a rather different gloss in the anthropological community's aesthetic treatises concerning Benin culture. Here degeneration played a rather more ambivalent role, but one no less symptomatic of vested political interests, this time of an institutional and disciplinary nature.

4. "The Benin Disaster: Scenes in the Niger Protectorate"
Illustrated London News
(23 January 1897), 122

The point at which ethnologists decided to intervene in the debate over the origin of the Benin bronzes was precisely when the paradox of technical sophistication and social savagery threatened a break with the evolutionary paradigm, which up to that time had also supplied the classificatory principles for most collections of material culture from the colonies. British anthropologists summoned up the concept of degeneration as an aesthetic principle which would appease anxiety over these recalcitrant objects that refused to conform to comfortingly familiar taxonomic solutions. It is their articulation of the concept of degeneration, as part of a systematic evolutionary schema for explaining the origins of all art, which provides a nuance for the concept that exploits but also belies its immediate association with racial denigration.

In Britain, Lane Fox Pitt Rivers, Henry Balfour, and Alfred Haddon were the most ardent devotees of the theory of degeneration. These men were the anthropologists working in the more public (and therefore more visible) sphere as curators of large public ethnographic collections. Consequently, it was their degenerationist thesis (as it came to be known) which set new terms for an aesthetic evaluation of material culture from the colonies.[21]

II

These anthropological theories were in direct opposition to most previous attempts to explain the "origin" of art. These usually expounded a development beginning with geometric form and culminating in naturalism. The protagonists of the degenerationist school believed that, through carefully plotted sequences, they could prove the opposite: the linear development of ornament from naturalistic to geometric and abstract.[22] Their method was characterized by a systematic analysis of the formal or stylistic elements of different objects in an attempt to produce a unified subject.

On the one hand, this thesis represents a clearly overdetermined evolutionist account. On the other, the degenerationists were at pains to point out that while the move to abstraction might be the result of unconscious variation (following the Darwinian model of accidental evolution), this tendency might also be due to the producers' conscious decision and invention. Since both Balfour's and Haddon's examples were drawn from African and Papua New Guinean societies, their arguments offered the possibility of acknowledging an alternative aesthetic motivation currently denied to these societies.

They nonetheless sought to produce a unified colonial subject which fitted neatly into the evolutionary mold. Crucially, however, this was thwarted at every turn not only by the internal inconsistencies of the thesis itself but also because of the ambivalence of the term "degenerate" as it was articulated across a range of discourses within Britain, from aesthetics to social policy. It is paradoxically this gap that allowed for a reevaluation of material culture from the colonies and also its significance as a constituent of national culture within Britain.

One instance of this more progressive potential of what was essentially a rather idiosyncratic thesis was that Haddon had already promoted degenerationism specifically as an antidote to the prevailing art-historical view of art as a work of individual, inspired genius. Haddon's and Balfour's critics within the art-historical establishment had already claimed that "in art there is no such thing as evolution but more or less isolated and veritable 'creations'—for their [Balfour's and Haddon's] law cannot by searching be found out by men whose genius is true divinity."[23] Haddon's response would not be out of place in a contemporary critique of formalist art history:

There are two ways in which decorative art may be studied; these may be briefly defined as the "aesthetic" and the "scientific." The former deals with all manifestations of art from a purely subjective point of view, and classifies objects according to certain so-called "canons of art." These may be the generally recognized rules of the country or race to which the critic belongs, and may even have the sanction of antiquity. Or they may simply be due to the idiosyncrasy of the critic himself.[24]

Haddon and the other degenerationists proposed instead a comparative analysis of all decorative art, both European and non-Western, as a branch of biology, mediated by environmental factors.

The cultural relativism implied by the

suggestion that all art was subject to the same determining factors of environmental conditions and material circumstances of production did more than simply undermine the myth of individual genius. One of the other effects of this debate was to self-consciously qualify the particular contribution of anthropology, as opposed to art history, to the study of material culture—not only that of the colonies but also closer to home.[25] At a moment when anthropologists were fighting for recognition as a scientific and academic discipline with a wide range of applications and use values, this could only count in their favor.

Furthermore, the biological basis of the degenerationist thesis, grounded as it was in a theory of racial purity, had other important implications for more specific debates around the nature of the Englishness of British art which were currently resurfacing in the art-historical establishment. Certain prominent critics and historians had already proposed that naturalism was somehow a precondition, if not an inherent property, of true English art—a property taken as irrefutable proof of the moral health of the nation. Conventional or abstract tendencies, on the other hand, were evidence of moral decline and degeneration. In this scenario, the morally degenerate examples were drawn from the decorative art of various colonies or from the Celtic Irish tradition currently being revived as part of the cultural nationalist movement within Ireland.[26] The relation of such xenophobia to the anxiety over resurgent Irish nationalism needs no rehearsal here. Haddon's and Balfour's thesis suggested a positive espousal of a non-European geometric idiom. Coupled with the indisputable "fact" of naturalism in the Benin bronzes themselves, this posed a potential threat to the moral integrity of English art.

However, the degenerationist thesis had other features which further complicated its relationship to the idea of racial purity. Like most anthropological treatises on aesthetics at this time, it sought to elucidate contemporary "man's" creative drive. In order for the theory to work and fulfill its ultimate objective, it was necessary to focus on those societies that conformed to E. B. Tylor's earlier concept of a "survival."[27] Balfour's book, *The Evolution of Decorative Art*, defined

two categories of "survival": primitive and degenerate. Certain societies were described as "lowest on the scale of civilization, whose condition of culture is in the most primitive of existing states;" others were classed as degenerate societies which had "in former times enjoyed a higher civilization" but now resided in a state of retrogression or degeneration.[28] Interestingly enough, this was a condition laid squarely at the door of the colonizer. Aboriginal Australians and Tasmanians, for example, were deemed truly "primitive," since they had remained outside the contaminating sphere of white contact until what Balfour describes as "their ruthless extermination by the savage methods of intruding civilization, which resulted in their complete extinction in 1876."[29]

However, such nostalgic reverie for the lost sanctity of originary unity was not always accompanied by so explicit a critique of colonial intervention. Haddon, for example, suggested that "impurities" in race led to regrettable impurities in form: "It will often be found that the more pure or the more homogeneous a people are, the more uniformity will be found in their art work, and that florescence of decorative art is a frequent result of race mixture."[30]

Consequently, in the context of art-historical debates, the degenerationist thesis had the power to rupture the xenophobic association of naturalism with moral stability as an intrinsic property of the English. But elsewhere the same argument could be mobilized to other, rather less progressive ends. Back at the British Museum, it provided Read and Dalton, the curators of the ethnographic collection, with the opportunity of safely comparing the Benin mastery of the technically complex *cire perdu* process with the work of the Italian Renaissance, also conceding that the castings were probably produced by a people long acquainted with the art of metal casting, while at the same time continuing to assign the Edo to a state of savage degeneration. They pointed to the apparent absence of any contemporary Benin work of similar naturalism in most eyewitness accounts, coupled with the tendency toward "florescence" of surface ornament in what were deemed later examples. This neatly ensured that there was no danger of their interpretation transgressing the theory

of degeneration in either its "scientific" and aesthetic aspect (via anthropology) or the specifically racialized aspect already disseminated in the middle-class illustrated press.

The more progressively disruptive potential of the degenerationist thesis could be disregarded, precisely because of the way in which notions of racial purity had already acquired a particular currency in another domain. The terms "primitive" and "degenerate" were familiar through their use in a context far closer to home. Discourses on health and racial purity, produced through medicine, philanthropy, and eugenics in the work of Francis Galton, and later Saleeby and Pearson, ensured the topicality of such theories. In this context the focus on racial purity was a symptom of anxiety over the degeneration of the "imperial" Aryan race. Medical research and social surveys indicated an alarming decline in the state of health of the working classes, which in turn had generated concern by certain sectors over the social circumstances of the mass of the population.[31]

The ensuing debate around the question of deterioration versus degeneration was exacerbated by the eugenists, who were still mostly convinced of the inherited, rather than environmental, determinants of such a decline in the nation's health. Consequently, while their findings provided the impetus for preventative health initiatives, they also provoked a public campaign for the surveillance and categorization of groups considered racially degenerate and unfit.[32] Alfred Haddon and other anthropologists who were proponents of the degenerationist thesis as applied to aesthetics had already supplied expertise in physical anthropology and anthropometry techniques and statistics for Galton's work on systematic race regeneration and population control within the British Isles. Evidently, then, such terms as "degeneration" had a particular resonance for certain ethnic, class, and gender constituencies within Britain.

Another feature of this preoccupation with racial purity was the way in which evidence could supposedly be deduced from the physiognomy of the subject. Consequently, the eighteenth-century principle that physiognomic characteristics were accurate indicators of intellect and morality acquired

new potency in the early twentieth century through the eugenic movement's insistence on the visibility of moral, intellectual, and racial degeneracy as physical traces left on the body and susceptible to mapping by the "specialist," be "he" medic or anthropologist.

In the public domain, the ethnographic collection deliberately exploited this connection between eugenics, racial purity, and the body. The body became the sign of the relationship between the inherited and cultural features of any race.[33] Photographs, and casts of the face or the body, were almost always included to enhance the display of material culture from the colonies. In fact it was precisely because of the ambivalence of material culture as an index of race and culture, particularly once it had crossed into the register of the aesthetic, that the body became an essential component in fixing the object as a sign of racial purity or degeneracy. Small wonder, then, at the colonial fascination with the "body" of Benin subjects and the neat topographic degeneracy mapped for Benin City in both popular and scientific press.

III

This contradictory intersection of anthropological, medical, and aesthetic discourse around the issue of degeneration, coupled with the exigencies of the demands for a professional status for ethnography, facilitated the transformation of what had initially been a debate centrally concerned with the origins and aesthetic evaluation of Benin material culture into a debate concerning British national pride and heritage. Contentions about the origin of the bronzes reached a height in 1899 with a new publication by Read and Dalton. *Antiques from the City of Benin and Other Parts of West Africa in the British Museum* contained several significant shifts from their earlier argument for a Portuguese or Egyptian origin. Now they were prepared to concede that the Benin material may well have preceded, or at any rate come into being independently of, Egyptian predecessors.

What does the admissibility of an African origin signify at such a moment? I would argue that the degree to which the Benin aesthetic is assigned an African origin corre-

sponds partly to the stepping up of pressure from ethnologists and anthropologists in the British Museum for government recognition and financial support. Furthermore, the course of Read and Dalton's argument for an African origin is inextricably linked to the fortunes of the ethnographic department within the museum.[34] Unlike the thriving department of egyptology, ethnography was granted the status of an autonomous department only in 1941. It is within this context that the possibility of claiming an African origin for the bronzes represented a viable strategy for both the ethnographic department's struggle in its bid for recognition within the museum *and* for the museum's bid for more government funds.[35] Initially the ethnographic curators assumed that the brass plaques on loan from the Foreign Office would become the property of the museum through the trustees' acquisition. By 1898, the year of Read and Dalton's first publication, it was clear that a much smaller proportion of the loot remained in the museum's possession than originally hoped. Over a third of the series had already been sold off as revenue for the Protectorate. The ensuing public auction aroused much bitterness among museum staff with an interest in the affairs of the ethnographic department. To compound this frustration, Dalton visited Germany and in June 1898 published a report on their large-scale acquisitions in African ethnography, especially in Berlin, with the financial and moral support of the kaiser. Following a detailed account of the facilities afforded museum ethnographers in Germany and a breakdown on annual government expenditure, Dalton observed that "in almost every section . . . it leaves the Ethnographical Gallery at the British Museum far behind."[36] His paper also stipulated that the director of the Berlin Museum für Völkerkunde had already spent one thousand pounds, chiefly in England, on the very Benin material for which the British Museum was unable to obtain government funds.

The cry of "national heritage" was taken up by the British press, which similarly couched its arguments in terms of British competition with Germany, a strategy calculated to inspire a sense of nationalist indignation. Details of the few "fine bronze heads" (as they were now described) in the British

Museum collection were compared with the thirty or forty acquired for Berlin through the kaiser's patronage. Anthropologists consistently played the German threat as a card in their bid for popular and government support. And the insistency with which this competition was stressed was commensurate with the perceived increasing threat posed by Germany to Britain's imperial supremacy.[37]

5. Entrance doors to the British Museum Department of Ethnography, the Museum of Mankind, London, 1990
Author photograph

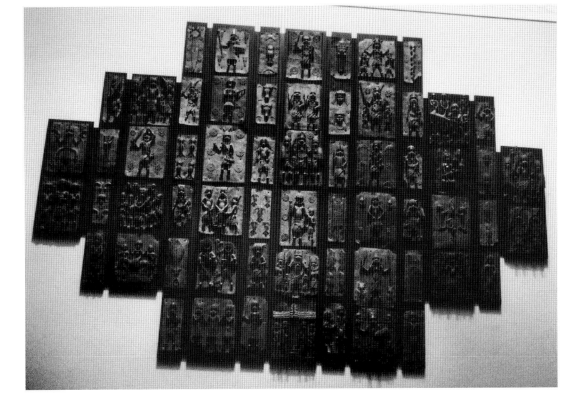

6. Benin "bronze" plaques on the facing wall of the main staircase in the British Museum, London, 1990
Author photograph

The ethnographic communities' hypotheses on the origin of the bronzes effectively produced knowledge that threatened to disturb the equilibrium of racial superiority that legitimized the colonial process.[38] But such knowledge was mediated by its function in the struggle for professional and institutional validation for the new "science" of anthropology. The ethnographic department was able to capitalize on the visibility of the Benin bronzes in the public domain as both evidence of barbaric savagery and artistic anomaly, in order to claim that their retention was a matter of national urgency. This strategy had the additional benefit of enhancing the department's own status in the eyes of both the government and the museum. The ethnographic curators' decision to assign an African (as opposed to Egyptian) origin to the bronzes enabled them to foreground the importance of ethnography as opposed to the already well-endowed egyptology department in the museum.

Similarly, while certain aspects of the anthropological knowledge on Benin suggested definitions and values that contradicted some of those stereotypes promulgated in the popular middle-class illustrated press, the fact that anthropologists consistently treated Benin as an anomaly of African culture ensured that the more racialized sense of the term "degenerate" popularized by the press was always inherent in descriptions of Benin culture. Furthermore, given the anthropologists' desire to be seen as indispensable to the colonial government, and thereby obtain both recognition and state funding for their discipline, ethnography (and museums) were a convenient way to broaden their popular appeal. This had, as in the case of Benin, particularly pernicious results. The popularization of the science meant that a highly selective and doctored version of anthropological theory was appropriable by parties with distinct vested interests in colonization. Paradoxically, anthropology's accessibility speeded the disintegration of a division between the "scientific" and "popular" that it sought to maintain. At the same time it ensured that the popular stereotype of African, and in this case Benin, culture was able to derive more credibility through its relationship to the supposedly separate sphere of scientific knowledge.

Today the Benin "bronzes" are still at the nexus of competing discourses which often reproduce the contradictions that made them such potent icons in the late nineteenth and early twentieth centuries. In 1983, for example, *Treasures of Ancient Nigeria* was exhibited at the Royal Academy of Arts in London, having already toured North America.[39] The British context added a certain poignancy to each of the narratives played out in the text of the catalogue. Tales of colonial benevolence, on the one hand, were suggested in accounts of the British-led archaeological excavations. On the other hand, histories invested with Nigerian hopes of self-determination were unearthed and charged with the task of reinscribing Africa in the West's consciousness as a continent with a long and complex historical memory. The tension between paternalistic discovery and disenfranchisement manifested itself on this occasion in the challenge extended by Ekpo Eyo, director of the Nigerian Federal Department of Antiquities and active campaigner on UNESCO's International Council of Museums. Eyo ended his introduction with a plea to Western museums to reassess, as he put it, "the circumstances in which these objects were removed from Benin" and to give the Benin Museum the opportunity to display more than just photos and casts of a once thriving local industry.[40]

In the case of Benin, the restitution issue gives a particular edge to the nature of the visibility of these cultural objects. Persistent demands for the restitution of Benin material have been made since independence. One of the best known occasions was during the 1977 Festival of International Black Art in Lagos (FESTAS) where the organizers requested the loan from the British Museum of a fifteenth-century Benin ivory hip mask which had been chosen as the festival's logo. The loan was refused.[41]

By 1989 the restitution debacle compelled the British Museum's director, Sir David Wilson, to publish a public rebuttal of criticisms of the museum as elitist and neo-imperialist.[42] Evidently a heartfelt response by a member of an increasingly harassed breed of public servant, Wilson's case nonetheless turns unhelpfully but tellingly on

the twin obfuscations of political neutrality and internationalism:

The establishment of the Museum as a trust with a board of trustees was surely intended to inhibit political, emotional, nationalistic or sentimental influence . . . our argument is . . . the sense of curatorial responsibility, of holding material in trust for mankind throughout the foreseeable future. In a period when all our aspirations are based on the hopes of international agreement, we cannot let narrow nationalism destroy a trust for the whole world.[43]

That the majority of the trustees are selected by the prime minister of the day and that one

7. Poster for "Southwark Black History Month," October 1991
Author photograph

of the museum's major benefactors is the National Heritage Memorial Fund suggests some ambiguity over Wilson's definitions of "neutrality" and "internationalism."

Even more perplexing in this defense is the fact that, despite the director's evident recognition of the delicacy of the restitution issue (particularly, one imagines, in terms of maintaining good "international" relations), the Benin bronzes have for some time been more prominently displayed than almost any other items in the museum's collection. Etched indelibly into the very fabric of the architecture, they usher the visitor into the museum's ethnographic section, the Museum of Mankind (fig. 5). Obsessively repeated in the British Museum, they are unavoidable encounters on the central staircase leading to the main collections (fig. 6).[44]

Finally, the still ambivalent status of the Benin and Ife bronzes as neither art nor ethnography, but simultaneously both, makes them the perfect items to mediate the impending reabsorption of the ethnographic department (the Museum of Mankind) back into the main body of the British Museum. Accordingly, they recently became ethnography's ambassadors to the Bloomsbury site in an exhibition entitled "Man and Metal in Ancient Nigeria."[45]

Of course, what is significant about the current trajectory of the bronzes is that it coincides with a moment in Britain when enterprise and heritage jockey for position with multiculturalism and globalism in the discourse of the New Right. Consequently, the contradictions that characterized the debates about the origins of the Benin bronzes at the turn of the century now take on a new potency.

If unyielding possession and flagrant display of the bronzes can be understood in part as the manifestation of an unconscious desire—the fantasy of a continued British sovereignty—it could also be interpreted as one outcome of the management of what other commentators have rightly identified as the tensions between the ideology of national sovereignty and a strong state on the one hand and the increasingly multinational character of finance capital on the other, the tension between an appeal to an older imperial identity and the realities of an increasingly politicized multicultural society.[46]

But perhaps it is as well to remember that it is precisely in the gap between the populism that is the New Right's answer to these contradictions and the recognition by some of the electorate of the exclusivity which it masks, that the possibility exists for an alternative vision of social transformation and the role that culture might play in this (fig. 7).

My thanks to Avtar Brah and Laura Marcus for generously sharing their critical insights on earlier versions of this article. A longer version of this paper has since appeared as Annie E. Coombes, "The Recalcitrant Object: Culture Contact and the Question of Hybridity," in *Colonial Discourse and Post-Colonial Theory*, eds. Francis Barker et al. (Manchester, 1994), 89–114. See also Annie E. Coombes, *Reinventing Africa: Museums, Material Culture, and Popular Imagination in Late Victorian and Edwardian England* (New Haven and London, 1994).

1. See Patrick Wright, *On Living in an Old Country: The National Trust in Contemporary Britain* (London, 1985); Robert Hewison, *The Heritage Industry: Britain in a Climate of Decline* (London, 1987); Robert Lumley, ed., *The Museum Time Machine* (London, 1988); John Corner and Sylvia Harvey, eds., *Enterprise and Heritage: Crosscurrents of National Culture* (London, 1991). It is important to realize that the "heritage" boom is fraught with ambivalence. For example, in Britain there is a cruel irony in the tendency to set up museums of working life in once thriving industrial areas where unemployment has now decimated the work force and shut down the very industries that are represented as "living" displays in the heritage museums. On the other hand, even the worst of these cannot avoid some reference to class and labor relations even of the most banal kind.

2. See, for example, *Education for All: The Report of the Committee of Inquiry into the Education of Children from Ethnic Minority Groups* (London, 1985); A. Sivanandan, "Challenging Racism: Strategies for the 80s," *Race and Class* 25 (fall 1983), 1–11; Sneja Gunew, "Australia 1984: A Moment in the Archaeology of Multiculturalism," in *Europe and Its Others*, ed. Francis Barker et al., vol. 1 (Colchester, 1984), 178–193.

3. Kathleen Gough, "New Proposals for Anthropologists," *Current Anthropology* 9 (1968); P. Bandyo-padhyay, "One Sociology or Many: Some Issues in Radical Sociology," *Sociological Review* 19 (1971); James Clifford and George E. Marcus, eds., *Writing Culture* (Berkeley, 1986); Edward W. Said, "Representing the Colonised: Anthropology's Interlocutors," *Critical Inquiry* 15 (1989), 205–225.

4. Technically speaking the term *bronze* is a misnomer. Analysis has shown that these objects are not always bronze but may be zinc brass or leaded bronze and are generally an alloy of copper, zinc, and lead in varying proportions. The term *bronze* is used here as a shorthand.

5. Kenneth Coutts-Smith, "Some General Observations on the Problem of Cultural Colonialism," in Susan Hiller, ed., *The Myth of Primitivism* (London, 1991), 14–31; Phyllis Mauch Messenger, ed., *The Ethics of Collecting Cultural Property* (Albuquerque, 1989); Jeanette Greenfield, *The Return of Cultural Treasures* (Cambridge, 1989). At the time of writing this, Anna Benaki, the new Greek minister of culture, was in London publicizing a new museum being built at the foot of the Acropolis. Certain walls of the museum will remain pointedly blank until the return of the Parthenon marbles to Greece.

6. See Annie E. Coombes, "Museums and the Formation of National and Cultural Identities," *The Oxford Art Journal* 11, no. 2 (1988), 57–68.

7. For a history of British interference in Benin City, see Philip Aigbora Igbafe, *Benin under British Administration: The Impact of Colonial Rule on an African Kingdom 1897–1938* (London, 1979); Alan Ryder, *Benin and the Europeans 1485–1897* (New York, 1969; London, 1977).

8. O. M. Dalton, "Booty from Benin," *English Illustrated Magazine* 18 (1898), 419.

9. *Illustrated London News* (23 January 1897), 123.

10. See Edward Said, *Orientalism* (London, 1978); Linda Nochlin, "The Imaginary Orient," *Art in America* (May 1983) 186–191; Sarah Graham-Brown, *Images of Women* (London, 1988).

11. For a more detailed discussion of this in relation to Benin c. 1900, see Coombes 1994.

12. Richard Quick, "On Bells," *The Reliquary* 6 (1900), 227.

13. *Illustrated London News* (27 February 1897), 292.

14. Christine Bolt, *Victorian Attitudes to Race* (London, 1971), 112–113.

15. Mary Kingsley to Frederick Lugard, 31 December 1897, cited in Dea Birkett, *Mary Kingsley, Imperial Adventuress* (London, 1992), 94.

16. Nochlin 1983 makes this point in relation to the eroticism of Orientalist paintings of the slave market, specifically in relation to the representation of women.

17. T. B. Auchterlonie, "The City of Benin," *Transactions of the Liverpool Geographical Society* 6 (1898), 7.

18. Auchterlonie 1898, 11. The full implications of this use of the adjective become clear in the light of Auchterlonie's remarks that since the Oba's skin was not as black as most coastal tribes, he did not look like a killer.

19. For accounts of the ideological implications of color in earlier periods, see Winthrop D. Jordan, "First Impressions: Initial English Confrontations with Africans," in Charles Husband, ed., *"Race" in Britain: Continuity and Change* (London, 1982), 42–58; James Walvin, "Black Caricature: The Roots of Racialism," in Husband 1982, 59–72; and Bolt 1971. For contemporary examples of the ideological function of color in the racial context, see Errol Lawrence, "Just Plain Common Sense: The 'Roots' of Racism," in Centre for Contemporary Cultural Studies, *The Empire Strikes Back: Race and Racism in Seventies Britain* (London, 1982), 97–94.

20. See, in particular, Commander R. H. Bacon, R.N., *Benin, the City of Blood* (London, 1897), which was reviewed in *The Times* (19 April 1898) as an ethnographic document. Other reviews reiterated this attitude.

21. Alfred C. Haddon, *Evolution in Art* (London,

1895); Henry Balfour, *The Evolution of Decorative Art* (London, 1893).

22. For a later and influential formulation of a similar thesis, see Wilhelm Worringer, *Abstraktion und Einfühlung* (Munich, 1907).

23. George Birdwood, "Conventionalism in Primitive Art," *Journal of the Society of Arts* 51 (October 1903), 881–889.

24. Alfred C. Haddon, *The Decorative Art of British Papua New Guinea: A Study in Papuan Ethnography* (Dublin, 1894), 1.

25. See *Journal of the Anthropological Institute* (January 1900), where the presidential address was devoted entirely to the importance of anthropology's as opposed to art history's contribution to the study of culture.

26. See J. Sheehy, *The Rediscovery of Ireland's Past: The Celtic Revival 1830–1930* (London, 1980); S. Dean, *Celtic Revivals* (London, 1988); William Vaughan, "The Englishness of British Art," *Oxford Art Journal* 13, no. 2 (1990), 11–23.

27. Edward B. Tylor, *Primitive Culture: Researches into the Development of Mythology, Philosophy, Religion, Language, Art, and Customs* (London, 1871); J. W. Burrow, *Evolution and Society: A Study in Victorian Social Theory* (Cambridge, 1966).

28. Balfour 1893, 14.

29. Balfour 1893, 15.

30. Haddon 1894, 252.

31. Charles Booth, *Life and Labour of the People in London* (London, 1892–1903); B. Seebohm Rowntree, *Poverty: A Study of Town Life* (London, 1901).

32. See Geoffrey R. Searle, *Eugenics and Politics in Britain 1900–1914* (Leiden, 1976); Charles Webster, ed., *Biology, Medicine and Society 1840–1940* (Cambridge, 1981); Frank Mort, *Dangerous Sexualities: Medico-Moral Politics in England since 1830* (London, 1987); Jeffrey Weeks, *Sex, Politics, and Society: The Regulation of Sexuality since 1800* (London, 1981); Anna Davin, "Imperialism and Motherhood," *History Workshop Journal* 5 (1978), 9–63.

33. For anthropologists' involvement in anthropometry over this period, see Annie E. Coombes, "'For God and for England': Contributions to an Image of Africa in the First Decade of the Twentieth Century," *Art History* (December 1985), 453–466. For the significance of photography for eugenics, see David Green, "Veins of Resemblance: Francis Galton, Photography and Eugenics," *Oxford Art Journal* 2 (1984), 3–16.

34. For a more detailed analysis of the development of the fortunes of the Ethnographic Department of the British Museum over this period, see Coombes 1994.

35. For a development of the relationship between Egypt and Africa in European scholarship, see Martin Bernal, *Black Athena: The Afroasiatic Roots of Classical Civilization*, vol. 1 (London, 1987).

36. O. M. Dalton, *Report on Ethnographic Museums in Germany* (London, 1898).

37. After 1906 a series of popular anthropological texts were published which all contained prefaces railing against the British government's indifference by comparison to the German government's expansive support and recognition for German anthropologists.

38. See, for example, Charles H. Read, *Antiques from the City of Benin and Other Parts of West Africa in the British Museum* (London, 1899). Apart from acknowledging a possible independent African origin for the Benin bronzes, this publication interviewed chiefs in the deposed Oba's retinue. These testimonials formed the basis of the history of the Edo narrated in Read's text. Consequently, it established the existence of an ancient history and helped validate an oral tradition as a legitimate source of information.

39. Ekpo Eyo and Frank Willett, *Treasures of Ancient Nigeria* (London, 1982).

40. Eyo and Willett 1982, 19.

41. Coutts-Smith 1991, 14–31.

42. David Wilson, *The British Museum: Purpose and Politics* (London, 1984).

43. Wilson 1984, 115.

44. The extraordinary fact that the delicate Benin plaques on the wall of the central staircase are neither replicas nor protected in any way makes a nonsense of any conservationist argument for keeping them in Britain.

45. "Man and Metal in Ancient Nigeria" was held at the British Museum from 15 May to 1 September 1991.

46. Corner and Harvey 1991, 10.

ROGER G. KENNEDY
National Park Service

Some Thoughts about National Museums at the End of the Century

Fifteen years ago, Washington cab drivers were in agreement that the correct name of the National Museum of American History was the "Museum of Science and Technology," because its official title then, the National Museum of History and Technology, was incomprehensible both to them and to most visitors.

Cab drivers are cosmopolitans, often thoughtful and highly educated. It is likely that they eschewed the composite history and technology title because it smelled to them of the ambitions of techno-imperialism. This is not to charge those who applied that title as intending to imply that all history is ordained by technological change. Instead, they were probably exhausted by the museum's institutional history. It had become the museum of everything else, intended to house all national collections not readily comprehended by art or what was then called "natural history," once "air and space" had its apotheosis in a museum across the Mall.

In reducing that name to American history we were moved by two not always harmonious intentions: to do right by our objects (which range across postage stamps, silver, harpsichords, Stradivarii, sharecroppers' cabins, Ku Klux Klan costumes, trains, organs, and bandstands) and at the same time to do right by the six million visitors who come each year seeking to learn about their national history.

If we have done a few things right, visitors are a little less likely now to come by chance upon cairns of objects, like those of Arctic explorers, wondering at them without hope of learning how they came there. By now those objects should be more purposefully juxtaposed and may, by sheer propinquity, impart something of their relationship. They can now be found in sequences offering equivalents at best to "story windows" of cathedrals, or at worst to comic strips or illustrated computer manuals.

We strove to convert a storage facility with visitorship into a place where significant stories are told by the arrangement of objects. That is as good a definition of a history museum as any. We supplemented that narrative format with many other modes of storytelling: interactive videos by the hundreds, drawing on discs whirring shyly in the basement; performances of song (which is pitched discourse) and dance; cooking for presentation on instructive place mats; sound-pools and video walls.

We also attempted to extend the experience in the museum by providing mnemonic "take-aways" or party favors: pamphlets, discs, cassettes, and even catalogues. Everybody knows by now that few museums, these days, issue mere listings as catalogues. Most feel an obligation to accompany iterations with essays, doing what exhibits strive to do, which is to link objects and labels into a coherent set of ideas.

The goals at the Museum of American History are several. The intention is to protect the collections (about fifteen million objects, including twelve million postage stamps, sixty-one pianos, and a dozen trains). One tries at the same time to study them and to learn from them. Thereafter, one goes forth to discuss what has been learned with academic scholars who write about the circumstances within which these objects are created. Together, the curators, with their things, and the scholars, with their words, make new words, which are digitalized for print, sound, and images. In recent years we in the museum have been striving to achieve new means of storing, conveniently and together, objects, words, still images, and those which move, so that future scholars may be able to draw on them all for exposition if not for exhibition.

What we do now is not necessarily what was contemplated when the collections came to the National Museum in the first place. In the United States, the first museums were in private hands, intended for the approbation and instruction only of persons certified to be seriously interested in them *and* to have been instructed in good manners. This was the way with Thomas Jefferson's Indian Hall, the nation's first museum of the American Indian. People who had neither slaves nor land to support their museums, such as Rembrandt Peale and P. T. Barnum, charged admission. After that, though in most places not until this century, public museums came to be considered civic assets, a story hardly requiring further discussion. It may, instead, be useful to reflect on the agglomerating tendency which, in Europe and America, was concurrent in politics and in museum-making while these transitions were in progress.

The relatively small number of people who organized what were called, until quite recently, "nation-states," often formed, simultaneously, national museums. By so doing, they aspired to assist the world (meaning equivalent elites elsewhere) to think well of them. Generally speaking, they were cosmopolitans, sharing the taste of others elsewhere who were of equivalent education and prowess. They shared gossip; on Hungarian hunting parties, they shared peasants; and in museums they shared a taste for Italian Renaissance painting.

Americans were at a great distance from most of the institutions built by these people, but, as Henry James has instructed us, some of them made every effort to come closer. One means of doing so was by assembling collections of paintings which, when subsequently given to art museums, have been of incalculable benefit to millions of fortunate people who would otherwise have had no opportunity to examine what the richest people in the world, served by the most expensive of advisers, would have accumulated for their own houses.

History and folk museums (related phenomena) tended to be bureaucratic rather than haut-bourgeois. Their taste was, therefore, more thoughtful and systematic, though less lively, than that represented in art museums. Art museum directors have their own ways of explaining themselves, and so do science museum directors, especially when a new museum is invented and someone has to explain to donors or legislators why they are necessary—being endearing or instructive to the rich is seldom sufficient anymore. History museum directors are not often asked why history is important, but they contend against the view that movies or books will do the job as well as buildings in which they are thought to preside over keepsakes.

My own response has been to begin with a refutation of the notion expressed by some senators that the objects in history museums—perhaps in all museums—"speak for themselves." (This view is given unwitting confirmation by the smugness of some curators.) Objects stand mute, except that their messages may be imparted to people who live with them all the time and have learned their silent language. It may be wonderful to feel oneself such a connoisseur, but no national museum would last long if it relied only on this group.

Besides, objects speak most powerfully in intentional juxtaposition. Great designers of museum exhibitions are narrators making respectful use of sequences. They need more furniture than easels.

Without claiming any universal application of the categories that follow, I suggest that a sharper sense of what has been found useful in national museums may emerge from a listing of some prototypes for contempo-

rary museum practice. These may be useful even to those who preside over museums dealing only with objects conventionally allocated to art, natural history, and science. The prototypes are set forth here because giving them occasional thought has helped us to consider how we wish to benefit from their successes as we seek to avoid their frailties.

(1) *The Schatzkammer*. Halls of treasures are often sufficient in themselves, even when unexplicated. The evolution of art and history museums in the 1980s represented a movement toward clumping and explaining the treasures.

(2) *The Iconostasis*. Assemblages of objects not to be looked *at* but looked *through*, significant not so much for themselves but for what they represent—apertures to another world—are most familiar to us in Eastern Orthodox churches. There are equally important examples in most Mission churches, in Mexico and the American Southwest. Elsewhere such ordered symbols may be seen in the stained or painted glass "story windows" of Europe, and in any collection of personal mementos. But symbolism goes dead when there are no memories to illuminate it or when there ceases to be a community sharing its meanings. History museums are large iconostases, more important for what they imply than for what they present.

(3) *The Triumph*. Hauling after you possessions taken from others—indeed, hauling *them*, too, in chains, cages, or in effigy—is a practice of many imperial peoples. Museums that present the artifacts taken at gunpoint from aborigines, or museums demonstrating the superiority of the collector to the collected, are vestiges of the triumphant school of museum-building.

(4) *The Gallery*. Two-dimensional objects arranged on walls with identifying labels serve a vastly important social function. They disperse and sometimes elevate concepts of taste, by making available to many what might otherwise be restricted to the delectation of the few. (Lest I be misunderstood, again, I like galleries. I wish we had more and better ones.)

(5) *The Academy*. The academy is a place where objects are dissolved into discourse. It is sometimes useful. Even semiotics and deconstructionism and new criticism have on

occasion justified the ink spent on them by providing piquant notions, though they have passed over museum practice in the last five decades without much effect. Essentially, however, the academy is about ideas and groups of words (not always the same thing). It is not about objects. People trained in academies may be refreshed by enlarging their consciousness to three dimensions, and may refresh museum professionals by suggesting values of juxtaposition not inherent in the objects themselves.

(6) *Shrines to the Muses*. It is not easy to know what was done in the museums of the classical age. My guess is that there was plenty of conversation, some of it, one hopes, on beat and on pitch. These seem to have been places where people met to pay special attention to the history of one or another mode of human communication over space or over time (as in history). Sometimes the worship of one or another muse called for a liturgy using just vocal sound. Sometimes that liturgy required the entire body. Sometimes it deployed objects of two and three dimensions. All these modes of discourse belong in museums.

(7) *The Basilica*. A rectilinear processional way, with stated places to pause for especially rapt attention to one aspect or another of a story, is a good format for any museum activity. So are mood-setting devices such as incense or its auditory equivalents, together with occasional instruction by persons of authority and special training.

(8) *The Rotunda*. When Hadrian placed his judging bench in the center of a building contrived to suggest the city, the state, and the universe, he wished to draw attention to what he was doing. Museums should do the same. We employ trumpets and drums, but we can also employ architectural devices implying that the visitor has arrived at a place of special importance to do something that matters. John Russell Pope never did that better than in the rotundas at the Jefferson Memorial and the National Gallery of Art, which hold solemn discourse with each other about their mutual importance.

(9) *The Hogan*. Smaller round forms have been used in many cultures to imply a unity of the community formed about a source of wisdom. Museums, also, can unify communities around very wise people or around ideas

shared widely by the members of that community. Roundness, in European architecture and that of Native Americans, implies a time dimension: that is to say, roundness connotes continuity. Within roundness, a central point may be the source of lines reaching out beyond the walls, but with known terminations, thereby implying a larger circle. At the core of all geometry, in a hogan, is *authority*. Authority comes from knowing something of use to the community, something justifying people coming to learn it. Museums, at their best, may be such places.

(10) *The Field of the Cloth of Gold*. The kings of France and England met to demonstrate how rich each was, *and* how each retained, amid the opulence, his capacity to function intellectually, by statecraft, and physically, through jousting. Thus those kings, Francis and Henry, set a proper standard for museum directors. Otherwise directors would suffer even earlier than they do the boredom that comes of self-importance within a small world, and the infirmities of indolence that afflict those who may have meals without getting the exercise of hunting.

Museums are still places in which people think. They are also places where serious people exert themselves to transcend the deadening routine of what is expected of them.

I cannot aver that all museums manifest the effects of all these prototypes. Especially do I doubt that all are Fields of the Cloth of Gold, but some are.

This is especially important these days. Directors of national museums are emerging from a period in which it was widely assumed that people knew what they were describing when they employed either the term "nation" or its derivative "national." Before we can consider the future usefulness of the experience of national museums of the past, we may well give further consideration to what is happening to the concept of nationhood.

It is one of the many ironies of the career of Woodrow Wilson that an American president should bring a childish notion of that concept to the attention of the world. Wilson, for all that he knew, knew very little about the multifariousness of American society.

The irony in this is, I believe, that citizens of the United States have a responsibility to bring to other peoples the benefits of their special experience in diversity. The best elements of their history demonstrate that, despite our foolishness and cruelties, we have learned from many peoples fiercely determined to retain their apartness while respectfully learning from each other.

A national museum in the United States is, or may be, a vastly different place from a national museum in a country more uniform racially or historically. It is a place demonstrating that diversity of cultures can be as fecund of blessings as diversity of species.

We know better than many others what horrors may be perpetrated when "national" is taken to be descriptive of homogeneity. If we seek our best selves, we can bring to Europe the experience of many peoples of diverse cultures living together without seeking to eradicate the most recently arrived or least opulently endowed among them.

In the nineteenth century, the word *nation* was even employed to describe accidental polities encompassing a multitude of disparate groups. Wilson's nationalism was, on the other hand, useful only to very small countries with homogeneous peoples. In large polities, each person or group of persons strives for fulfillment in their own terms, united only by whatever degree of mutual respect can be summoned out of the darkness of mutual distrust, ignorance, and prejudice.

A national museum in such a polity cannot be the same sort of place as one appearing after the jostling of nations produced the cracking apart of many of them. The breakup of some agglomerations in 1918–1921 divided the Austro-Hungarian consortium into smaller agglomerates, two of which were called Yugoslavia and Czechoslovakia. Between the two world wars, the dissolution of the Second British Empire caused a sharp reduction in the call for dusty-rose paint on the part of mapmakers. (The First British Empire had been depleted between 1775 and 1783 by the secession of thirteen of the fifteen North American colonies). And, in recent years, the Soviet Union has gone the way of the Ottoman Empire after 1878.

The American experience is full of examples of political arrangements made to accommodate resistance to homogenization, and it does require us to be clear about

which nations we are talking about when we speak of a National Gallery or a National Museum of American History.

We were invited to consider the role of national museums. The word "museum" has been found to have many meanings, arising from many antecedents. Conscientious people are striving to reconcile these meanings, and the lessons with which each is incandescent, as they tend the objects precious to those who came before them.

The word *nation* and its derivative *national* are even more problematic. The best I do, as a citizen of the United States and therefore of many barely and precariously united polities, is to seek for those characteristics of our own culture that may benefit from reinforcement in an institution serving us all. Chief among them, I think, is a capacious concept of culture and an inclusive definition of nationhood. The worst enemy to both is anxiety, and only slightly less pernicious than anxiety is snobbery.

DONALD PREZIOSI
University of California, Los Angeles

In the Temple of Entelechy:
The Museum as Evidentiary Artifact

There is no right or wrong way to visit a museum. The most important rule you should keep in mind as you go through the front door is to follow your own instincts. Be prepared to find what excites you, to enjoy what delights your heart and mind, perhaps to have aesthetic experiences you will never forget. You have a feast in store for you and you should make the most of it. Stay as long or as short a time as you will, but do your best at all times to let the work of art speak directly to you with a minimum of interference or distraction.

David Finn, *How to Visit a Museum*
(New York, 1985), 1

Our museums are houses of murdered evidence.
Attributed to W. Flinders Petrie, 1904

As is often the case with brilliant yet deceptively simple inventions, it is difficult to appreciate precisely how revolutionary the European invention of the art history museum was in its origins some two centuries ago. This is due in part to another characteristic of many major inventions, namely, that their full potential and their indispensability often come to be realized through use, exploration, and experimentation over time.

During the nineteenth century, the institution of the public, civic, and national museum of art history became an indispensable feature of the modern nation-state, and it has remained a necessary component of statehood in the twentieth century in every corner of the world. It is frankly rather easy to overlook or forget the extraordinary power the institution has had in legitimizing the modernity of the nation-state precisely because the art museum has come to be so perfectly natural and obvious in all our lives, so widespread, and so adaptable to the needs of all kinds of political circumstances.

Another impediment to our appreciation of the institution derives from a set of common assumptions we typically have had regarding the nature and functions of the museum of art. Such assumptions have been invariably historicist in motivation, and have concerned the ways we figure the institution in relationship both to anterior institutions and practices which appear similar and anticipatory, and to practices and disciplines concurrent with the earliest modern museums. Thus we commonly construe the modern museum of art as an advanced stage in a historical continuum beginning with earlier and less encyclopedic collections of art and archaeology, or we take the modern museum to be at base a systematized or rationally ordered version of earlier *Kunst- und Wunderkammern*, or curio cabinets, or as incrementally more faithful representations of scientific method.[1] Another impediment to our understanding has derived from the common but hasty assumption that what is being practiced in the new modern art museum reflects or parallels what is going on in other museological foundations, such as museums of natural history or ethnography,[2] where the epistemological dra-

maturgy is very clearly different.

The evidence we do have for early modern practices suggests that the rise of the new modern museum of art history represents a significant break with earlier practices of exhibiting, collecting, and recording historically and culturally important materials, justifying the recognition of a new epistemological technology in modern life.[3]

My aim in what follows is to outline a shorthand version of arguments justifying this and related assertions; a fuller explication of the arguments below will be found elsewhere.[4] I will begin with a series of claims and proceed to discuss one nineteenth-century institution that illustrates and exemplifies these general observations. These observations are of several types, dealing with the epistemological status of museological specimens in the new museums of art history; with the stagecraft or dramaturgy of the institution—its modes of address, as it were; and with the evidential and disciplinary character of the art museum as a cultural artifact. My general claim is that the innovativeness of the institution as it evolves in the nineteenth century is grounded in these three features and, in particular, in the manner in which they were orchestrated together at the end of the eighteenth century in Europe.

The first claim is that in the new museum of art history, the object or specimen comes to have a distinctly *hybrid* epistemological status such that its significance is simultaneously differential and semantic in nature. By this, I mean that the artifact is deployed within a field of visibility wherein its meaning is perpetually deferred across a network of relationships of formal and thematic associations among specimens of what comes increasingly to be staged as a class of like (art) objects.

In this regard, a work's significance is construed as a function of *place* in an unfolded diachronic array of works. A primary aim of museological practice becomes that of assigning to an object its fixed and proper place in a chronological bible of begatting, along any number of graded scales of filiation, descent, or association. In short, the art object's meaning comes to be equivalent to its differential position in a spatial-temporal web of associations. The artwork thereby comes to be staged as *entelechal* in nature: as an episode or station along a path of historical (which is to say, teleological) evolution. The system is at base historicist in the literal sense of the term—which is to say, idealist.

It is here that we may begin to appreciate the sheer brilliance of the invention of the museum of art history, and the compelling power of its social-historical address. In staging the past as that from which we, as a modern population, might wish to be descended (one thinks here especially of the postrevolutionary Louvre), that "past" is staged in an ordered, rigid, and oriented manner in relationship, quite explicitly and literally, to the presentness—and modernity—of that which is Europe. The increasing encyclopedicality and supranationality of the institution during the nineteenth century both serves and at the same time fabricates an ideology of modernization as progress wherein all that is not Europe is invariably legible as *anterior* to Europe (and its colonial extensions).

There is an additional effect entailed by the new (hybrid) epistemological status of the art museum specimen. Precisely because the object was deployed as a diachronically arrowed entity—because, in other words, it became legible as inherently possessing an evolutionary directionality—the artwork acquired the status of a standard of "scientific" measurement. It was able to be employed—and, as will be discussed below, was in fact commonly used—as an instrument for the evaluative assessment of aesthetic quality and cognitive worth, in two dimensions.

First, the artwork was used as that against which to measure the evolutionary value or position of non-European artifacts, and, second, as an instrument for the comparative measurement of ethnic and ethical advancement or status within the orbit of competitive European nation-states. This in fact becomes commonplace in the nineteenth century both in museological stagecraft and its routines of foregrounding, hierarchizing, and marginalization, as well as in the expanding professional discourse of art history and its academic apparatus, as this comes to be formatted in its rhetorical and analytic protocols after mid-century in Europe and America.[5]

The other facet of the hybrid nature of the new art museum object is what has been termed earlier as its *semanticity*: its completeness as a significative item, based upon its uniqueness and nonreproducibility, and upon its emblematic properties with respect, quite specifically, to its maker. It is in this regard that the very form of the work comes to be construed as the figure of its (art-) historical truth: a truth ultimately grounded in the vision, mission, and persona of the maker.

It is here that we may perhaps appreciate an important source of the methodological differences and debates within the modern discourse of art history itself regarding what should be deemed an adequate accounting for the origins of the "truth" of the work of art.[6] What is clear is that the evolving museological stagecraft of the new art museum itself allows for and entails a wide spectrum of apparently divergent or contrary paradigms of art-historical causality, wherein everything from the particular mentality of the artist to the ambient circumstances of production and reception, to the economic, social, or political forces of a time and place, or the more global mentality of an age, place, race, class, gender, or nationality, may, with equal logic, be plausibly adduced as final and determinative causes of the way a work appears. In short, the dramaturgical economy of the new museum of art affords the possibility of any number of possible "origins" for the truth of a work, and thereby any number of possible "methods" for making that truth legible.

If the first facet of the hybrid status of the art museum object may be seen as differential and metonymic, this second facet of the artwork is clearly metaphoric in nature, in the root sense of that term, in that the viewed object is staged as in some sense congruent with or iconic to its presumed source and content.

Clearly, one of the implications being made here is that in a substantive manner the theoretical and methodological discourse of the new discipline of art history is in a variety of ways itself an *artifact* of museological praxis, a product of all that the museum as an epistemological technology affords. It is here that we may begin to appreciate the foundational dilemma that confronted the articulation of a discipline such as art history in the nineteenth century (and which, it must be added, has continued to confound disciplinary practice up to the present time), namely, how to fabricate a "science" of historical artifacts simultaneously construed as unique and self-referential, and as specimens of a class of like phenomena. Of what, in short, is the artwork to be taken as evidence?

The disciplinary "solution" to this dilemma (in one sense not a resolution at all) was the cobbling in tandem of a series of overlapping institutions and discursive practices which taken *in concert* constituted a "discipline"— academic art history, art criticism, museology, the art market, connoisseurship, and so on—which maintains simultaneously shifting and contrasting systems of evidence and proof, demonstration and explication, analysis and contemplation, with respect to objects both semantically complete and differential in significance. Objects, in short, are paradoxically complete and incomplete at the same time.

Which brings us to the second generic claim regarding the innovativeness of the new institution of the modern museum of art: its stagecraft or dramaturgy, or its modes of address and legibility. The new institution came to establish certain routine conditions or protocols for the reading of objects and images. We have been dealing until now with the hybrid nature of the art museum specimen, by which I have meant its enigmatic status; its oscillation between differential and semantic states almost in the manner of certain familiar optical illusions wherein the dimensional particularity of an image is unstable. Beyond this, museums operate to situate their audiences—operators of their historiographic machineries, if you will—in what are in effect *anamorphic positions* from which the "history of art" may be seen, palpably and materially, as unfolding before their eyes. Regardless of the partial or fragmentary nature of a given museum collection, it will invariably be seen as exemplary or emblematic of an imaginary and ideal plenitude, some "universal history of art" which (it begins to seem natural to assume) exists somewhere in *disciplinary* space.

At the same time, museological objects

are staged, to paraphrase Walter Benjamin, as allegorical figures that are seen as expressing a certain "will to symbolic totality," precisely because they continually stare out at us as incomplete and imperfect.[7] It is in this regard that the spectator's role in the museum is indispensable as that point at which this incompleteness is to be resolved. The object, in short, is staged so as to be a component in the ethical practice of the self, foregrounded and highlighted as the object comes to be, precisely as an anchor for the mobile and drifting gaze of the spectator.

The spectator or subject is thereby interpolated by the work in this juxtaposition of (what we typically distinguish as) subject and object, in a choreography of phenomenological or psychodramatic interchange. The artwork thus achieves an emblematic status with regard to some ideal selfhood or subjecthood through a process of transference: a very palpable object of desire. The dynamics of this are complex, but the effects are ultimately straightforward in their ethical or moral implications in the life-worlds of the new bourgeois subject/citizen.[8]

It is here that we may begin to appreciate what came to be brilliantly accomplished by the new civic art museum of the nineteenth century—a kind of pragmatics of ethical philosophy in that the institution was both an occasion for inward and contemplative work on the part of the bourgeois subject of the nation-state, and that it provided palpable means for the comparative ethical assessment of works and peoples.

Indeed, one of the most ubiquitous perspectives on the history of art—and in particular on what museums were thought to afford and accomplish—was that works of visual and plastic art, construed increasingly as among the most complex and telling products of the human mind, could provide quite distinctive and profound evidence for the moral or ethical character of individuals, groups, nations, classes, genders, and races. What the art museum came in fact to be was nothing less than a laboratory for the education and refinement of bourgeois sentiment.

This perspective is clear in the massive body of nineteenth-century literature on the museum, wherein the institution is commonly considered as a laboratory or theater for the moral education of the public, along with its disciplinary complement, the academic study of the history of art, as we shall see below. The following will consider one institution whose organization exemplifies the claims made above, and which both crystallized the various phenomena described above, and focused and solidified the academic discourse of art history on the tracks it has followed in the twentieth century.

One of the more remarkable art institutions to be founded in the nineteenth century—and one to embody all of the issues discussed in the first part of this essay—was the Fogg Museum at Harvard, the first institution anywhere in the world specifically designed to house the entire disciplinary apparatus of art history and its museology in a single construction. Although the building itself was completed and dedicated in 1895, the Fogg was built upon the various practices and principles inaugurated in the early 1870s by Charles Eliot Norton, who had been appointed in 1874 as the first academic professor of art history in the United States.[9] Norton had been appointed to a university position whose job description was "Lecturer on the History of the Fine Arts as Connected with Literature."

By training, an expert on medieval Italian literature and a noted Dante scholar, Norton had traveled extensively in Europe after his graduation from Harvard College in 1854, spending a great deal of time at Oxford attending lectures by John Ruskin on Italian art. Over the years, Ruskin became a close personal friend, model, and mentor, and Norton very explicitly set out to create at Harvard what Ruskin was himself unable to bring to fruition in England, namely, the establishment of an academic institution synthesizing museology, criticism, historical research, and studio practice.

Norton's synthetic institution, the Fogg Museum, was intended, in the words of an early chronicler, to be quite explicitly a common, scientific "laboratory" environment whose organization was to be guided by "the principle that the history of the arts should always be related to the history of civilization; that monuments should be interpreted as expressions of the peculiar genius of the people who produced them; that fundamental principles of design should be

emphasized as a basis for aesthetic judgments; and that opportunities for training in drawing and painting be provided for all serious students of the subject."[10]

The overriding business of the Fogg was the collection and organization of evidence for demonstrating these principles, and especially the most fundamental principle of all: that there is an essential, direct, and demonstrable relationship between the aesthetic character of a people's works of art and that people's social, moral, and ethical character and social evolution. This visual evidence was presumed to be homologous to that which might be evinced from a people's other arts, and in particular its literature. One "scientific" basis for such aesthetic and ethical comparative judgments was the (presumedly universal) "principles of design" common to all peoples.

At the heart of Norton's plan was a central data bank of images, casts, models, and other reproductions. (It is important to note that Norton felt that only by permitting students to study similarly formatted photographs of actual artworks before being allowed to study "original" artworks could the student develop a strictly scientific understanding of the history of art and of the principles of design. Only with very great reluctance were actual artworks admitted to the Fogg Museum, despite great external pressures from university administrators and potential donors, and only after Norton's own retirement in 1896.)

The data bank was in principle an indefinitely expandable archive of lantern slides and photographs, ordered geographically and chronologically, and, within those categories, by known and unknown artist, by stylistic traits (where that was not equally coterminous with historical and geographical divisions), and by medium. Further divisions were made between "major" arts (painting, sculpture, and architecture) and "minor" arts (book illumination, luxury, domestic and ceremonial objects, jewelry, and so on).

The significance of any item in the data bank was in principle a function of its relationship to another or others, as embodied in the material arrangements of cabinets in which (images of) objects were sequentially filed. In this sense, any item bore the traces of others, and its significance was a function of what the system's juxtapositions and separations afforded. Each item was thereby in an *anaphoric* position, cueing absent others, and eliciting resonances ("influences") with like objects, both metonymically (by material contiguity) and metaphorically (by resemblance), elsewhere in the archival mass.

At the same time, Norton's system was organized, with respect to the user, in an *anamorphic* manner such that relationships among specimens in the collection were visible (legible) only from certain prefabricated stances on the part of the user of the data bank. This mode of address involved accessing the collection in such a way as to facilitate and entail the fabrication of consistent and internally coherent narratives of aesthetic (and, thus, to Norton, social and ethical) development, filiation, progress, or decline. Such narratives as the comparative examination of painters of the Venetian and Florentine schools (a favorite subject of Norton's own classes) might thereby be facilitated by the spatial logic of the archival system.

Art-historical discourse—and, indeed, the parameters of art-historical research—came thus to be in no small measure artifacts of the systemic logic of the collection. Every lantern slide, so to speak, was staged as a "still" in a historicist movie. And the organization of lecture classes and seminars initiated by Norton (and now more or less standard everywhere in the discipline internationally), from the introductory art history survey (first offered at the turn of the century at Harvard) to the advanced, specialist seminar, have their modern origins in the work of Norton's institution—a term that I think proper to describe a phenomenon which was neither museum, studio, nor academic department, but all of these conceived in a synthetic fashion in this veritable "Bauhaus" of art history and museology of the last quarter of the nineteenth century.

In a very real sense, Charles Eliot Norton could be said to have founded English—or at least Ruskinian—art history on the wrong side of the Atlantic. In fact what he and his associates accomplished in Cambridge, Massachusetts, was rather more than the endowment of institutional substance to what his mentor in England failed to accomplish. At

the original Fogg Museum of 1895 (demolished a few years ago, and augmented by the present building in 1927), a disciplinary practice more thoroughly and explicitly "scientific" than could be predicted from Ruskin's own aesthetic philosophy came to be realized. It should parenthetically be mentioned that Norton's institution was also in distinct and explicit opposition to developments in Germany. Norton was quite clear in his opposition to art history as practiced in Germany, which he held to be so abstract and unscientific, and so distinctly ahistorical, as to be shunned by the serious art historian and museologist.

My final observations are entailed by my previous remarks. We would make a serious mistake were we to presume that the modern civic museum of art history that evolved during the nineteenth century was little more than a passive collection or archive focused simply on the past. In fact, the institution's mode of address was (and indeed still is) to the present, functioning in and operating on the present so as to fabricate the conclusion that our presentness is the inevitable result and product of a certain past. In this regard it may be claimed that the museum has been a social instrument for the fabrication and maintenance of *modernity*, and of those ideologies of modernization and progress indispensable to the self-definition of modern nation-states initially in Europe and eventually everywhere in the world.

The modern museum of art has been an essential technology for the production of that modernity, a modernity increasingly strongly defined, throughout the nineteenth century, by idealized ethnic, linguistic, cultural, and racial homogeneities, by retrojected fictions of national spirit, essence, character, or distinction: Germanness, Gallicness, Italicism, Hellenism, Jewishness, Englishness, Americanness, or by one or another mode of Aboriginality.

We should not underestimate the sheer brilliance of the idea of circulating populations through simulacra of the past, along galleries of aesthetic development and refinement wherein artworks are staged as "speaking" to one another over time (as if the history of art were at base a genealogy of aesthetic problems posed and solved), along

passages charting palpable progress in manners, taste, and morality, and amidst evidentiary artifacts of a hybrid and enigmatic character purporting to demonstrate in a seemingly neutral, scientific manner propositions which were, after all, at base, political in nature, tied inextricably to the emergent needs for self-identity of modern nation-states.

For over the past century and a half, as this remarkable invention has been disseminated to every country in the world, it has come to be, everywhere in similar ways, an indispensable instrument for weaving together, naturalizing, and perpetuating essentialist ideals for selfhood, ethnicity, gender, race, and nationality, over a teleologically gridded loom of fictional narratives masquerading as "history."

Moreover, as an astonishingly successful engine of historicism, the modern museum of art history has come to be an essential component of all that we construe our modernity to be. In this regard, all that the discourse of art history has become, in all its theoretical and methodological diversity, was already entailed by what the modern museum came to afford in its nineteenth-century exploration of its own potentials.

Unless we come to appreciate more fully the invention of the art history museum as the invention of an *epistemological technology*, our understanding of the institution will remain complicit with the historicist idealisms and essentialisms which have themselves in no small measure been a museological artifact and effect. In enframing history, memory, and meaning through the patterned deployment of objects abstracted from our own and other cultures, and by choreographing these together with the moving bodies and shifting gaze of individuals, museums have worked both to define and discipline desire, to finalize the past as both ordered and oriented, and to establish paradigms and objects of contemplation and emulation for the composition and refinement of our individual and collective selves. Museums, in short, are addressed to the present as the palpable outcome and determinate product of a past staged as the prologue to our presentness; as evidentiary artifacts, museums display what is framed as evidence for the causal antecedents of that

presentness, that modernity. Our modernity, indeed, has itself been an artifact and effect of the ways of knowing institutionalized both in and by the museum: the history of the one is entailed in the history of the other.[11]

NOTES

1. Oliver Impey and Arthur MacGregor, eds., *The Origins of Museums: The Cabinet of Curiosities in Sixteenth- and Seventeenth-Century Europe* (Oxford, 1985), 281–312; Adalgisa Lugli, *Naturalia et mirabilia: Il collezionismo enciclopedico nelle Wunderkammern d'Europa* (Milan, 1983), 243–258; Stephen Bann, *The Clothing of Clio: A Study of the Representation of History in Nineteenth-Century Britain and France* (Cambridge, 1984), 76–92.

2. Mieke Bal, "Telling, Showing, Showing Off," *Critical Inquiry* 18 (spring 1992), 556–594.

3. Eilean Hooper-Greenhill, *Museums and the Shaping of Knowledge* (London, 1992), 1–46.

4. Donald Preziosi, "The Question of Art History," *Critical Inquiry* 18 (winter 1992), 363–386.

5. Donald Preziosi, *Rethinking Art History: Meditations on a Coy Science* (New Haven, Conn., 1989), 80–121.

6. Jacques Derrida, *The Truth in Painting*, trans. Geoff Bennington and Ian McLeod (Chicago, 1987), 15–148.

7. Walter Benjamin, *The Origin of the German Tragic Drama*, trans. John Osborne (London, 1977), 186.

8. Donald Preziosi, "Seeing through Art History," in *Knowledges: Historical and Critical Studies in Disciplinarity*, ed. Ellen Messer-Davidow, David R. Shumway, and David J. Sylvan (Richmond, Va., 1993), 215–231.

9. Preziosi 1989, 72–79.

10. George Chase, "The Fine Arts, 1874–1929," in Stephen E. Morison, ed., *The Development of Harvard University (since the Inauguration of President Eliot) 1869–1929* (Cambridge, Mass., 1930), 133.

11. Issues discussed in this essay are taken up in greater detail in Donald Preziosi, "Brain of the Earth's Body: Museums and the Framing of Modernity," in Paul Duro, ed., *The Rhetoric of the Frame* (Cambridge, 1996), in press.

Contributors

Per Bjurström is professor emeritus and the former director of the Nationalmuseum, Stockholm. He earned his Ph.D. at Uppsala University. Among his recent publications are *Lennart Rodhe Blockteckninger och reseskisser* (1995), *The Genesis of the Art Museum in the Eighteenth Century* (1993), *Nationalmuseum, 1792–1992* (1992), and *The Art of Drawing in France, 1400–1900: Drawings from the Nationalmuseum, Stockholm* (1987). He is a member of the Royal Academy of Fine Art and the Royal Academy of Letters, History, and Antiquities, Sweden.

Annie E. Coombes teaches art history and cultural studies at Birkbeck College, University of London. She is the author of *Reinventing Africa: Museums, Material Culture, and Popular Imagination in Late Victorian and Edwardian England* (1994) and is on the editorial collectives of the *Oxford Art Journal* and *Feminist Review*.

Carol Duncan's recent publications include *The Aesthetics of Power: Essays in the Critical History of Art* (1993) and *Civilizing Rituals: Inside Public Art Museums* (1995). She is professor of art history in the School of Contemporary Art, Ramapo College of New Jersey.

Philip Fisher, the Reid Professor of English at Harvard University, has written on the English and American novel, on cultural institutions, and on the passions. His books include *Making and Effacing Art: Modern American Art in a Culture of Museums* (1991), the forthcoming "Wonder, the Rainbow, and the Aesthetics of Rare Experiences," and, in literary studies, *Hard Facts* (1985) and "Still the New World," forthcoming. His current project is on the passions of anger and fear as they determine the genres of literature and art and the philosophical account of human nature.

Françoise Forster-Hahn is professor of the history of art at the University of California, Riverside. She has published on issues of nineteenth-century art and the role of museum displays and expositions in the construction of national and cultural identity. She is working on a book, "Adolph Menzel (1815–1905): A Career between National Empire and International Modernity," and is the editor of *Imagining Modern German Culture, 1889–1910* (1996).

Thomas W. Gaehtgens, professor of art history at the Freie Universität Berlin, has published on French and German art from the eighteenth through the twentieth century. His work includes *Zum frühen und reifen Werk des Germain Pillon* (1967); *Napoleon's Arc de Triomphe* (1974); *Versailles as a National Monument* (1984); with J. Lugand, *Joseph-Marie Vien, Peintre du Roi, 1716–*

1809 (1988); *Anton von Werner, Die Prokla-*
mierung des Deutschen Kaiserreiches. Ein
Historienbild im Wandel preussischer Politik
(1990); and *Die Berliner Museumsinsel im*
Deutschen Kaiserreich (1992). Since 1992 he
has been president of the Comité Interna-
tional d'Histoire de l'Art.

Roger Kennedy was for fourteen years direc-
tor of the Smithsonian's Museum of
American History, where he served as editor
of the twelve-volume *Guide to Historic*
America. He is the author of many books on
history and architectural history, including
Hidden Cities (1994), *Orders from France*
(1989), and *Rediscovering America* (1990),
which is also the title of the television series
"Roger Kennedy's Rediscovering America."
He is director of the National Park Service.

Andrew McClellan is chair of the art history
department at Tufts University and author
of *Inventing the Louvre: Art, Politics, and*
the Origins of the Modern Museum in
Eighteenth-Century Paris (1994). He is
working on a book-length study of seven-
teenth- and eighteenth-century sculpture.

Donald Preziosi is professor of art history at
the University of California, Los Angeles,
and the author of *Rethinking Art History:*
Meditations on a Coy Science (1989). He has
published on critical theory, contemporary
visual culture, and the history of the disci-

pline of art history. Current research con-
cerns the history of museums and museol-
ogy and their roles in the fabrication of mod-
ern national and ethnic identities in Europe,
America, and the Middle East.

Alan Wallach is Ralph H. Wark Professor of
art and art history and professor of Amer-
ican studies at the College of William and
Mary. He was co-curator of the exhibition
Thomas Cole: Landscape into History and
co-author of the accompanying catalogue
(1994). A book of essays on the museum in
the United States is forthcoming.

Gwendolyn Wright is professor of architec-
ture, history, and art history at Columbia
University. Her latest book, *The Politics of*
Design in French Colonial Urbanism (1992),
analyzes French modernism and historic
preservation, both in France and in the
major cities of three French colonies, includ-
ing Indochina, in the late nineteenth and
early twentieth centuries. She has also pub-
lished on the history of American domestic
architecture and architectural education.
Her research now focuses on the varied
strategies and philosophies of American
modernism during the 1930s and 1940s.

Studies in the History of Art
Published by the National Gallery of Art, Washington

This series includes: Studies in the History of Art, collected papers on objects in the Gallery's collections and other art-historical studies (formerly *Report and Studies in the History of Art*); Monograph Series I, a catalogue of stained glass in the United States; Monograph Series II, on conservation topics; and Symposium Papers (formerly Symposium Series), the proceedings of symposia sponsored by the Center for Advanced Study in the Visual Arts at the National Gallery of Art.

[1] *Report and Studies in the History of Art,* 1967

[2] *Report and Studies in the History of Art,* 1968

[3] *Report and Studies in the History of Art,* 1969 [In 1970 the National Gallery of Art's annual report became a separate publication.]

[4] *Studies in the History of Art,* 1972

[5] *Studies in the History of Art,* 1973 [The first five volumes are unnumbered.]

6 *Studies in the History of Art,* 1974

7 *Studies in the History of Art,* 1975

8 *Studies in the History of Art,* 1978

9 *Studies in the History of Art,* 1980

10 *Macedonia and Greece in Late Classical and Early Hellenistic Times,* edited by Beryl Barr-Sharrar and Eugene N. Borza. Symposium Series I, 1982

11 *Figures of Thought: El Greco as Interpreter of History, Tradition, and Ideas,* edited by Jonathan Brown, 1982

12 *Studies in the History of Art,* 1982

13 *El Greco: Italy and Spain,* edited by Jonathan Brown and José Manuel Pita Andrade. Symposium Series II, 1984

14 *Claude Lorrain, 1600–1682: A Symposium,* edited by Pamela Askew. Symposium Series III, 1984

15 *Stained Glass before 1700 in American Collections: New England and New York (Corpus Vitrearum Checklist I),* compiled by Madeline H. Caviness et al. Monograph Series I, 1985

16 *Pictorial Narrative in Antiquity and the Middle Ages,* edited by Herbert L. Kessler and Marianna Shreve Simpson. Symposium Series IV, 1985

17 *Raphael before Rome,* edited by James Beck. Symposium Series V, 1986

18 *Studies in the History of Art,* 1985

19 *James McNeill Whistler: A Reexamination,* edited by Ruth E. Fine. Symposium Papers VI, 1987

20 *Retaining the Original: Multiple Originals, Copies, and Reproductions.* Symposium Papers VII, 1989

21 *Italian Medals,* edited by J. Graham Pollard. Symposium Papers VIII, 1987

22 *Italian Plaquettes,* edited by Alison Luchs. Symposium Papers IX, 1989

23 *Stained Glass before 1700 in American Collections: Mid-Atlantic and Southeastern Seaboard States (Corpus Vitrearum Checklist II),* compiled by Madeline H. Caviness et al. Monograph Series I, 1987

24 *Studies in the History of Art,* 1990

25 *The Fashioning and Functioning of the British Country House,* edited by Gervase Jackson-Stops et al. Symposium Papers X, 1989

26 *Winslow Homer,* edited by Nicolai Cikovsky Jr. Symposium Papers XI, 1990

27 *Cultural Differentiation and Cultural Identity in the Visual Arts,* edited by Susan J. Barnes and Walter S. Melion. Symposium Papers XII, 1989

28 *Stained Glass before 1700 in American Collections: Midwestern and Western States (Corpus Vitrearum Checklist III),* compiled by Madeline H. Caviness et al. Monograph Series I, 1989

29 *Nationalism in the Visual Arts,* edited by Richard A. Etlin. Symposium Papers XIII, 1991

30 *The Mall in Washington, 1791–1991,* edited by Richard Longstreth. Symposium Papers XIV, 1991

31 *Urban Form and Meaning in South Asia: The Shaping of Cities from Prehistoric to Precolonial Times,* edited by Howard Spodek and Doris Meth Srinivasan. Symposium Papers XV, 1993